THE FAR SIDE
OF MADNESS

SECOND EDITION

WITH A NEW PREFACE BY JOHN BEEBE

JOHN WEIR PERRY

SPRING PUBLICATIONS, INC.
PUTNAM, CONNECTICUT

Copyright © 2005 by Spring Publications, Inc.

Published by Spring Publications, Inc.
28 Front Street, Suite 3
Putnam, CT 06260
www.springpublications.com

Originally published in 1974 by Prentice-Hall, Inc.

Second edition 2005

Printed in Canada
Design by white.room productions, New York

ISBN-13: 978-0-88214-557-0
ISBN-10: 0-882145-557-6

Library of Congress Cataloging-in-Publication Data

Perry, John Weir.
 The far side of madness / John Weir Perry ; with a new preface by John Beebe.
 — 2nd ed.
 p. ; cm.
 Originally published: Englewood Cliffs, N.J. : Prentice-Hall, 1974.
 Includes bibliographical references and index.
 ISBN-13: 978-0-88214-557-0 (pbk. : alk. paper)
 ISBN-10: 0-88214-557-6 (pbk. : alk. paper)
 1. Schizophrenia. 2. Self. 3. Signs and symbols.
 [DNLM: 1. Schizophrenia. 2. Schizophrenic Psychology.] I. Title.

RC514.P45 2005
616.89'8—dc22

 2004028417

∞ The paper used in this publication meets the minimum requirements of the
American National Standard for Information Sciences—Permanence of Paper for
Printed Library Materials, ANSI Z39.48-1992.

PREFACE

In 1974, when *The Far Side of Madness* first appeared, the most recent mad moment in American culture had passed, and the country was in something like a post-psychotic depression. The counterculture experiment of saying and doing the unthinkable, which had impregnated the late 1960s with the possibilities of creative breakdown, had straitened into a new consensus that the traditional structures could, after all, be made to serve, if only women and men of good will would fill them. Watergate had superseded Woodstock in collective fantasy: Nixon was the scapegoat who would prove, by his resignation, that the system worked. The book, which John Perry imagined would be a rallying cry for his view that acute schizophrenia was society's natural "renewal syndrome," was received as a nostalgic afterthought. A generation later, now that the regressive aspect of this return to the normal order of things has become more evident, Perry's polemic may be better positioned in time to convince an American audience that psychotic intervals are necessary to generate the capacity to envision and to care.

His was always a counter-establishment view, and in the end he paid heavily for his unreflective confidence in rebellion. At first, however, this innovative psychiatrist's perspective had seemed like the soul of great medicine. A decade after he joined the C.G. Jung Institute of San Francisco in 1950, fresh from psychiatric residency and a year of fellowship in Zurich, he published a very influential article, "Image, Complex, and Transference in Schizophrenia," in the book *Psychotherapy of the Psychoses*, edited by Arthur Burton, who placed Perry alongside Silvano Arieti and Marguerite Sechehaye, in a volume that also included contributions by Otto Allen Will, Harold F. Searles, Don D. Jackson, and Edith Weigert, names that remain canonical in the

field of psychological medicine for the seriously disturbed. Searles, in particular, saw that Perry had formulated the importance of therapist-responsiveness in "particularly appealing terms" when he wrote:

> The individuation process probably takes place only, or comes to fruition only, in relationship . . . [W]hen a patient in an acute turmoil is at some level trying to formulate a self-image, this stands in acute need of affirmation . . . Such a self tends to take shape best in such a mutually animated emotional field . . .
> (Perry, quoted in Searles 1965, p. 651)

Although Searles had his doubts about empathy as the *exclusive* therapeutic stance, and argued in the same essay that the schizophrenic patient also needs "responses of inscrutability, imperturbability, impassivity and, on many occasions, what can only be called indifference" (ibid., p. 637), there was no doubt that Perry's understanding of affirmation commanded the respect of this master of the psychotherapy of the psychotic.

It was the first time since Jung's visits to America in the first decade of the twentieth century that anything resembling "Jungian psychiatry" had won such recognition. Nor was the recognition accorded only by the published leaders of the field. In San Francisco in 1966, I heard a merchant seaman at the United States Public Health Service Hospital say that John Perry was the best psychiatrist in San Francisco, a view held in common with psychiatric nurses who had seen his results with patients in the inpatient unit of San Francisco General Hospital, and by many in both psychiatric residency and analytic training at the time, who felt fortunate to have Perry as a clinical teacher. Yet by the end of the 1960s, he had also become, like the more internationally famous existential psychoanalyst R.D. Laing, an icon of the antipsychiatry movement. As "future shock" became a popular concern, and conferences were offered on topics like "Toward the Year 2000," Perry appeared on public stages with the likes of Gregory Bateson and Allen Ginsberg, arguing that the only people who had been prepared from within for the world-rescuing paradigms everyone was now being urged to adopt, such as feminism, ecology, antimaterialism, pacifism, and pansexualism, were

the schizophrenic patients who had anticipated all this in their messianic delusions in the 1950s.

His own utopian dream, for which this book gives the rationale, was the emergence of genuine asylums for people undergoing acute schizophrenic episodes, therapeutic communities that would regard the psychosis as an inner journey to be facilitated rather than as an illness to be cured. The final chapter of *The Far Side of Madness* was written at a time when Perry had actually succeeded in getting a public facility in San Francisco operating according to his philosophy, the short-lived Diabasis, which was to last only three years before funding and administrative difficulties forced its closure. Perry never abandoned his belief that the premorbid personality was the illness that schizophrenia was attempting to cure and that therapeutic arrangements for the patient needed to respect that fact.

In Perry's view, the people who developed catatonic psychoses were invariably rigid, schizoid personalities; before they became psychotic, they were so in the grip of the patriarchal animus that they could not relate openly to others. It was this control that the catatonia sought to break. To recover, they not only needed environments that mirrored their emerging democracy as they attempted to loosen their authoritarian structures of thought, they needed to be allowed to articulate their own vision of a better society so that we could all benefit. As early as the 1950s, paying close attention to the content of the delusions in a series of such patients, Perry had verified that their fantasies revealed, to a therapist able to induce trust and willing to let the patient's intuition have its say, a highly meaningful sequence of political images that led the patient to insist upon embodying a divine kingship inspired by the principle of love. With precision and brilliance, Perry argued that the appropriation of the archaic kingship archetype by modern individuals was not simply a compensatory power drive in people with weak egos but the very path toward the liberation of the sovereignty of the self. The experiential basis of this intuitive view is well presented in *The Far Side of Madness*, and there is still no substitute for reading Perry's own account of it. He brings a remarkable feeling for history as an internal reality to his analysis of cultural symbolism as he sketches out his conviction that every

acutely schizophrenic person in the grip of his or her vision is a poten-
tial culture-maker. For Perry, the direction both psyche and history want
to take is essentially Christian, in that love turns aside power, though
this evolution takes place in an organic, rather than a dogmatic way.

Perry's idealism regarding external therapeutic love as a way to fos-
ter the overcoming of internalized power structures that have become
too rigid requires, however, a warning to the potential buyer. There is
something not just incomplete, in the sense that the therapeutic im-
portance of the analyst's hate is left out, but somewhere deluded in
his belief in the healing powers of the loving or, as Perry would put it,
"affirming" analyst. Believing that "a mutually animated emotional
field" needed to rule in the therapy sessions, Perry began to confuse
eros with anima and in time lost his ability to reflect and discriminate
the limits of love as a cure, with the result that a shadow of seduction
tars the empathy and compassion that his published clinical writings re-
cord. He couldn't see that to take it upon himself to erotically validate
the embodied self of the patient emerging from a psychotic regression
was to forget the restraint imposed by his role and to lead the patient
into a new form of self-violation. By 1980, enough had been made pub-
lic about his boundary violations and reported to a newly reorganized
Ethics Committee at the C. G. Jung Institute of San Francisco that the
Institute put him on indefinite suspension (Kirsch 2000, pp, 84–85).
A decade later, after also surrendering his medical license, he resigned
from the Institute and began to describe himself only as a teacher. To
the end, he insisted that people in whom the self was emerging were
beautiful and that this beauty needed to be affirmed in an embodied way.

Perhaps it would take a writer of fiction to do justice to the pathetic
trajectory of John Perry's career. Indeed, the oral tradition that has sprung
up around 'Perry' in Jungian circles has many elements of fiction — like
much gossip, both revealing and concealing the daimon that drove the
man. The John Perry I knew, as my analyst and later as a colleague, was
as elegant as he was shabby. In his preface to *Winesburg, Ohio,* Sherwood
Anderson develops a little myth of how consciousness sometimes devel-
ops, which I think has something to say about the danger that often lies
in wait for any analyst who tries to get at the truth of the unconscious:

... in the beginning when the world was young there were a great many thoughts but no such thing as a truth. Man made the truths himself and each truth was a composite of a great many vague thoughts. All about in the world were the truths and they were all beautiful ... And then the people came along. Each as he appeared snatched up one of the truths and some who were quite strong snatched up a dozen of them.

It was the truths that made the people grotesques ... [T]he moment one of the people took one of the truths to himself, called it his truth, and tried to live his life by it, he became a grotesque and the truth he embraced became a falsehood.
(Anderson 1919/1995, p. 25–26)

In this sense, John Perry had become, by the end of his career, grotesque. Despite the damage to the analyses of several of his patients and to his own reputation that he inflicted in the name of the truth he had found, he *had* found a truth. There is a process in the psyche that demands that power give over to love. He himself acted this out until his own power was stripped away. In our own time, however, when the power mode, and the kind of leadership that doesn't understand a communal process, has resurrected undemocratized kingship (and its corollary, empire) to the world stage, we have to be grateful for the crazy purity of Perry's intuition. The self's natural move is away from individual control by and of others and toward a community to which each of us is ethically responsible through a principle of care. It is not hard to find much in *The Far Side of Madness* that still inspires the right kind of respect for the psyche during its times of disoriented compensatory expression. The reader will need to be able to supplement this wounded teacher's perspective on healing with the corollary recognition that using such an orientation is only safe when it is applied in a way that respects the autonomy of the patient. For it is, after all, Perry's seminal insight in this Jungian classic that the autonomous psyche holds the archetypal energy people need to overcome the rigidities of a paranoid time.

John Beebe
San Francisco, California

References

Anderson, Sherwood (1996). "The Book of the Grotesque," in John H. Ferres, ed., *Winesburg, Ohio: Text and Criticism* (revised ed.). New York: Penguin Books.

Kirsch, Thomas (1990). *The Jungians: A Comparative and Historical Perspective*. London and New York: Brunner Routledge.

Perry, J. W. (1961). "Image, Complex and Transference in Schizophrenia," in Arthur Burton, ed., *Psychotherapy of the Psychoses*. New York: Basic Books.

Searles, Harold (1963/1965). "The Place of Neutral Therapist Responses in Psychotherapy with the Schizophrenic Patient," in *Collected Papers on Schizophrenia and Related Subjects*. New York: International Universities Press.

Acknowledgment is gratefully made to the following publishers for granting permission to reprint selections from their works:

To Simon and Schuster, Inc. and Jonathan Cape Limited, for quotations from *The Diary of Vaslav Nijinski,* edited by Romola Nijinski. Copyright 1936 by Simon and Schuster, Inc.

To Methuen & Company Ltd., for quotations from *Mysticism,* by Evelyn Underhill.

To The Clarendon Press, Oxford, for quotations from *The Dialogies of Plato,* translated by Benjamin Jowett.

To the University of Wales, for quotations from *Sacral Kinship in Ancient Israel,* by A. R. Johnson.

To Macmillan Publishing Group, Inc. and George Allen & Unwin Ltd., for quotations from *The Messianic Idea in Israel,* by Joseph Klausner.

Chapter One, "On Madness," was presented as a lecture in a panel on *The Poetry of Madness,* in an Esalen series on *The Value of Psychotic Experience,* Summer 1968, in San Francisco. It has been published on audio tape by Big Sur Recordings.

Chapter Four, "The Nature of the Kingship Archetype," was first published published under that title in *Journal of Analytical Psychology* XI, no. 2 (1966).

Chapter Six, "The Messianic Hero," was first published under that title in *Journal of Analytical Psychology* XVII, no. 2 (1972).

Chapter Seven, "Mysticism and its Heroes," and Chapter Eight, "Mysticism and Madness," were presented under the title "Mores, Mysticism, and Madness," on a panel with Dr. Julian Silverman, Winter 1970, under the auspices of the C. G. Jung Institute, San Francisco.

Chapter Nine, "Societal Implications of the Renewal Process," was first published under that title in *Spring* 1971.

Chapter Eleven, "The Creative Element in the Renewal Process," was first published under that title in *Art Psychotherapy* I (1973).

INTRODUCTION

During the several years that this volume was in preparation, new trends appeared in the concept and care of psychosis in young adults. They hold promise of changing not only the demeanor of psychiatry, but even perhaps of the presuppositions by which we have been accustomed to distinguish normal from abnormal.

Had I hurried this work toward publication ten years ago, as I had then intended, my stand on these issues would have been less bold than it appears here. For until then I had been working with psychotic individuals in a standard county hospital setting. In the intervening years I have suffered the instructive trials of attempting to bring about a favorable milieu in an experimental ward of a state hospital. In consequence I am at present embarking upon a more innovative venture, participating in setting up a non-hospital residence facility for the care of acute young psychotic individuals within a community mental health system. The net effect of these experiences for me has been an enforced revaluation of my own presuppositions in assigning normality and abnormality to administrative and to "patient" personnel. I can only conclude that when the depths of the psyche erupt into the open, everyone concerned becomes strange! Madness seems as surely to appear in the high places as the low! Most of all I find myself deeply impressed with the magnitude of the difficulties one is up against in a schizophrenic break, when the forces and contents of one's unconscious are thus unleashed and the world around seems suddenly galvanized into a stony resolve to suppress them. Even those with the kindest possible will to "help" rarely understand what comes from the depths. For even after seven decades of depth psychology we still remain largely in the dark in this regard.

On this account, my effort in this volume is to present a distinctly interior approach to psychosis. It focuses primarily on all that goes on within the psyche during the profound turmoil of the acute schizophrenic episode in young adults.

In times and in cultural conditions in which the interpersonal and group and family studies are the predilection, the view here presented stands in some contrast to the usual trend, and comes out of my distinctly introverted bias toward the intrapsychic experience. One could call it a study of interpersonal relationships. My feeling is that the extensive interpersonal investigations now prevailing bring to light mainly what has gone wrong for an individual leading him into his psychosis, and what can be of help to him in relation to his emotional surroundings. This interpersonal approach, on the other hand, relates to the individual where he happens to be dwelling psychically while in his psychosis. That inner space where the individual finds himself in his turmoil I find to be an astoundingly abundant cosmos, full of the potential of enriching and deepening his emotional existence, yet all the while appearing as elusive as can be.

This work, then, seeks only to explore these inner reaches and potentials. It does not pretend to set forth any full clinical description of a medical psychiatric "disorder." On the contrary, it attempts to find a way to release our conception of this condition from the shackles of medical thinking with its special taste for signs and symptoms of pathology. In so doing, I try to grasp and investigate extensively the many allusory meanings that come to light when one sloughs off the clinician's white coat and, in an informal relationship person to person, one settles in to listen to all that goes on inside the disturbed individual's world. The term "patient" has been shunned and eliminated from this text.

Psychiatry has developed a new habit in this era of "sane-making" drugs: that of nonhearing, of an interdiction against listening to the "patient's" nonrational concerns. My own start in the field got off on a different footing. When I was first entering upon medicine on the way toward psychiatry, my cousin's wife told me about a psychosis she had had and about the ideas, feelings, and delusional beliefs that had filled her mind. She wound up her account with one emphatic admonition: "What

makes the crucial difference to a patient is to be able to talk all about it to someone who will really listen." She clearly pointed to this as the thing that allowed her to get over her psychosis. I never forgot that tip, and have always put it into practice; many others since have told me of their recovering from psychosis when they found an understanding listener.

The imperative to provide such an ear and open mind is no mere physicianly platitude. Psychiatry at present is establishing a set of practices that both blinds itself and often fixates the "patient" in an arrested state of disability. It comes about in this fashion. No one is more isolated than when withdrawn in an altered state of consciousness. When one is thus prey to every psychic force, one is in desperate need of the human response of empathy, for which drugs are so poor a substitute as to amount to a mockery. But when the psychiatrist resorts only to medication and management to stamp out the nonrational, the "patient" quickly senses that this is not a congenial atmosphere in which to open up or a safe relation in which to reveal his actual preoccupations — so he "clams up." The psychiatrist, who did not believe there was anything of note in those preoccupations in the first place, is then deprived of any opportunity to hear about them, and never comes to know what he is missing. He feels infinitely confident that he is justified in his line of treatment, and has no occasion to alter his firm conviction that the nonrational is simply pathological.

This volume sets out to reveal that which is not heard in such situations of nonlistening, and which the psychiatrist has no occasion to expect is there. It is based on the experience of a dozen selected cases of acute schizophrenic episodes of young adults, with whom I held interviews thrice weekly and found surprisingly meaningful processes going on.

The series of cases studied are persons I saw in therapy in ordinary hospital setting from 1949–61. The point of view and formulation of the process have grown step by step out of the material revealed by these individuals. I was set upon this road of exploration by the experience of the first of them, in which I was astonished at the orderly way in which the psyche sought its reintegration of the self even in the midst of a turmoil that to the casual eye appeared chaotic; the

study of that process eventuated in my book, *The Self in Psychotic Process.*[1] During the writing up of the fourth experience of therapy, I stumbled upon the myth and ritual of the archaic kingship and recognized in it, again to my astonishment, the close parallels to the inner process of the acute psychosis; this was recorded in an article, "Acute Catatonic Schizophrenia."[2] Opportunity was given me a decade ago to review all my experiences of therapy with psychotic individuals up to that time, leading to my formulation of the reconstitutive process as deriving from the archaic ritual dramas of renewal.[3]

In respect to the physiological and biochemical elements in the schizophrenic syndrome, I do not mention them in this study because I take them for granted. I adhere to a holistic view of the human organism, that would see all processes both psychic and somatic as being indissolubly interwoven. I see the organism acting as a whole, and am not inclined to see any question of primacy of either thepsyche or the soma over the other in the causality of schizophrenia.Especially in respect to the emotions is this true, for in an emotion orits disturbance the psychic, the neurophysiological, and the endocrine and other chemical elements are all bound together in one single phenomenon. My interest and efforts are directed toward understand-ing experience, and one does not directly experience one's chemistrybut one's mental life. I believe the ideal therapy for psychosis wouldbring together the handling of the psychic turmoil and the biochemicalreflections of it in equal measure. So far there are no specific chemicalremedies to restore the physiology of the altered state of consciousness to its normative state; tranquilizers do not perform that exact functionany more than sedatives restore a normative sleep state.

The volume, then, focuses on the psychic experience in depth. The opening chapters describe the content of the psychotic episode; the sequence moves through several parallel forms of process derived from history, and ends with the application of my conclusions to practical experience with psychosis. If the material from myth and ritual, and from messianism and mysticism might at first glance seem remote, it will turn out in the end that all the parts fit together and are necessary to the whole.

1. J. W. Perry, *The Self in Psychotic Process.* Berkeley: University of California Press, 1953.

2. J. W. Perry, "Acute Catatonic Schizophrenia," *Journal of Analytical Psychology* 11, no. 2 (1957).

3. J. W. Perry, "Reconstitutive Process in the Psychopathology of the Self," *Annals of the New York Academy of Sciences* 96, art. 3 (January 27, 1962).

ON MADNESS

In setting out to discuss madness, one should begin at the beginning: It would not seem right to start without reference to the first great psychologist of the Western world, Plato, who had some arresting comments to make about it. He tells us that Socrates enumerated four kinds of madness that conveyed a wisdom higher than the wisdom of the world: that of prophecy, of initiation, of poets, and of lovers. In *Phaedrus,* Plato writes:

> In proportion as prophecy is higher and more perfect than divination . . . in the same proportion . . . is madness superior to the sane mind, for the one is only of human, but the other of divine origin. Again, where plagues and mightiest woes have bred in a race, owing to some ancient wrath, there madness, lifting up her voice and flying to prayers and rites, has come to the rescue of those who are in need; and he who has part in this gift, and is truly possessed and duly out of his mind, is by the use of purifications and mysteries made whole and delivered from evil, future as well as present, and has a release from the calamity which afflicts him. There is also a third kind of madness, which is a possession of the Muses; this enters into a delicate and virgin soul, and there inspiring frenzy, awakens lyric . . . But he who, not being inspired and having no touch of madness in his soul, comes to the door and thinks that he will get into the temple by the help of art — he, I say, and his poetry are not admitted; the sane man is nowhere at all when he enters into rivalry with the madman.[1]

Socrates was not merely quipping, for his praise of madness was part and parcel of his doctrine of "recollection": when the soul is born into the world it is inclined to forget its previously acquired vision of the divine light of heaven and must enter into these extraordinary mad states in order to retrieve what it has lost.

Can it be as this ancient wisdom has intuitively seen it to be? Does the psyche find some profound "recollection" in the nonrational state and get in touch with an otherwise lost vision of the meaning of things? Those who have experience with the psychedelic agents or with meditation techniques have little doubt that it does, bringing them to the same conclusions that others of us have reached through studying psychotic madness. Plato was speaking of the nonrational psyche in "altered states of consciousness" more than he was of psychosis as such, but does the same principle apply in the study of schizophrenia? Do we have the right any longer to regard this state as mere mental disease and disorder? For what, then, would we make of the fact that some people emerge from such an episode "weller than well," as one psychiatrist has put it?[2] That is, some come out of this state with a newly quickened capacity for depth in their concerns, their callings, and their relationships. What do we make of the fact that when out of their senses, some people have experiences perhaps of beauty, perhaps of terror, but always with implications of awesome depth, and that when they reemerge out of their craze and into their so-called normal ego, they may shut the trapdoor after them and close out their vision once more and become prosaic in the extreme, straitened in a bland and shallow usualness? What goes wrong when someone becomes a visionary, looking into the heart of his cosmos and of his fellow beings around him, only when he is "sick," only to become blind, constricted, and timid, understanding nothing, when he is "well" again, dependent for the rest of his days perhaps on a drug to keep this soul and its vision dampened down and safely out of reach?

It does sound as if there may be two opposite kinds of madness: a madness of the left, full of ecstasy and terror and of the bewildering encounter with spiritual and demonic powers in the psyche; and a madness of the right, hollowed out in bland impoverishment and narrow-

ness, in which the conventions and concreteness of the mundane world are taken for self-evident reality.

The fact of the matter is that in all of us, only a hairsbreadth below the level of conscious rational functioning, there is quite another state of being with an altogether different view of the world and an altogether different way of growing to meet it. And that state of being, or that world, since it is experienced in terms of images and symbols, metaphors and myths, is considered mad and worthy only of banishment from the sane world of common sense. We find ourselves being very fussy about allowing it to appear only on certain terms.

If I went to a friend and told him that I died last night and entered into an afterlife state right here, and that I saw the world divided into opposing forces of good and evil ready for the great cataclysm, he would reach for the phone and gently and compassionately turn me over to a hospital where they know how to stamp out such wildness of mind. But if I were more circumspect, and put it that I dreamed last night that I died and so on, he and I could have a little laugh about it — nervously, of course — then pass it off lightly and forget it. Or, I might choose another route, radiantly recounting to him a great happening at a Sunday revival meeting, couching my experience in the commonly agreed language of a religious form, that I felt myself dying with Jesus on that rugged cross while the world was riven between the power of God and of Satan. My friend would doubtless say that this is all right for those who like it, but would excuse himself from joining me in my salvation. Or, if I were even more strategic in rendering my experience, and wrote it in rhymed couplets and showed these to my friend, he would ponder it and make an effort to empathize with it — indeed, he might feel defeated if he showed himself obtuse in regard to the metaphorical implications.

In our dreams, our religion, or our poetic moments, regardless of our intellectual or philosophic tenets of belief, we all have this madness in us as part of our makeup. We are not at all dismayed to know that in our sleep we do the most shocking things: We hallucinate vividly, seeing people and hearing voices to which we respond; we merge the past and the future; the dead live, and we die and live again; and all manner of irrational events take place. Especially when dreams are symbolic and

mythological, they seem even more preposterous. Yet such dreams can be the surest guide in psychotherapy, and outside therapy they can influence people's lives profoundly.

Even in waking life we do many mad things; for instance, in the commonly agreed and accepted rituals of the historical religions. How do we account for ourselves when we submit to a baptismal ceremony in which we are "baptized into the death of Christ," undergoing death with him and resurrection, and we declare in regard to the cosmic struggle between good and evil that we renounce Satan and all his works? Has the human race been hoodwinked all these many centuries into going along with this, or have they indeed found it a profoundly meaningful way of expressing processes that the rational mind cannot deal with?

Since the beginning of our century it has been recognized by scholars studying such rituals and myths that, through them, cultures have found a way to express "collective emotion."[3] Also, those of us in the field of psychotherapy who have studied the equivalent processes in the individual psyche have arrived at the same conclusion, that the symbolic images in the nonrational mind are the very stuff of which the emotional psychic life — that is, the unconscious — is made. For every emotion is accompanied by its image, every image by its affective tone. An image renders the meaning of an emotion, while an emotion gives the image its dynamism. The way we read our world emotionally is in the terms of this imagery.[4] And most particularly, the way our emotional psyche grows and develops is in the terms of these unfamiliar symbolic images, similar to those of myth and ritual.[5] Psychic development, unlike the learning process, is not an even, linear, or constant progress, but a series of phases marked by cataclysmic beginnings and endings, death and new life, regressions back and leaps forward, clashes of opposites and resolutions into synthesis — all this is the natural language of the emotional psyche.

We live all the while in two different dimensions of understanding, and thus two kinds of reality. One is the ego's knowledge, with its mundane ways of handling a mundane reality. The other is knowing in depth, that which we call wisdom, in which the great basic metaphors of the human

experience provide intimations of meaning and involvements of emotion with things of the world that are not yet quite clear or conscious.[6]

This latter is the mind into which one plummets when seized with madness. As Plato told us, it might be the divine frenzy of the seer or the revelation of the founder of religious forms, the inspiration of the artist or possession by a great love. And it might be a "schizophrenic" episode.

How does such a schizophrenic manifest itself? Because of an activation of the unconscious and a collapse of the ego, consciousness is overwhelmed by the deepest levels of the psyche, and the individual finds himself living in a psychic modality quite different from his surroundings. He is immersed in a myth world. He feels suddenly isolated because he finds no understanding of it on the part of those around him. The fear of this overwhelmingness and of this isolation causes a wave of panic, which sends him into an acute withdrawal. His emotions no longer connect with ordinary things, but drop into concerns and titanic involvements with an entire inner world of myth and image.

There appears to be one kind of episode which can be characterized by its content, by its imagery, enough to merit its recognition as a syndrome.[7] In it there is a clustering of symbolic contents into a number of major themes strangely alike from one case to another. It is just like myth and ritual text, save only that it is broken up in scattered fragments much as dream contents are. The analogy that comes always to my mind is that of taking an intact myth and ritual form as one might see it depicted in a Gothic stained-glass window and, by removing the lead and dismantling it into its fragments, watching them revolve into patterns in a kaleidoscope. Schizophrenic contents similarly hover and play around the theme of a center to which they have reference.

This inner world of the psychotic does not look like the one we know outwardly, but it is recognizable as a view of the cosmos familiar in myth and ritual forms since ancient times.[8] For it is a world in which there is a center, a cosmic axis running through and connecting the human world with the Sky World and the Underworld. In this center powerful events take place. There, the psychotic individual has died and has found himself in an afterlife state. There, occurs a clash of opposite powers, of light and dark halves of the world, either threatening disintegration or main-

taining integration of the whole of the cosmic order. There, he is thrown back in time to the Creation and the first beginnings, and he repeats the evolution of the world step by step. There, he is raised up into a position of supremacy, of world rulership or spiritual leadership. There, a new birth or rebirth takes place in association with an extraordinary marriage to some divine personage. And, finally, around this center come resolutions of cosmic proportions in the form of a redeemed society and a quadrated world structure in harmonious equipoise of four continents, powers, races, creeds, or elements.[9]

An example is the experience of a young man of thirty-three (case number 3) who was markedly withdrawn and disturbed, delusional and hallucinating. He gave me an account of his experiences as they were occurring to him. They may be reassembled and summarized as follows:

He spoke of himself as beneath everyone and lonely, and called himself "skunk." On the other hand, when he was admitted, he felt he was "brought here by God" and was especially chosen to serve Our Lady. He had ideas of play-acting going on, and said that the people helping him were Hollywood actors. In his first interview, he drew a diagram on the wall tile which described a square, a circle, and a cross, all concentric; at the center he stressed a point and identified it with himself; from then on he spoke of himself or the Holy Ghost as being at the center. At this center there was a "going up and down," for he was to go to Hell and Purgatory and back, these being the "Three Ways of Initiation," a little earlier he felt that he was "making the way of the cross" and imagined he felt the nails in him. At other times he thought he was being poisoned and sometimes shouted, "Go ahead, kill me, kill me." He thought of time as going backward, and he drew a diagram of the sun at the center of the cosmos and the four directions as time in reverse, called "back-o'clock." He saw the world divided in a mortal struggle between Catholicism and the forces of the Devil, in the form of the Sodality of Our Lady leading the war against communism; it was Bishop Sheen against the Movie Set (the Reds). Sometimes he heard the Devil talking to him. The world was about to be ruled by Our Lady of Fatima, of whom he was a special apostle and chief defender. He felt an urgent need to marry and gave indications of great aggravation when there was any hint of a homosexual advance toward him on the ward and was put into a tremendous rage on these occasions. He saw himself as having the characteristics and powers of Christ, and as being the Second Coming; thus he drew diagrams of himself as the Holy Ghost in a quaternity of Father, Mary, Jesus, and himself as Holy Ghost

(called "Dope" on one occasion). Also, he was the successor to the fifteenth President. One day he gazed upward and said he was seeing the Immaculate Conception; all redheads were recognized as Mary, whom he was to marry; one was Cora, which meant the Sacred Heart; one Rose, or the Rose of Sharon; and one Claire, the moon, or "claire de lune." Along with these ideas of wedding Mary were many comments about birth, and a wish for twelve babies. Claire's image seemed indistinguishable from his sister's, and he associated this with conception, with birth; this was like an egg, which he drew. He also thought of the "fourth degree of initiation" as a rebirth. He envisioned a splendid new order to be brought into the world by the World Mission of Our Lady of Fatima; there was a ceremony in which candle lights were carried from the altar as a center, to all parts of the world; this would be Victory in Heaven; in this order there would be tolerance for all colors and creeds without discrimination. He drew this as a world in four segments in the form of a rosary in four colors — the "World Mission Rosary" — representing the four races and creeds and continents.

Are we to write off this ideation as just gibberish or just the distortions of the mundane world by a diseased mind? Is it merely an archaic mode of thinking, a so-called primary process gone berserk and of no use in the modern mind? It might seem so, at first glance, if it were not a close replica of the highest myth and ritual forms of the central religious practices of archaic times. These were the ceremonial death and renewal of the year and of the sacral king and his kingdom, out of which other religious forms have differentiated and evolved in the centuries since.[10] A modern psychiatrist would give, in an unhesitating pronouncement, a diagnosis of paranoid schizophrenia to the sacral kings of Mesopotamia of the Third Millennium B.C. who called themselves "King of the Universe" and "Son of the God," suckled by the Goddess. But it is a madness in which our most revered traditions of government and of religion are solidly rooted.

Far from dismissing this ideation as crazy nonsense, we would do well to seek out in every possible way the meanings of this language of the unconscious, emotional psyche. For there is every indication that this process emerges as the psyche's own way of dissolving old states of being, and of creatively bringing to birth its new starts — its own way of forming visions of a renewed self and of a new design of life with revivified meanings in one's world.

In my opinion the real pathology in psychosis does not reside in the "mental content," the images and the symbolic sequences. All of that appears to be natural psychic process, present and working in all of us. This is normal madness, so to speak. The schizophrenic "disorder" lies rather in the ego, which suffers from a constricted consciousness that has been educated out of its needed contact with the natural elements of the psychic life, both emotion and image. The madness is perhaps required but comes in overwhelming strength. The need of the schizoid personality is to learn to perceive symbolic meanings as they pertain to the living of one's psychic life, and thus to keep connected with the ever-enriching wellsprings of the emotions which nourish that life. The problem of the prepsychotic state is how to discover the impassioned life, and nature has its own answer in the form of a turbulent ordeal, a trial by immersion in the source of the passions — that is, a psychosis.

For this reason it is absolutely vital to the psychotic person's welfare that the response from his surroundings be in accord with the nature of the experience he is undergoing. A damaging and disqualifying view in terms of psychopathology gives him instant dismay and a sense of isolation. Many of the signs of "insanity" are manifestations of the individual's withdrawal from a hostile emotional setting, including the psychiatric one.[11] If, on the other hand, the person's journey into the unconscious psyche is given the empathy and understanding it deserves, his experience feels like the "altered state of consciousness" that it is, and not like craziness. Then, too, the psyche can get on with its work without having to combat an uncomprehending environment. If psychiatry could learn to cooperate with rather than combat nature, we might be of more benefit to persons meeting their developmental crises.

1. Plato, "Phaedrus," in *The Dialogues of Plato,* translated by B. Jowett. Oxford: Clarendon Press, 1871, I, pp. 578–79.

2. K. Menninger, "Healthier than Healthy," in *A Psychiatrist's World.* New York: Viking, 1959; see also *The Vital Balance.* New York: Viking, 1969, pp. 406ff.

3. J. Harrison, *Themis.* Cambridge: Cambridge University Press, 1927, chap. 2; G. Murray, *Five Stages of Greek Religion.* New York: Columbia University Press, 1925; F. M. Cornford, *From Religion to Philosophy.* New York: Harper, 1957, chap. 8; E. Cassirer, *The Myth of the State.* Garden City: Doubleday, 1955, chap. 4.

4. J. W. Perry, "Emotions and Object Relations," *Journal of Analytical Psychology* XV, no. 1 (1970).

5. C. G. Jung, "Conscious, Unconscious, and Individuation," *Collected Works,* vol. 9: *The Archetypes and the Collective Unconscious,* Bollingen Series XX. New York: Pantheon, 1959.

6. C. G. Jung, *Collected Works,* vol. 12: *Psychology and Alchemy,* Bollingen Series XX. New York: Pantheon, 1955, part 3, chap. 2 and epilogue.

7. J. W. Perry, "Reconstitutive Process in the Psychopathology of the Self," in *Annals of the New York Academy of Sciences* 96, art. 3 (January 27, 1962).

8. J. W. Perry, *Lord of the Four Quarters.* New York: Braziller, 1966.

9. J. W. Perry, "Reconstitutive Process in the Psychopathology of the Self."

10. J. W. Perry, "Reflections on the Nature of the Kingship Archetype," *Journal of Analytical Psychology* II, no. 2 (1966).

11. T. Scheff, *On Being Mentally Ill.* Chicago: Aldine, 1966.

AN EXPERIENCE IN MADNESS

I have always approached individuals in an acute schizophrenic turmoil with the general assumption that everything they say, everything they are preoccupied with, is meaningful. This significance often eludes us at first, but sooner or later we come to recognize that he is an emotional truth lurking behind the somewhat inscrutable play of image and symbol. In fact, following the line of thought in an individual in this psychic state, or "space," is quite like trying to grasp the metaphorical meaning in the lines of an obscure poem. The less one tries to transliterate it into rational talk, and the more one flows along with it, the more it speaks its own meaning.

AN INDIVIDUAL'S EXPERIENCE OF AN ACUTE EPISODE

One person I worked with in therapy in an inpatient setting was a young woman in her early twenties, dark-haired, attractive, and winning. When I first saw her she was confused and fearful, tending to hold back and remain uncommunicative; at the same time, a note of arrogance showed through her somewhat challenging gaze of appraisal of me. This test I apparently passed, probably because she recognized that I simply wanted to hear her experience without imposing any psychiatric judgments or regimes on her. In the third week of our sessions, she told me her impressions of her onset and admission.

She told me that on a certain saint's day just before her entry into the hospital she had spent five hours in church in prayer, weeping. She had felt an intense pain across her chest at the breasts, which signified that she was going to die. The air was filled with the smell of death, and she knew the Devil was near by.

"But this meant the death of the ego, of course, so as to be born again in Mary. Because women are born again in Mary, and men are born again in Christ. And women's sin is pride, just as men's sin is impurity."

About her entry she explained:

"I thought I was Eve, because of the evil in me and my being the temptress [apparently thinking of being in Eden]. *On the ward I was being given some sort of truth serum and it was being injected by some communists for brain washing me* [the Phenothiazine]. *Then this doctor started asking me questions about my faith* [i.e., her delusional ideas], *so I asked him about his, and then he called me being resistant. When I was brought in, you see, I thought I was supposed to say nothing, as a test of my dedication and my strength."*

As she warmed up to her narration of her first experiences on the ward, it became apparent that the admission procedure was frightening and totally out of keeping with her state of mind.

She told me she thought she was pregnant and would soon be having a child. When I wondered by whom she might have conceived, she seemed rather nonplussed at the question, and passed it off by saying she never even thought of that. "Well, no one. It is a child of the spirit, you know, conceived by the spirit." In this blissful state of special election, she was dropped into the bustling turmoil of a crowded ward, which seemed to her quite sordid. The opposites were driven asunder and an alarming confusion took over.

A graphic picture of the clash of opposites came to her on the morning after admission. When she perceived patients grouping in opposite sides of the ward, she thought that this was a great war — two sides lining up to go at each other in a massive Armageddon. One was the side of Good, the other of Evil; one the side of Christ, the other of the Devil.

More immediately sinister things seemed to be happening around her. "These doctors went around raping patients, you know. The patients were all talking about these doctors, who came around late in the evening talking with the patients in their rooms and sitting on the edge of their beds. Are we really here for the doctors to use?" It seems she had developed a fearful image of a white-slavery traffic being set up to take advantage of these women when they could not fend for themselves.

If one listens to this "ideation" not as a bizarre thinking process but as metaphoric expressions of emotional states, then one can perceive this young person's terror, bewilderment, and thwarted hopes. Yet the content of her talk remains strange enough to the ear that is not accustomed to it.

The question that at this point would present itself to the psychiatric mind is, "What on earth do you do with all that gibberish?" The usual current attitude is, "You do not do anything with it — in fact, you should have nothing to do with it." Residents in training are supposed to discourage their patients from speaking of it, and instead to turn their attention to the more immediate ego-level concerns of everyday existence. Yet the difficulty is that when this policy is followed, the affect does not come along with the individual's adaptation to that objective reality. Such a person is apt to drag his heels in the effort and arrive in that reality with a poor level of motivation and involvement, often with resentment. The policy of suppressing the irrational psyche and of building up the defenses against it rests on some assumptions about unconscious contents. These are that such symbolic imagery is either meaningless primary-process atavism or, if not meaningless, at least without therapeutic import; and in this event that it would be only harmful to encourage such atavistic tendencies because it is too enticing for the ego to withdraw into them, to the detriment of its adaptive interests.

Yet the fact of the matter is that during the acute episode the individual is emotionally absorbed in these psychic depths. The missing affect is ensconced in an inner world of myth, symbol, and religious concern. However strange that archaic world may seem to us, it is vivid and all-important to her; the feeling invested in it makes it more real than the outer reality. Thus her reality is at odds with ours. The question then confronts us, whether to stifle that inward experience and attempt to dry up the investment of feeling in it, thus to wean her from it and entice her into the outer world. Or is there something to say for meeting her on her own ground? Let us look at what may happen if we continue to listen to what this person's own psyche does with it.

I will briefly give a picture of the essential elements in her history and in the events leading up to the psychosis, as a background to the very dynamic process that we will find her undergoing.

She was of French Catholic parentage. She lost her father when only an infant, and her mother, left alone with her, had no interest or love or time for her. There was no ability in this woman to talk with her daughter about the things that mattered. "At school there was no interest in how I did. So I tried very hard to excel and win her notice, but the more I tried the less I got. So I became a leader and a good student and won the appreciation of the sisters who taught there." Again she told me,

"I learned to be perfect in whatever J did, to be strong. I decided that if I couldn't have love from my mother, I could surely depend on love from God. So I learned to live for this."

The mother had a series of boyfriends coming into the home from the earliest years and seemed too preoccupied with their attentions to have much interest in her child. The daughter, although needing a father figure, found that these men demonstrated only a sexual interest in her, even making sexual advances to her on some occasions. This exclusively physical interest in her left her feeling rejected as a person; she was often humiliated by it, and found the entire atmosphere of the home sordid.

As she summarized the outlook that she cultivated throughout those years, she based her life on three fundamental guidelines: Since the love of God is the only dependable love, she must be spiritual; since she was frightened by the sexual activities in the home, she must be pure; since love is unpromising, and excellence alone can bring rewards, she must be strong. The net effect, of course, was that she maintained in this fashion a position, aloof from the ways of the world, superior to worldly love or passions, and to her fellow beings. These gave her a bearing and an expression that told the story: She was arrogant, not in the cynical but the idealistic way, and she made this claim to superiority dearly felt. Yet something else was coming through her communications all the while. I found myself not put off by her manner but, on the contrary, attracted to her and soon very fond of her. We were able to develop a relationship with some little mutual warmth and affection.

In part, this circumstance is accountable to the fact that nature had not allowed her to remain in this world of purity undisturbed. For she had fallen in love the year before, and indeed had come to the West Coast from the East to flee from this predicament. The young man struck her

as being a kind of genius who seemed to know about everything, and he was full of a dynamic energy that made him "live fully and violently." He loved people who likewise manifested the life force in themselves. Yet with this impassioned nature, he seemed to her to be of the Devil, dark and demonic and fascinating.

"He taught me many things about life, and I taught him about the spirit. He liked to call me 'Innocent Eyes' . . . I used to think I wanted to be like him, to be a genius and know everything, but then I decided it would be wrong for me, that I must live by my heart and not my head, as a woman."

She decided she must get away, since she could be neither with him nor away from him so long as she was near him.

Clearly enough her psyche was attempting to "compensate" for her aloneness and aloofness; that is, to introduce into her consciousness the elements needed for redressing the psychic imbalance by embroiling her with a man who carried the projected image of "her opposite" of a nature and standpoint directly contrary to her ego's. This was the image of her own masculine component, in Jungian psychology called her "animus," which she perceived as demonic, confronting her with the fascination for this world and its human passions, and for the lust for knowledge and experience — in short, for all that she had renounced and disclaimed for herself. Only when she turned her back on this fertile psychic situation did she begin to be embroiled in that more drastic compensatory process, the psychosis. Jung's discussion of the role of the compensatory function of psychosis emphasizes this point in his early work with schizophrenia.[1]

In July, six months after she left, she wrote a letter to her friend saying the relationship was finished. Soon after, she felt her "heart lifted up as if on a cloud, floating and cushioned"; she also was experiencing subjective feelings of levitation. At the same time she felt herself called by the Virgin Mother to give herself to her. "She would lead me because she needed me. I've been very happy since — not quite of this world, after that." She described herself as having felt very pure and serene" — it was such a beautiful experience."

These events were in keeping with her effort to pull away from the new experience confronting her in the person of her boyfriend, and to revert instead to her previous spiritual aloofness and specialness.

The reversion went too far, and became a manifest inflation by the time she wrote a second letter to her friend in December. She went to a lecture by a priest but was disappointed, for he seemed unworthy of what he was saying. "Was I guilty of the sin of pride? I was so much more fit for it than he. I felt he should be listening to me." She wanted then to confess, but found that the first priest she went to was insincere and without wisdom, and he called her arrogant with the sin of pride. Another told her she was all mixed up. She went to five in all and never found what she was looking for. "I have eyes to see who's real and who isn't."

Then followed the episode in church already narrated, of her experiencing the "odors of death" and the pain across her chest, sent by the Devil as a sign of her imminent spiritual death. She also on other occasions sensed the "odors of life" in the form of incense as a sign of the presence of the Blessed Mother. From her she received a message that sent her out to circle the city of San Francisco on foot. This circumambulation of the city was to initiate a spiritual renovation of the world emanating from this center. She was to have a child by the spirit who would be "a Holy One," a new Redeemer.

This spiritual task was rudely interrupted by the highway patrol, who picked her up for walking illegally on the skyways.

I held interviews with her regularly three mornings a week, trying not to impose myself upon her or to intrude, but to invite her to share with me her experience if she felt so inclined. She did, and she seemed, as is so often the case, to be very appreciative of the effort to give her understanding. The first couple of weeks were spent going over her whole life and over the events leading up to the episode narrated above.

In the third week an impressive event occurred in her play of imagery, initiating what I take to be a profoundly compensatory move from her psyche to alter her outlook. She was looking out her window one day and saw a dramatic vision: The world was turning inside out, and as a result becoming "all different." It was hard to get her to spell out the visual

impression of this alteration, but she was clear enough as to its implica-
tions. Her beautiful, serene, spiritual world, in which she had been so
much at home in her purity, was now disappearing and the one now con-
fronting her was the Devil's world.

In the fourth week she was becoming disillusioned and bitter.

*"Sometimes I think it's all just a huge joke. We're all in this as a game. We all have a role
in the play. It's the 'Folly of the Cross.' What does it all mean? It's just funny."*

When I raised my eyebrows at this display of unaccustomed cyni-
cism, she explained that she had been severely let down the day before.
She had gone out into the town on a pass, happy because she was expect-
ing a large crowd of ten thousand to be gathered in the central square of
the city to "acknowledge" her; that is, to acclaim her as the one sent by
the Blessed Mother to start the world reform movement. She was dashed
and puzzled to find no one there. She had expected them to give recog-
nition to what she had gone through in the hospital to bring help to the
people there. A little later she told me that at this time she believed her-
self to be so like Jacqueline Kennedy as to be the same person; she as-
sumed many of the television broadcasts were telling about her.

The "Folly of the Cross" alludes to a theological expression epit-
omizing the incomprehensible willingness of the godhead to conde-
scend to enter lowly human form and invite upon himself the suffering
and humiliation of the Crucifixion. It exactly expressed her subjective
state in being brought down from her exalted spiritual position.

She had much to say about the cross as an image of the ego's relation
to the world. On it the ego rises toward the fulfillment of its spiritual po-
tential. The vertical dimension of the cross represents the spiritual life
and the aspiration toward the heavenly world. The horizontal limbs, on
the other hand, represent the ego's life in relation to the mundane world.
The cross then became for her a symbol of the paradoxical meeting of the
spiritual and natural worlds, as a pair of opposites that were giving her
great distress and suffering at the time.

In the next interview I found her tearful and in distress. She had just
been in the group meeting and had found there that far from being in a
position to bring help and salvation, she did not know anything:

"I'm so stupid. It seems I can't handle anything. How could I have been so wrong? All these years I've been living in such an illusion about myself. I thought I was so superior and knew so much! It's as though I was living like in a superstructure, so superior and above everyone."

I commented to her on her former preference for living in the spirit, in a world full of beauty and goodness and purity, which only left the "passions" of the human level all going unlived; I agreed that it was a very hard task to embrace this other, "lower" side of life under such circumstances. She wept in misery with the words, "It's a little like dying, you know." I leapt at this statement, to assure her that dying was just the point, that it is what has to happen when there is an urgent need for change. She responded, "Have you been through all this yourself? I've never met anyone before as wise as you about these things." I answered her question. I said, Yes, in a fashion I'd been through this, too; but my way was not in the involuntary experience of being overwhelmed by it as she was, but in intentionally dipping down into this same inner life to explore it; the inner experiences in that process were much the same, though. She said that on the day before she had been talking with a man on the male ward, who had pointed to someone and said, "See, there goes Lucifer." She asked me whether this really was Hell here, as so many of the patients seemed to be thinking it was; she thought it was her mission to help the man. I replied that it did feel to people quite like it in many ways, but that it was not in fact Hell; many patients, I agreed, had this same feeling of dying and of being in an underworld here, but that it was because they were all going through this same psychic process.

Again a week later she came to the interview in tears:

"I seem to be losing so much. I'm becoming less than I am, when I lower myself this way. It lowers me to understand other people. Yet I am here to help them; that's why I signed in . . . It's a compromise that hurts my spiritual life . . . All this is of the Devil here."

I asked if by this she was referring to all the emotions that were being experienced and expressed. "Yes! They're so violent and so raw!" My response, of course, was to acknowledge that I could see her suffering and hurt and could feel for her in this plight, but that it was all worth the pain if

it meant her finally achieving her wholeness, by being at last in touch with her emotional life and that of others. I pointed out that this would bring her a new ability to empathize with people's emotions, and thus to relate to them and love them with a new and greater depth.

This development, in fact, was beginning, and it continued during the following weeks. She was discharged, improved, in the sixth week.

FORMULATION OF THE PROCESS

This young lady had been living with a world view that was too spiritual, purist, and precious to be tenable. Because she did not receive the natural love and affirmation that was due her in her childhood, she grew up with a grave doubt whether she could be found lovable; she thus became oriented to the heavenly world and to God, but hardly to this world and to man. This bias, serving to compensate for her grave self-doubts, resulted only in arrogance and a judgmental superiority over other mortals. The whole outlook was governed mostly by a masculine principle tending to lead her into a power drive to excel and win prestige; little place was left for the feminine principle, which might have given her more relatedness to her fellow beings.[2] In brief, she was psychologically "too high up," living in a state of spiritual specialness, above the more human ordinariness.[3]

The progress of the psychotic journey led to a change of world view toward an acceptance of human failing and error, and toward orienting her less to principles and more to persons and their natural emotions. The heavenly world of her former preference gave place to a demonic world, as she saw it. This "lowering" of herself resulted in a new capacity for understanding and compassion in which she could exchange raw emotional experience with her friends. These "passions" were at first distasteful to her, and she experienced the entire trend as a distressing compromise with the world, until she discovered what was beautiful and rewarding in it.

The dynamics of this psychotic episode, as I see it, center upon the image of the self, of the way the individual experiences herself. When it is too limited, isolated, one-sided, or debased, this "self-image" becomes due for a reorganization, and various compensatory mechanisms come into play. If these are not successful because of the ego's resistance to them, as in her abortive love affair, a more drastic and turbulent pro-

cess — in the realm of psychosis — gets under way to enforce the needed changes. The portion of the psychic energy ("libido")[4] that usually fuels the higher centers is then drawn out of the higher into the deepest levels, in order to activate there the components whose nature is to effect transformation of these energies. In working terms, this is experienced as a shift of interest away from the ego's adaptive life and toward the inner activity of the primordial images in the play of fantasy. In theoretical terms, it means a shift of psychic energy from the conscious hookup into the dynamisms of the unconscious. These dynamisms consist of the work of the "archetypes of the collective unconscious," as Jung has termed them.[5] I like to speak of them as the "affect-images," since they express themselves in terms of symbolic representations and their accompanying emotional charge.[6] In the psychosis, these mythologically styled contents are the ones belonging to the sequence that I am describing as the "renewal process."

It is part of the nature of archetypal imagery or process to be, in its fundamental ground-plan, universal. These forms appear and reappear in various parts of the world, usually in myth and ritual and other religious guise, or in legend and fairy tale, and in a variety of art forms. They also occur in the dreams and fantasies of individuals in modern as well as ancient times. Therefore it is not surprising that the elements of the process I am describing are the same as the components of the myth and ritual forms of the renewal of the year and of the sacral kingship in archaic times, a set of parallels that I have described extensively in other writings.[7] This whole archetypal process becomes the vehicle in the individual psyche for a fundamental reorganization of the self.

This "self" tends to represent itself in its symbolic affect-imagery as a center, which has led me to refer to it by preference as the "central archetype." It has been described and discussed by Jung as designating the totality of the personality, both conscious and unconscious, and also its governing center.[8] In this it corresponds to the centrality of the ego in the sphere of the ego-consciousness. The focus of the reorganizational process is this central archetype, which through the mechanisms of death and rebirth, and through the clash and reversal and union of "the opposites" (the various opposing principles), becomes reconstituted.

I would stress that these "transpersonal," archetypal affect-images
here act as the vehicles for the resolution and setting straight of these very
personal emotional life issues. These issues occur in the form of "complex-
es" in the Jungian model.[9] A complex is an emotionally toned grouping
of associations gathered about a nucleus consisting of an image represent-
ing an archetype and the first person or object in the outer world which
carries its "projection." For instance, the mother complex is based upon
the archetypal affect-image of the Great Mother and begins to take form
in those moments when the child's emotional experience of the mother
coincides with the emotional nature of the archetype; the mother is then
apperceived through the affect-image. Later experiences that are similar
will add to the contents of this complex. The entire psyche is conceived,
in this model, as structured in complexes. The emotional life consists in
the play of such complexes; that is, the occurrence of an emotion is the
activation of a complex.

When a person is talking about "odors of life and of death," "preg-
nancy by the spirit," and the "world turning inside out," a great gulf seems
to exist between these and the emotions and the concrete experiences of
her personal, daily, living relationships. When psychotic ideation has the
upper hand, we do not hear the connections of the imagery with its emo-
tional context, for the reason that the complexes have become disinte-
grated and fragmented, and their root archetypal images have become
activated, out of their usual structural context as nuclear components of
these complexes. The myth-producing activity represents a phase of the
process in which reorganization is taking place on the deepest levels to
realign the individual's motivations and the foundations of the psychic
structure. As Sullivan[10] and Boisen[11] have expressed it, "whole masses
of life experience are being reorganized" during the turmoil. The myth-
like imagery deals with core issues in terms of core statements. Essences
of the emotional life are handled by universal imagery that pertains to
all men and all times. Hence the high level — actually, the deep level —
of generalization. Only after these archetypal affect-images reach their
own objectives is the individual free to reconnect those concerns with
the specific issues of his or her personal life. At such a time the individ-
ual comes back out of his or her withdrawal into a new way of experienc-

ing people and things, with new concerns and with new investment in relationships.

Thus the fruits of the process may be regarded as only potential solutions to emotional issues. They await reconnection with the actual specific emotional problems of daily life. This is tantamount to saying that the archetypal affect-images await a kind of reinsertion into their natural context in the complexes, and their projective involvements in outer life.[12] Through these emotional entanglements and in the course of time they become gradually explored, understood, and reassimilated into the conscious structure of the personality.[13]

Any interpretations given during the psychotic activity may be on the level of pointing out the general meanings of general symbols, such as death and rebirth as an expression of change, or messianism as an expression of a necessary new cultural program, etc.[14] Otherwise, on more rare occasions, there is a chance to point out what one recognizes of the place of an image in the personal emotional life context; when this occurs, there is apt to be an inrush of the affect heretofore lost from view in the psychosis, creating a situation I like to call "moments of realization."[15]

Taking into account various observations on schizophrenia, I have been inclined to think of the "psychopathology" differently from the usual textbook psychiatric formulation. It is justifiable to regard the term "sickness" as pertaining not to the acute turmoil but to the prepsychotic personality, standing as it does in need of profound reorganization. In this case, the renewal process occurring in the acute psychotic episode may be considered nature's way of setting things right. Even though this compensatory process may become a massive turmoil, the turbulence is a step on the way toward the living of a more fulfilled emotional life.

1. C. G. Jung, "The Importance of the Unconscious in Psychopathology," *Collected Works,* vol. 8: *Psychogenesis of Mental Disease,* Bollingen Series XX. New York: Pantheon, 1914.

2. C. G. Jung, "The Relations between the Ego and the Unconscious," *Collected Works,* vol. 7: *Two Essays on Analytical Psychology,* Bollingen Series XX. New York: Pantheon, 1953, 7, part 2, chap. 2; C. G. Jung, *The Secret of the Golden Flower.* London: Kegan Paul, Trench, Trubner & Co., 1935, pp. 114ff.; F. Wickes, *The Inner World of Man.* New York: Farrar and Rhinehart, 1938, chaps. 5 and 6.

3. P. Metman, "The Ego in Schizophrenia," *Journal of Analytical Psychology* 1, no. 2 (1956); 2, no. 1 (1957).

4. C. G. Jung, "On Psychic Energy," *Collected Works,* vol. 18: *Structure and Dynamics of the Personality,* Bollingen Series XX. New York: Pantheon, 1960.

5. C. G. Jung, *Collected Works,* vol. 9.1: *The Archetypes and the Collective Unconscious,* Bollingen Series XX. New York: Pantheon, 1959.

6. J. W. Perry, "Emotions and Object Relations," *Journal of Analytical Psychology* 15, no. 1 (1970).

7. J. W. Perry, *Lord of the Four Quarters.* New York: Braziller, 1966.

8. C. G. Jung, "The Structure and Dynamics of the Self," *Collected Works,* vol. 9.2: *Aion,* Bollingen Series XX. New York: Pantheon, 1959; C. G. Jung, "Conscious, Unconscious, and Individuation," *Collected Works,* vol. 9.1: *The Archetypes and the Collective Unconscious.*

9. C. G. Jung, "The Psychology of Dementia Praecox," *Collected Works,* vol. 3: *The Psychogenesis of Mental Disease,* Bollingen Series XX. New York: Pantheon, 1960, chap. 2; C. G. Jung, "A Review of the Complex Theory," *Collected Works,* vol. 18: *The Structure and Dynamics of the Psyche,* Bollingen Series XX. New York: Pantheon, 1960; C. G. Jung, *The Tavistock Lectures.* New York: Pantheon, 1968, lecture 2: "Analytical Psychology."

10. H. S. Sullivan, *Schizophrenia as a Human Process.* New York: Norton, 1962, p. 20.

11. A. Boisen, *The Exploration of the Inner World.* New York: Willett, Clark, 1936, pp. 30, 53–54.

12. J. W. Perry, "Image, Complex, and Transference in Schizophrenia," in *Psychotherapy of the Psychoses,* edited by Arthur Burton. New York: Basic Books, 1961.

13. Perry, "Emotions and Object Relations."

14. J. W. Perry, "Societal Implications of the Renewal Process," *Spring* (1971).

15. Perry, "Image, Complex, and Transference in Schizophrenia."

REORGANIZATION OF THE SELF

For a period of twelve years, beginning in 1949, alongside my usual analytic work in private practice, I spent several hours a week in psychotherapy with acutely disturbed schizophrenic individuals during their hospitalization. Through following these persons' psychoses carefully and relating to them closely, I have found what I take to be a consistent syndrome among the ones usually given the diagnostic labels "acute undifferentiated" or else "catatonic" schizophrenia. It is recognizable primarily by the "mental content," that is, the image sequence that comes into play during the initial weeks of the episode, for in this the processes are enough alike from person to person to render the progress of the motifs both recognizable and somewhat predictable.

Customarily I selected for this work persons newly in hospital, preferably in their first psychotic episode, and in their twenties or early thirties. They were usually the most disturbed individuals on the ward, hyperactive, productive of delusional ideas, and engrossed in their preoccupations. I would work with them in interview style, sitting down with them in a separate room on the ward for an hour or so on alternate days three times a week. The hospital stay lasted usually for three to six months, and with many I held interviews once a week after discharge long enough to help them readjust to their life outside. This being in the 1950s, I used subcoma insulin in large doses to help hasten the progress of their readjustment. Of eighteen such cases, twelve showed themselves to be in the syndrome that I am discussing.

REORGANIZATION OF THE SELF IN TERMS OF AFFECTS

A severe injury to the self-image was apparently at the heart of the genesis of the prepsychotic personality in the cases that I have studied. Things went wrong during the phase in which the archetypal bond with the mother would ordinarily be bringing into play the attentive, tender, caring, and even worshipful emotions of the mother toward her child — this being the child's fundamental need during this phase. Typically, the mothers of these individuals seemed to have failed to render such love. Such a mother tends to have the feeling, in regard to this particular offspring at least, that she is dealing with a child that she cannot wholeheartedly love with full acceptance. There may be a projection of an image upon the child of unattractiveness or strangeness or perhaps of the black sheep; then the child grows to sense an ill-defined negative judgment of some sort, and his image of himself depicting this emotion will reflect the mother's emotion. If she sees in him a black sheep, then his image of himself will be the black sheep. Very often this image will turn out to have its origin in the mother's complexes derived from her own unfavorable parent-sibling relationships. The image representing the mother's experience of the child becomes all-important to his psychic welfare, establishing for him either the emotional conditions of health and warmth of feeling, or those of distortion and painfulness.

From observing the behavior of the archetypal affect-images in schizophrenic episodes, the impression has grown on me that the syndrome revolves around the problem of self-image. In it, there is a pathological division between its two forms, the personal and the archetypal ones; that is, the personal self-image in the usual sense of the way the person views and evaluates himself, and the archetypal image that compensates it in depth. In the prepsychotic development, the personality has grown into an identity that does not properly belong to him. For he has grown up with a feeling of unlovedness and consequent outsideness, and the self-image is that of being faulty, undesirable, unworthy, and unpromising. These are derived from the mother's projection, and are taken over by the ego as its personal self-image. Close behind these feelings are the fantasy ones — from the compensating archetypal affect-

image — of being superlative, more than human, a genius, or a person of momentous importance to the world. Thus, when the personal self-image is severely debased — as it usually is in the prepsychotic make-up — the archetypal self-image is in the same measure exalted.

The discrepancy between the two self-images in their counterpoise sets up an unstable psychic situation full of a sense of unreality and of anxiety, which is prone at any time to precipitate one into the archetypal renewal process. It seems that when the psyche cannot progress further into its next steps of experience so encumbered by this very negative self-image — especially at times of the great crises of ebullient falling in love or of hurtful falling into rejection — a change is initiated. The psychic energy, the libido, is attracted to the archetypal level of the psyche, where a process of very high energy-charge starts moving, reorganizing the central archetype and hence reconstituting the self-image. It appears that this recession of the libido leaves the higher levels of the psyche stripped of their usual energy-charge, and hence in a state of disorganization. Both the ego-consciousness and the complexes are left in a state of fragmentation.

As I see it, the principal change that takes place in the reconstitution of the self-image is not merely that self-esteem is restored, but much more, that the capacity to love and be loved is generated. The plight of the schizoid personality is that love has been disappointed. The mother-child bond as the first basic experience of secure love should have been the model for all later experiences of closeness; the mother should have become the first representative of the "Eros" principle, that of relating and loving and allowing intimacy. But what took its place instead was control and suppression. Thus, not only did the child learn for self-protection to withdraw feeling, but even more, he came to deal with people according to the Power principle, instead of the more natural Eros one to which it stands as an opposite.[1] Power wants status and control, while Eros seeks relatedness and closeness. The prepsychotic make-up, with its assumption of unlovability, then suffers a difficult combination of feelings of crushing insignificance and of superlative prestige-hunger. In other words, the initial tendency of the archetypal self-image is to prompt the ego to seek out a balm for unacceptability in the form of

some absolute mastery. The psychotic process habitually puts this power-oriented form of the self through a transformation that awakens the potentials for relationship and gives them their rightful place in the structure of the personality and in the style of life.

One example comes to mind that was so classic in its outlines as to be almost schematic. It is that of a young man in therapy with one of the residents whom I was supervising; I can therefore say with some assurance that I did not influence the content or the direction of flow of the imagery. For the first weeks of his episode he believed himself to be specially elected by the "Space Wizards," superintelligent and superpowerful beings who ruled the galaxy, to be Chief Space Wizard on earth. (This is twentieth-century language for the title King of the Universe.) In the course of the following weeks, however, his interest shifted remarkably away from such superlative imagery and he became engrossed instead in the fantasy of immersing himself in life on a farm with his wife, raising children and vegetables and livestock. The atmosphere of these preoccupations, starting with the crisp, cold, electric excitement of cosmic power from the sky, turned now to the opposite extreme, the warm quiet comfort of loving family bonds and of nursing the life of animals and plants living on the soil of earth.

REORGANIZATION OF THE SELF IN TERMS OF IMAGES

To be able to get access to the private and inmost preoccupations of the person who is deeply engrossed in his psychosis requires certain essential conditions, the chief of which is an intense and intimate relation of mutual trust which takes days or weeks to establish. The imagery that to the psychotic individual seems particularly fraught with importance is often then conveyed to the therapist only in the spirit of revealing the most personal and intimate of secrets. Such an individual is prone to be watchful and distrustful lest there be a hint of some derogatory stance on the therapist's part toward these loaded and secret preoccupations; with any failure on the therapist's part to regard them as meaningful, the veil may be quickly drawn over them, despite any such futile measures as an external manner of friendly reassurance. The personal factor is apparently unavoidable; the individual will open up to one therapist and keep

strictly closed to another. Even interests in and familiarity with the usage of symbols are not always sufficient to invite the individual to openness. My impression is that a mutual emotional field must be established in interaction with the individual, by entering into a reciprocal intimacy of feeling with him. Apparently only then will the image process move forward in a more or less aimful way. Without this mutual emotional field, I doubt whether the process of reconstituting the self would progress toward its goal.

When this process does move in this way, one finds an astonishing regularity in the occurrence of motifs from case to case. This observation alone suggests that within the apparent chaos of images and ideations tumbling upon one another, there must be some sort of order or ground plan. In order to ferret this out, I went carefully over my records of the twelve cases showing evidence of the syndrome in question and assembled the welter of contents into categories. I found ten such groupings, but they must be understood to be purely arbitrary assignments and arrangements for purposes of descriptive study and formulation. My thesis, then, is that these categories represent elements of a process that becomes recognizable from an acquaintance with comparative symbolism. I had no prior notion of such elements or sequence at the start of my work with psychosis, however, and was at that time not at all aware of the comparative symbolism that specifically applies to it. One would therefore be in no sense justified in thinking that I was influencing the flow of images into a certain direction while working with these individuals. My experience was the opposite, of looking on at things that I did not expect and that puzzled and surprised me. It was not until the time of writing a formulation of one of the early examples that I began to perceive the sense of the sequence, when I was just halfway through the series and midway through the twelve years.

The categories as I arranged them are as follows: A negative self-image at the ego level presents itself, along with a compensatory overblown self-image at the fantasy level, in mythological and delusional form (negative: clown, ghost, witch, puny outsider; positive: hero, saint, one chosen for leadership).

There are feelings of participating in some form of drama or ritual performance (playing parts on radio, television, or stage; dancing, chanting, mimetic or ceremonial motions).

A. *Center:* A location is established at a world center or cosmic axis (point where sky world, regular world, and underworld meet; between opposing halves of the world; center of attention).

B. *Death:* Themes of dismemberment or sacrifice are scattered throughout and make themselves evident in drawings (crucifixion, pounding or chopping up, tortures, limbs or bones rearranged, poisoning). A predominant delusional statement is that of having died and of being in an afterlife state (people look like living dead; in hell or in heaven; or in prison as equivalent to death).

C. *Return to Beginnings:* A regression is expressed that takes the person back to the beginnings of time and the creation of the cosmos (Garden of Eden, waters of the abyss, early steps of evolution, primitive tribal society, creation of planets). There is a parallel regression, of course, to emotions, behavior, and associations of infancy (surrounded by parent figures; crawling, suckling; needs for touch and texture; oral needs).

D. *Cosmic Conflict:* There arises a world conflict of cosmic import between forces of good and evil, or light and darkness, or order and chaos (surprisingly often expressed nowadays as democracy and communism; Armageddon, or the triumph of the Antichrist; destruction or end of the world, or the Last Judgment; intrigues, plots, spying, poisoning — for all to gain world supremacy).

E. *Threat of Opposite:* There is feeling of a threat from the opposite sex, a fear of being overcome by it, or turned into it (drugs to turn one into the opposite; identifications with figures of the other sex; supremacy of the other sex; moves to eradicate the other sex).

F. *Apotheosis:* The person experiences an apotheosis as royalty or divinity (as a king or queen, deity or saint, hero or heroine, messiah).

G. *Sacred Marriage:* The person enters upon a sacred marriage of ritual or mythological character (royal marriage, perhaps incestuous; marriage with God or Goddess; as Virgin Mother, who conceives by the spirit).

H. New Birth: A new birth takes place or is expected of a superhuman child or of oneself (ideas of rebirth; Divine Child, Infant Savior, Prince, or Reconciler of the division of the world).

I. New Society: A new order of society is envisioned, of an ideal or sacred quality (a New Jerusalem, Last Paradise, Utopia, World Peace; a New Age, a New Heaven and New Earth).

J. Quadrated World: A fourfold structure of the world or cosmos is established, usually in the form of a quadrated circle (four continents or quarters; four political factions, governments, or nations; four races or religions; four persons of the godhead; four elements or states of being).

I do not at all mean to imply that these are steps occurring in this order; they may be all jumbled together for a long time. However, the themes of the regression and cosmic conflict tend to come early, and those of new birth, new social order, and fourfold world structure to come late.

I will present a brief glimpse of how the array of ideational imagery of a person looks when outlined in this fashion. The gathering of information about these fantasy products in the interviews might take several weeks, if the person only lets out a bit at a time; or the sequence may develop slowly from one interview to the next, through the weeks; or it may be communicated to the therapist only afterward, in retrospect. Either way, one may summarize these images in retrospect without much difficulty, especially when one is on the alert for a consistent process unfolding through them. In this case the individual told me of them afterward, as a story already formed and finished. This is number seven in my series, one whom I interviewed in therapy over a three-month period, and who made a good adjustment over the years following her discharge from the hospital.

This was a twenty-seven-year old, unmarried woman who worked as an administrative secretary. Her mother was depriving and denying toward her, which led to a mutual antipathy; she felt a good deal of love toward her father and needed him very much, but found him remote. An older sister was favored by the mother, and the woman found in her a surrogate mother with some real warmth.

She had customarily found herself cold and teasing toward men, and disliked herself for it, but at the onset of her illness her first delusion was that she was a witch, and had the

Evil Eye and magic power. She also identified with Queen Elizabeth I as a cold and ruthless figure of power.

Ideas of ritual and drama were not expressed.

She felt that the Bay Area was being engulfed, either by fire or water, and was dropping down to become a new Hell (A. Center).

She thought she was being punished for her evil and wanted to be baptized, and that she had died and was in an afterlife state, along with the hospital personnel (B. Death).

She had visions of the time of creation and early evolution, and of the first primitive peoples migrating across the continents and over the English Channel to the British Isles. She found herself preoccupied with sinister visions of holes in the earth she had known in early childhood, and thought herself back there again, and felt very young (C. Beginnings).

She was frightened at being caught up in a struggle for power between communism and democracy, between which two camps the world was divided (D. Cosmic Conflict). She was at the center of plots and counterplots, both sides wanting to make use of her knowledge, and she feared being poisoned (A. Center).

She believed the feminine women were to be sent away to South America to be given work, leaving only the masculine women to deal with the men (E. Threat of Opposite).

One day she was watching a lightning storm and had visions of a series of great holy men — Moses, Paul, and Luther — and in great exultation received the revelation that she was to be the fourth, and thus the leader of a fourth major new religious era; each holy man was a reincarnation of the same great divine spirit (F. Apotheosis).

There were vague allusions to her being a new Virgin Mother (Elizabeth as the Virgin Queen), but this was kept secret; this idea was overshadowed by a greater picture of things to come (G. Sacred Marriage).

When the Bay Area became the new Hell, a new Bethlehem was to drop from the sky in spaceships, and a whole new order was to be brought to the world as an achievement of science (I. New Society).

This city was to be understood as a new version of the Heavenly City, the New Jerusalem (J. Quadrated World), and its place as the center of the world (A. Center).

There was to be no one new Savior, but every oldest son was to be a Son of Man, and all were to be perfect men, knowing everything of importance for human welfare, even as children (H. New Birth). As a result people were to have the wisdom to enable them to live sensibly together, in peace (J. New Society).

If one tabulates the categories with ten elements of the syndrome that I am delineating, and checks them out in each of my twelve cases, one gets a picture like this:

	1	2	3	4	5	6	7	8	9	10	11	12
Self-Images	•	•	•	•	•	•	•	•	•	•	•	•
Drama or Ritual			•	•	•	•				•	•	•
A. Center	•	•	•	•	•	•	•		•			•
B. Death	•	•	•	•	•	•	•	•		•	•	•
C. Return to Beginning	•	•	•	•	•	•	•	•	•	•	•	•
D. Cosmic Conflict	•	•	•	•	•	•	•	•	•	•	•	•
E. Threat of Opposite	•	•	•	•	•	•	•	•	•	•	•	•
F. Apotheosis	•	•	•	•	•	•	•	•	•	•	•	•
G. Sacred Marriage	•	•	•	•	•	•	•	•	•		•	•
H. New Birth	•	•	•	•	•	•	•	•	•	•	•	•
I. New Society	•	•	•	•	•	•	•	•	•	•		•
J. Quadrated World	•	•	•	•	•	•	•			•		•

On counting up the ten elements, it can be seen that nine persons show the complete sequence. In two more, numbers eight and eleven, I felt that the other items were there in all probability, but were being withheld; they did not communicate easily about their imagery. In the case of number nine, he did not enter into such a profound turmoil, and the process was undoubtedly incomplete.

The image of the quadrated circle often prevails throughout these sequences as distinct mandala forms. Of course, most of the imagery is expressed verbally, and the mind's eye can sketch its morphology without much difficulty, but for many persons there is great satisfaction in drawing the configurations on paper while they talk in the interview. There is no need to draw upon extraneous interpretations of the symbolism thus portrayed; we should let the person tell us what it represents. At this level of regression we rarely find an "art of the psychotic," for more

commonly it consists of simple diagrams, often in the class of "space-time diagrams,"[2] (portraying three dimensions of space and a fourth of time). I have in my collection from these cases many such diagrams, representing any one of the ten steps of the image sequence, signifying that the quadrated circle is descriptive of the psychic entity that is undergoing this process; that is, the self. In this model, as Jung has defined it, the archetypal self is seen as the governing center of the total psychic organism, and it represents itself in terms of centrality and quadrated circular forms.[3]

Not only is this sequence prevalent and standard in its outlines in the deep turmoil of the schizophrenic process, but we can look for its appearance in other forms in human experience as well. Essentially archaic and religiously toned, it is found in cultural form in archaic religious expressions. There are myths and rituals that also describe a process of death, return to the beginnings, and renewal. Indeed, the myth and ritual form that resembles it is the principal and central rite of the civilizations of remote antiquity, and it parallels the image sequence step for step. I am referring to that ceremonial pattern of sacral kingship which arose in the ancient Near East and spread by diffusion throughout the Mediterranean area, Europe, and perhaps the Far East, in which there was an annual seasonal festival for the renewal of the year, of the world, of the kingdom, and of the kingship, on the days of the New Year.[4]

This ceremony was a ritual drama, beginning with (A) the king's confession of guilt on behalf of the people and (B) placed in a setting representing the cosmic axis or world center (C) There was an overcoming of the king by the powers of death and darkness and (D) a return to the beginnings of creation when it arose out of the primordial flood, as an outcome of (E) a ritual combat carried out in pantomime between the forces of order and light and those of chaos and darkness. There was (F) a Saturnalia in which laws turned into their opposites and there was topsy-turviness, including forms of transvestism. The king (G) was reinvested, and reenthroned, and his kingship reconfirmed as the representative or the son or the embodiment of the god. He entered (H) upon a sacred marriage with the queen or the high priestess as the personification of the goddess, thus representing and indeed effecting (I) a renewal

of the life and virility of the kingship and the kingdom. It wound up with (J) a "determination of destinies" for the next cycle of time, and a reaffirmation of the ideals by which the society was structured. The city kingdom was often a circular and quadrated "world."[5]

The image sequence of death and birth, with the prevailing motifs of dismemberment, is in the class of *rites de passage* made famous by van Gennep,[6] and is suggestive of puberty rites and initiations.[7] However, I find the general overall pattern of imagery far more closely consistent with the rites of divine kingship, with their motifs of rejuvenation and their governmental and cosmological accompaniments.[8] As a matter of fact, it is being suggested by leading scholars in the field of myth and ritual that puberty rites may well have derived out of these ceremonies of divine kingship, just as the marriage ceremony is known to have done. [9]

REFORMULATION OF THE PREVIOUS CASE

Using this arrangement of the content of the psychotic episode, I will indicate how I see it applied to the case of the young lady of Chapter 2:

In her negative self-image she saw herself as unlovable and alone; in her positive one, as pure, excelling, and loved only by God. The latter slipped over into a conviction of special election, in her exaltation feeling "not quite of this world." As to the dramatic form, she looked upon her need to compromise with the mundane world and humanity as "just a game" ("we all have parts to play in this act").

She felt a special calling from the Blessed Mother to circle the city as the center and starting point of the new order (A. Center). Just before that, in her hours of prayer, she sensed the "odors of death" and felt pains which signified that she was to die, a death of the ego to be reborn (B. Death). She believed herself to be Eve the Temptress, returning to the primitive emotional ways of the Garden of Eden. When her world "turned inside out" she lost her old world and the formerly hidden Devil's world was now what she looked out on (C. Beginnings, Creation). Communists were giving her truth serum, and their forces and those of Christianity or democracy were lined up for battle, a war of Evil against Good, Death against Life, and the Devil against the Blessed Mother (D. Cosmic Conflict). She was anxious over some people's misunderstanding her sexuality, thinking her a lesbian; she also feared men's sexual intentions (E. Fear of the Opposite Sex). The Virgin Mary sent her "odors of life," calling her to a special election to change the world;

*she also felt an identification with the first lady, Jacqueline Kennedy, and hence an im-
portant role in national affairs, expecting a huge crowd to give her an ovation downtown
(F. Apotheosis). She knew herself to be married to God (G. Sacred Marriage), and to be
pregnant with a divine child by the Spirit, to be a holy birth; she was also being "reborn in
the heart of the Virgin" (H. New Birth).*

*There would be a redemption of the world and a new order under the Blessed Mother,
in which both she and her divine child would play a leading part (I. New Society). Her
image of living in the world was visualized in the symbol of the cross representing the ten-
sion between dwelling in the spirit and in the flesh, as seen in the vertical and the hori-
zontal limbs respectively, one reaching to Heaven, the other to the world (J. Quadrated
World Image).*

THE UNFAVORABLE AND THE FAVORABLE RELATIONS
TO THE AFFECT-IMAGES

The problem of understanding the inner workings of a psychosis is the
problem of understanding the primordial imagery. For when the ego ab-
rogates its position of mastery and is overwhelmed by the unconscious in
the psychotic break, it is the archaic unconscious that sweeps forward into
the ascendancy, and it has its own processes to undergo before there can be
any thorough resolution of the syndrome. If we ignore these processes, the
only alternative is to hold the person up to some external criteria of behav-
ior that we impose upon him, rather than helping him follow the demands
of his own psychic individuality.

It appears that the imagery itself is not abnormal in these sequenc-
es, for we find the same forms, and the same rather disjointed play of
images, in the unconscious of various kinds of persons, from the non-
pathological to the profoundly disturbed. Rather, it seems that pathol-
ogy lies in the ego's wrong relation to the affect-images, in allowing itself
to identify with them, or to be overwhelmed by them.

There is, under these conditions of activation of the central arche-
type, a tendency for the ego to identify easily with it in any of its image
forms, especially with the royal or divine figures at the position of the
world axis. This leads into an inflation, producing delusions of grandeur,
of course. It is accompanied by paranoid fears, inasmuch as the royal

image of the center is necessarily fated to be attacked by the destructive powers of death, darkness, and chaos, in the typical cosmic conflict. The alternations between the hyperactive and the withdrawn, stuporous phases parallel this imagery directly: In the "high" phase, the imagery is of the exaltation of the royal figure; in the "low" phase, that figure is succumbing to sacrifice and descent into death and darkness. One may accurately predict the shift from one phase to the other by the appearance of the imagery.

The recession of the libido, then, leads to these archetypal processes and, at the same time, to a regression to the earliest relations with the mother. This is only natural and to be expected, since the archetypal process aims to reestablish an experience of the mother-child relationship that was never fulfilled at its rightful time in infancy. It seeks a fulfillment now of the archetypal configuration that had been left incomplete and hence distorted in early life, warping the rest of development from then on. Following this, one sees a recapitulation and reenactment, step by step, of the major stages of growth at critical periods, evidently in order to set up a realignment of the self-image at each phase of its development. Each of these steps occurs within the framework of the "transference" relation, either with the therapist, or — in a hospital — with other staff members. In therapy the transference is a love relation, starting at the level of the mother-child bond, that involves the central archetype, this time capable, one hopes, of providing a favorable emotional setting for any of the stages of the evolution of the self from phase to phase, from the beginning.

The perception of the image sequence as I have arranged it in the psychotic process and in the royal enthronement ceremonials has led me to investigate extensively the myth and ritual of kingship to discover what could be learned from it and from its historical sequel, messianism.

1. See Chapter 10 below.

2. J. W. Perry, *The Self in Psychotic Process.* Berkeley: University of California Press, 1953.

3. C. G. Jung, "Conscious, Unconscious, and Individuation," *Collected Works,* vol. 9: *The Archetypes and the Collective Unconscious,* Bollingen Series XX. New York: Pantheon, 1959, part 1.

4. J. W. Perry, *Lord of the Four Quarters.* New York: Braziller, 1966; E. O. James, *Myth and Ritual in the Ancient Near East.* New York: Praeger, 1958.

5. Perry, *Lord of the Four Quarters;* H. P. L'Orange, *Studies on the Iconography of Cosmic Kingship in the Ancient World.* Cambridge: Harvard University Press, 1953.

6. A. van Gennep, *The Rites of Passage.* Chicago: University of Chicago Press, 1960.

7. M. Eliade, *Birth and Rebirth.* New York: Harper, 1958.

8. J. W. Perry, "Reflections on the Nature of the Kingship Archetype," *Journal of Analytical Psychology* XI, no. 2 (1966).

9. Edwin O. James, *Christian Myth and Ritual.* New York: Meridian Books, 1965; A. M. Hocart, *Kingship.* London: Oxford University Press, 1927, chaps. 8 and 12.

THE NATURE OF THE KINGSHIP ARCHETYPE

The investigation of the history and psychology of kingship has become an absorbing interest for me since my work with schizophrenic persons led me to define a reconstitutive process.[1] In these psychotherapeutic efforts I departed from clinical custom in giving full attention to the delusional productions during the acute phase of the disorder. I was convinced that the individual's need was to convey to the therapist his inner experience, and often to use more than merely verbal means to communicate what was happening in his world of images. Seeing two major motifs occurring with some regularity — that of death and rebirth and that of centrality — I concluded at first that the process must belong to the initiation class of images.[2] However, midway through a dozen years of collecting such observations on "inpatients," I stumbled upon some of the literature on archaic kingship and recognized that this class of images accounted for the contents of the process far more completely and satisfactorily.

These considerations led me to conclude that we see in certain schizophrenic cases a specific archetypal process describing the synthetic work of the unconscious even in the most severe of disorders. That delusions can have restitutive significance has been noted by others. Freud formulated these fantasy formations in terms of the restoration of object relations by infantile substitutes for reality.[3] Jung, in his more extensive explorations of psychosis, described the compensatory role of delusions in attempting to rescue the personality from a pathological one-sidedness;[4] also, he saw in delusions the attempt of the pathological complex to destroy itself.[5]

In my paper on reconstitutive process,[6] I grouped the themes regularly recurring from case to case under broad headings and ordered

them as already described in the last chapter. In classifying the archetypal themes of these cases, I was astonished at the close correspondence of the two sets of images I was studying, those of the historical kingship and those of the psychotic productions. This started me on a long detour of investigations of the historical material to see what the original texts would reveal for further clarification of the nature of the process; these I gathered in my volume on the mythology of the father figure, *Lord of the Four Quarters.*[7]

I intend now to cull from this circuitous search a few observations that have a bearing on the questions that prompted it: Why should imagery of the kingship class characterize this reconstitutive process in psychosis? What particular meanings does it hold as a process and what do its images signify?

My guiding premise for the investigation of any such collective themes is that an archetypal image is a hollow, empty, insubstantial shape apart from its life setting — what some ethnologists have designated as its *Sitz im Leben.*[8] Of course, the archetype proper is known only as an abstraction until it takes form in a dynamic image when activated in a typical life situation; my point goes beyond this and concerns our manner of reading the image when constellated. In the individual I regard it as lacking in its vital significance unless it is considered in its natural emotional setting and, in the collective life of a people, similarly lacking unless handled in reference to its full context in its current historical setting. For, as Jung has pointed out, the archetype is simultaneously both emotion and image.[9]

Therefore we have two approaches to the understanding of the kingship motif, two sets of data of observation: the individual data of persons in therapy and the place it took in their current and past emotional life, and the historical data of archaic societies and its function in their life of "collective emotion." I stress this point because in the case of schizophrenia, in which the patient has lost touch with the meanings of his emotions, I believe it important to discover the life context to which the images belong, in order for them to convey meaningfulness once more and thus restore the otherwise maimed affectivity. Also, in the case of the sacral kingships of antiquity, we quite miss the point of their role

unless we keep in mind the exact historical settings, not only of place — the cultures to which they belonged — but also of time — the specific phases of these cultures in their evolution.

The essential point about such archetypal process is that, since the component images come out relatively the same from case to case in this syndrome, it is easy to regard them as almost purely collective. Yet a distinctly individual aspect emerges in them in a couple of ways. For each motif there turns out to be a place in life where they are currently being experienced; that is, where they are operative in projective emotional relations to people or to things. This is the kind of life context that makes a collective component an individual experience, however blindly it is being concretized in projection. Also, the individual nature of each personality makes use of the imagery in the process to steer its course toward somewhat different outcomes, representing perhaps quite different solutions to the plight. To these we shall return shortly.

In psychotic persons this sequence of images apparently represents only one among several possible syndromes, such as those of the initiatory or those of the shamanistic class.[10] For example, one patient of mine had a delusion that in an operation a precious stone had been put into her head, which gave her magical powers of knowing, hearing, seeing, and controlling by telepathy; she did not have any of the usual images of the kingship syndrome just described. Only several years later did I learn that such precious stones are a commonly occurring phenomenon in shamanism in various parts of the world.[11] The amplification that brings the material extracted from my twelve cases into line with the kingship class of images is that the entire array turns out to be a strikingly close facsimile of the principal ritual of the kingship; that is, the New Year festivals, which are at the same time the rites of Renewal of the King and the Kingdom.[12] This seasonal ritual drama was a creation rite also emphasizing the center, the beginnings, death and renewal, the sacred combat and sacred marriage, and the other elements of the process.[13]

Turning now to the historical data on kingship, we must recognize first that all the indications point to its not being a primordial institution.[14] Its fully mythological form, called the "sacral kingship," is that in which the monarch either embodies the deity or is his son, or at least acts

as his earthly representative and priest. Following the lead of Gordon Childe and carefully checking the historical facts, I found that kingship of this sacral type finds its regular position in a cultural sequence, marked by the rise of cities, industry and warfare, and that only from this context do we learn what are the main functions of the archetype of the kingship.

The historical picture opens against the background of the immense Paleolithic era, with its extraordinarily wide diffusions of sameness and long aeons of time. About nine thousand years ago there set in a series of "revolutions" of cultural forms, each with a new way of life, and each with its own mythology characterizing this new way. These we will now consider.

THE NEOLITHIC REVOLUTION

The first stirring of man's new life was the Neolithic Revolution,[15] ushered in by his discovery of new means of food production; up to that time men had been food gatherers only. This began first in the Near East, where the kinds of food plants that could be cultivated and the kinds of animals that could be domesticated were living wild, ready at hand. The oldest among the settlements so far discovered is the oldest level of Jericho, which as early as 7000 B.C. was a town with stone ramparts and central tower, an extraordinarily early anticipation of town life and its need for defense from attack.[16] In the main, this era was marked by village life, agriculture and stock-breeding, and stable, settled communities.

During the sixth and fifth millennia B.C. this new mode of sustaining life spread by diffusion right up through Europe to such distant points as Denmark, bringing with it new species of plants and stock. The new arts of food production were sustained by the cults of the mother goddess and the fertility that came from her, either alone, or slightly later, together with her son-lover and spouse (or at least his phallic equivalent). The cults spread by diffusion from the Near East along with the new techniques. The change from an economic matriarchy[17] in which the techniques of food production were in the hands of the women, to one which probably coincided with the advent of the plough and the accumulation of herds, both handled by the men, took place in the fourth millennium B.C.

THE URBAN REVOLUTION

The second great revolution, and the one of particular significance for the myth and ritual of kingship, came with the rise of cities; up to this time there had been large aggregates of population in certain centers, but in their socioeconomic structure they were not yet "cities," but over-grown villages which should be designated as "towns." This new Urban Revolution [18] took place at first in the four great river valleys: the Tigris-Euphrates in roughly 3500 B.C.; the Nile in ca. 3000 B.C.; the Indus in ca. 2500 B.C.; and the Yellow River in ca. 2000 or 15000 B.C. Each gives the appearance of a spontaneous and independent rise of this new stage of culture, and especially so in the fifth, the valley of the Mexican Plateau, and the sixth, the Peruvian highlands. [19]

In each case the transformation of village into city culture was the outcome of extensive changes in the material life of the people: that is, in technology and trade. Industry was now characterized for the first time by full-time specialists, a fact made possible by the production of a sur-plus of food, freeing a whole population of workers from the need to give time to the basic means of survival. The discovery of metallurgy made possible the increased effectiveness of implements for food and weapons and promoted the gathering of wealth. This wealth accumulated in the hands of some form of central power, which could then patronize indus-try and metallurgy. With increased productiveness came an increase in population, and an intensified competitiveness for ownership of land, of the means of industrial production, and of the raw materials. Warfare on an organized scale for economic ends set in for the first time in man's history, with a new violence and destructiveness that made his erstwhile village life look like a paradise. All these new developments led to a mas-sive reorganization of the structure of society, grouping now by func-tions rather than by clans.

This world of energetic business and expansion was the setting in which the sacral kingship made its first appearance. Up to this point the prevailing mode of government had been the "primitive democracy," [20] in which the clan elders had conducted the affairs of the community in their assembly. The birth of kingship, however sacral it may have been, was not in the noblest or most spiritual of circumstances. Apparently the

urgency of need for aggression and defense provided the first occasions for the election of a potent chief out of the assembly to lead and organize the community (much as happened in the election of Saul in the face of pressure from the Philistines).

In this can be discerned very clearly the rise of the king figure as great father out of the group of family fathers. Thus the sacral kingship arose in Egypt in ca. 3000 B.C.; Sumer ca. 2850 B.C. (also in the Troad); in the Indus Valley ca. 2500 B.C.; and China ca. 2000 or 1600 B.C.; also in Mexico in the early centuries A.D.; and the Inca Empire ca. 1000 A.D. It was conveyed by trading and raiding over the Caucasus into South Russia, where in the late third millennium B.C. potent chiefs ruled over a culture that became the spawning ground of the immense Indo-European diffusion into the four directions.

Together with the rise of these first royal chiefs and their new city kingdoms came their great mythological counterparts, the forceful father gods who were now set up as king gods; those of the sky, sun, storm, water, and fertility. These leading figures in the world of myth can now be seen very clearly to portray actual dynamic historical forces, powerfully efficacious in this transformed world of rule, conquest, and empire-building.

The figures arose in a highly specific psychological setting. This was the tremendously creative phase of burgeoning cultural innovations, which meant at the same time the unleashing of unknown and unfamiliar forces whose operations seemed uncanny and of immeasurable limits, and hence filled with the aura of magic and divinity. It was, then, quite comparable to the rich proliferation of alchemical mythology in its late medieval flowering upon the threshold of the scientific exploration of matter, when again a new and incomprehensible world was opening up.[21]

In the Urban Revolution, myths of kingship and their accompanying rituals were characterized by a kind of realness; that is, they were earnest and genuine expressions of the making and functioning of kingship, believed in as necessary to life. As soon as these dynamic historical forces became more familiar, they consequently became secularized and the order that was hitherto divinely given became the material of the philosophy or the science of politics, laws, and ethics. But before this the

decadence of the royal ideology had already set in, and the divinity of the kingship had become instead a pomposity and a conceit.

The period of genuineness — that is, of earnest belief and reverence and awe for the majesty of kingship — lasted usually not more than a half to three-quarters of a millennium, sometimes only a few centuries. This characteristic phase in the development of urban civilization I have termed the "archaic era of incarnated myth," for the reason that in that brief epoch the human world and the mythical 'world were seen as reflections of each other, and the government of society was regarded as fashioned in the image of the ordering of the cosmos.[22] The mythical world was embodied in social forms, and the city kingdom was a model of the cosmos on the human plane.[23] In this the king at the head of his kingdom was the counterpart of the king god in the divine realm; each was now "King of the Universe" or "Lord of the Four Quarters."

MYTHOLOGICAL REPRESENTATIONS OF THE KING

At this point, then, a remarkable differentiation of mythological figures took place. The circumstance that excites our wonderment is that this array of gods appeared at this point for the first time in man's history. They came upon the scene as a function of the differentiation of culture itself, which in turn was an expression of the differentiation of the psyche. We can only suppose that culture-making is at the same time psyche-making, that the creative work of structuring the one is equivalent to the same work upon the other. Even more intriguing is the unexpected fact that this cosmological mythology of kingship tended to appear in fullest flower at its start. For example, it was apparently the genius of Menes, founder of Egypt's first dynasty, that clothed the vision of the dual kingship in a complete theological justification and thus laid the ground plan of Egypt's core mythology and cosmology.[24] This can be taken to imply that we should attribute to the creative imagination of great founders the establishment of our archetypal heritage.

As we undertake now to describe this differentiation of kingly deities, we must bear in mind that while we may recognize distinct motifs, their expression in various mythologies may or may not merge them or separate them in their personification.[25]

A. The Sky God

The broad outlines of this differentiation of the kingly father gods may be schematized in somewhat the following way. The primordial figures that had presumably been the primitive antecedents had been two, the sky father above and ancestral father below. Our two words referring to deity derive from these opposite sources: "divinity," whose root *div* comes from the ancient Indo-European *dyeus,* designating the shining sky; and "theology," whose root *theo* has its origins in the more eerie, dark, and misty ancestral deities in the land of the dead.[26] Out of the older sky father were differentiated the gods of the storm and of the sun, while out of the older ancestral father arose the figure of the first ancestor and founder of the royal lineage, and also the king's enemy.

In the early days of kingship the older sky father receded to an aloof distance from and remote noninvolvement in earthly affairs. He was often overthrown by his younger successor.

B. The Storm God

The dynamic new arrival on the scene and the most prominent representative of the new kingship was the storm god. He was typically the son of the sky father and overthrew him to usurp leadership and inherit the kingship. The clearest prototype of these figures is found in the Sumerian Anu and Enlil: The older Anu represented cosmic order, and the authoritativeness that compels spontaneous obedience. The younger storm god carried the executive function as sheriff and chastiser who brought force to bear to compel obedience. He personified the vigorous, aggressive aggrandizement and mastery that characterized this new style of kingship.[27] His was also the cosmocratic work of vanquishing chaos to enlarge the domains of the ordered world. These emotional forces were the attributes par excellence of the new psychic state of the time, and he was the maker of history and harbinger of a new consciousness.

In the particular era under discussion the sun god had a hand specifically in the establishment and promotion of regularity, inasmuch as he embodied the epitome of the regularity of the sky. Hence his activity came into play most typically in connection with the legal code. It is interesting to note that his supremacy as principal king-god occurred whenever the

culture was most given to excessive discipline and rigid ordering and regimentation; the two most spectacular instances of this were ancient Egypt of the later years of the Old Kingdom and the Inca Empire.

The broad generalization may be hazarded that these gods of the sky presided mainly over the promotion of order in the larger cosmos of nature and the smaller cosmos of the kingdom. The ancestral gods of below, however, had as their province the giving and taking of life and the enhancement or the prevention of life's renewal. As the storm god was a giver of order, the first founding ancestor was a giver of life, the king's enemy a bringer of death.

C. The Ancestor God

This first ancestor god was typically the older demon of fertility transformed at the time when the great royal lineages and kingly clans were being established. He personified that aspect of the kingship which nourished life, virility, and peace — a good example of the entire configuration is found in the figure of Freyr in the Norse mythology[28] Since life was found to be cyclical in its ebbing and flooding, it was regarded as emanating from death by processes of renewal; therefore the giver of life was the spirit presiding over renewal, rebirth, regeneration, and resurrection. His being ancestral emphasized his close association with the realm of death as the source of life: In the case of Osiris, for example, he was Lord of the Dead.

D. The King's Enemy

The king's enemy in this phase of history was a most important figure, both mythologically and ritually, and was himself a king-god like the others and an integral part of the whole makeup of the archetype of the kingship as its own inner contradiction. Usually he was also a derivative of a god of the older order, often, as for instance in Canaan, a god who had presided over the control of the waters until the new king-god took over. He, too, belongs to the realm of death, but in this case is no longer a giver of life in death but of death in death. His nature is that of opposite to the favorable aspect of the kingship: opposing chaos to order, dessication to fertility, etc. His domain was the underworld and also the de-

mon territory outside the kingdom, "below" and "outside" being equated. Hence foreign kingdoms and political enemies were embodiments of this mythological figure.

Finally, in the middle zone between the sky world and the lower world, the kingdoms of men were each considered to be the entire ordered world fashioned in the shape of the larger cosmos, frequently and typically a quadrated square or circle. Its living center of potency was the sacral king, who was its giver of life and giver of order; his three classical functions were as head of the priesthood, of the judiciary, and of the military. As chief warrior his function was still cosmocratic, inasmuch as it had the significance of defending the order of the realm against chaos, in the form of its inner and outer enemies. Thus military campaigns took on the meaning of ritual combats against the king's enemy, increasing the bounds of the ordered cosmos at the expense of the domain of chaos.[29] The renewal of life potency and of ordered organization was accomplished in the New Year festival, in which the king took the part of the god, in ritual form reenacting the mythical doings of the beginnings.[30] Death and renewal, the sacred combat with the king's enemy and sacred marriage with his divine spouse, enthronement and triumphal procession, and fixing the fates for the coming year, were all the broadly typical features of this annual seasonal ritual drama.

E. "The King Must Die"

A word should be mentioned of the current adage that "the king must die." In fact, in the entire gamut of cultures passing through that archaic era, king-killing is evidenced only in certain Indo-European cultures: in Magadha in eastern India among the founders of the Mauryan Dynasty, and in Sweden, and then only in the form of legends on the threshold of history; legend also speaks of it in Greece and perhaps Ireland. The Africa that has been so much described as primordial is in fact a posturban Africa with many signs of the decadence of older forms of a high civilization resorbed into the jungle; therefore its king-killing could as well be a degeneration of erstwhile ritual death for renewal.

REVOLUTION OF DEMOCRATIZATION

This leads us into the question of what became of this full, vital form of the sacral kingship. As already mentioned, it lasted only a few centuries, only as long as the Urban Revolution was new. Different historical eventualities occurred to put a finish to it. The most likely was that historical accident might bring it to a swift termination by conquest or other disasters, never to rise again. A slower process hollowed it out by gradual decadence, when the urgent need for this renewal of the center diminished as man became more confident of his own powers to sustain life and to govern his realms and build his empires. The divinity of kingship then became a burlesque played about a filial relation to the god. A third eventuality, however, went the other direction, into a spiritual refinement of the whole concept of the sacral kingship.

This best outcome of the sacral kingship, I suggest, is the third great revolution in the development of cultures, in the sequence after the Neolithic and the Urban. This might best be designated in its practical aspect as the revolution of Democratization;[31] however, if we speak in any depth about it we are really pointing to an internalization of the kingship and of its myth and ritual forms.

This internalization is the natural next step in the evolution of kingship. For it is natural for an archetypal form at the outset to find itself concretized and externalized by the creative activity or imageful perception of archaic men. That is the implication of my term "archaic era of incarnated myth,"[32] when psychic forms were built into the material and social world around man. In those times the royal father was the only great individual or unique man, in Egypt the only one with an immortal soul. Then with the democratization of these forms, each man might accomplish his great individuality, uniqueness, and immortality by the realization of the kingly powers within himself.

The most familiar and closest to us is the development of this concept in the Judeo-Christian tradition: The figure of the Messiah, born of the lineage of the sacral Davidic kings, grew from a political savior into a spiritual redeemer; there is a direct chain of steps from the archaic Davidic sacral kingship to the kingly Christ within. Familiar also is the nature of the Buddha as *Chakravartin*, with the choice open to him to take

the worldly throne of the kingdom as Universal Monarch or its spiritual counterpart as the Enlightened One: for his followers, to achieve the Buddha mind was expressed as equivalent to the supreme rulership. It is just as clearly seen in the Chinese conception of the sage, the genuine or complete man, who was Son of Heaven and equivalent in every way in his accomplished nature to the Emperor as Son of Heaven. We should note that again it was the spiritually creative geniuses, the prophetic visionaries, whose gifts ushered in a new era with a new myth for new men.

A FORMULATION OF CULTURAL PHASES

The archaic era of incarnated myth, then, was a threshold experience between an older and a new world, and this pattern may be conveniently summarized in the form of the three great revolutions in culture:

Phase I (the Neolithic Revolution): an era centered about the mother figure; its way of life emphasized the earth and its fertility, the growth of plant and animal life; the ideal was to live by the laws of the blood, of kindred bonds and loyalties, and of traditional custom as spoken by the elders; the predominant motif among life's objectives was increase.

Phase II (the Urban Revolution): an era centered about the father figure; its way of life emphasized industry and competition, wealth and power; the ideal was to live by the laws of generally societal and moral bonds, conceived on the principles of cosmological order and written in legal codes by rulers, and defended by them; the predominant motif among life's objectives was the development of the power principle, with an emphasis on the cultivation of violence.

Phase III (the Revolution of Democratization): an era centered about the individual; its way of life emphasized nonmaterial objectives and spiritual achievement; the ideal was to live by the laws of enlightenment and regeneration, of inner purity and self-mastery; the predominant motif among life's objectives was the development of the eros principle (and *agape*), with an emphasis on the cultivation of nonviolence.

CLINICAL APPLICATION

Returning now from this excursion into the historical background to our clinical starting point, the main question to confront is, Why should parallels with kingship and its myth and ritual forms occur in my schizophrenic cases with such distinctness? To me the remarkable and very puzzling feature of this process is that in the midst of the very profound regression to the earliest mother bond,[33] the archetypal content goes back not to the mother but to the imagery of the superlative father — not to mother cult material but to that of the father cult. One might expect that in a profound regression the psyche would return to the maternal archetypal level corresponding to the Neolithic phase and its preoccupation with the great mother. We find parallels instead to all the full ideology and imagery of the phase of the urban revolution under the masterful dominance of the great father, the "King of the Universe," with his cosmic combat and sacred marriage.

In keeping with the spirit of that cultural phase, the beginning of this process is filled with the atmosphere of the power drives, corresponding to the personality's faulty modes of dealing with feelings and relationships in terms of control rather than of openness. The later trend of the process is in the direction of an Eros orientation, toward releasing the potential for lovingness. Our problem, then, is to discern the avenue by which such a progress toward an Eros mode is expressed in the archetypal imagery.

I find this trend or direction of the process to be most clearly expressed in the class of images that I put under the heading, "New Society." That category represents the style of life most idealized by the individual undergoing the process, and most cathected by him. There is a hint that this group of images establishes the lines along which the reconstruction and reintegration may take shape.

In my group of twelve cases, we find different cultural affinities:

A. a retrogressive one, in which the imagery reveals a development from the Urban to the Neolithic idiom of earth and mother cult (Phase I, Neolithic, one case);

B. a static one, in which all remains within the Urban idiom of political and kingly supremacy (Phase II, Urban, three cases);

C. a progressive one, in which the movement is from the Urban to the Democratization idiom with its spiritual internalization (Phase III, Democratization, eight cases).

In the last group, however, three expressed their New Society as formed under the leadership of the goddess, with a New Birth as her hero and chosen one, suggestive of the "matriarchal" order.

Why, then, is the preferred class of imagery in this syndrome the idiom of kingship? The first suggestion that springs to mind is that perhaps this is what comes to view whenever the psyche is highly aroused. This has to be turned down as an answer, for there are many image sequences of quite a different nature that might come into play instead, such as initiatory, shamanistic, or alchemical. I feel that the kingship process represents one among several possible syndromes. One might suggest that since the process deals with images of the center, it depicts processes of the central archetype in its language of kings, etc.[34] (I prefer to use the term "central archetype" rather than "self" here, since it is not properly an individuation process at this stage.) This idea may be refuted, for there could be many other ways of expressing such processes of the center besides kingship.

I can think of four possible implications of this specific choice of imagery in this syndrome and in this particular kind of personality.

First, we are considering an individual who has been living in a position of "outsideness," in an amorphous darkness of rejection and a consequent lack of structure of his emotional life, as a nonmember of the human community in the emotional and participating sense. Reacting to this amorphous outsideness, the archetypal compensation puts him at the very heart of social belongingness and activates the emotional concerns with social structure, city founding, and world creation, preparatory to reentering the social world.

Second, he is an individual with a markedly damaged self-image, as powerless and ineffectual (a "central injury").[35] Reacting to this lack of feeling of mastery, the compensation activates the archetypes of supreme power to order, direct, and structure the psychic life.

Third, he is an individual who knows only the devices of omnipotent control as a mode of dealing with his relationships; he has never

found a satisfying representation of Eros in his mother bond,[36] but only controllingness in its place. Reacting to this lack of relatedness, the compensating process activates the archetypes of Eros preparatory to living a life of loving relationships and openness of exchange of feeling.

Fourth, he is static in his fixation upon a negative mother bond in a network of destructive family relationships. Reacting to this mother-bound state, the archetypal compensation activates the image of the great father and all his creative dynamic potential.

Now, while these possibilities spring to mind quite readily and naturally, and might have something to them, I somehow do not find them particularly gripping as explanations for the kingship motif. What does seem to me to throw more light on the nature of the process is found on a slightly broader level of consideration. There is an outstanding quality of this whole group of cases which distinguishes its imagery from that of the dream sequences of most other kinds of individuals, and that is the appearance of feelings and expressions that have a distinctly "religious" or "spiritual" tone; that is, the kind of reverence that pertains to those factors that have transforming effects on the inner life — redemption, salvation, renewal, etc. Linked with this is an opposite quality, of externalizing and concretizing in the paranoid manner of projection. Yet we have just seen how much this is the quality of the archaic era of incarnated myth, of Phase II, the Urban. In this the monarch, as "Lord of the Four Quarters" and "King of the Universe," as the Son of God combating the forces of Darkness on behalf of those of the Light, and as Creator of the World, would be taken for paranoid were he not the only figure in the world fully and legitimately entitled to such grandeur by being granted society's mandate to embody its myth ceremonially.

Only when these kingly functions became recognized as the rightful psychic properties of any spiritually accomplished individuals did their expression in the persons of boisterous monarchs begin to take on the appearance of a gross megalomania. Democratizing, internalizing, and spiritualizing came hand in hand as the gift of the great prophets and founders of the great religions.

The natural progress in the evolution of kingship, then, was the arduous work of realizing inwardly that which had been more naïvely lived

out in projected, concrete, externalized form. In this perspective we discover a more convincing reason for the choice of the kingship motif in this reconstitutive syndrome. It is that kingship is the natural historical framework and vehicle of this transition from the concretism of the archaic mentality to the spirit quality of the more fully awakened mind of our era. In that older stage of development, man needed to learn self-assertion, mastery, and purposeful aggression, all that goes into establishing an effective ego-consciousness in a societal context. In the newer, he strove to accomplish an enlightened awareness that would cultivate personal acceptance and affirmation both toward one's self and toward others' selves, in a spirit of nondominance. Along this pathway the process of the syndrome needs to progress. In view of these observations it appears necessary to acknowledge that the paranoid's religious delusions of a messianic cast may be seen in a new light. They should be regarded as different in meaning from the imagery of the heroics of rulership, just as the kingly imagery of Phase III, the Democratic, was distinct from and an advance over that of Phase II, the Urban. It seems indeed that the religious expressions represent a potential corrective to the power imagery of the supreme rulership. Are they not an attempt on the part of the psyche to promote the archetypal foundations of the lovingness that is so embryonic in the schizoid plight? I suggest they have the significance of the internalizing of psychic values that in the paranoid condition tend to be so blindly disowned in projection.

To the question of why kingship motifs should prevail in this particular schizophrenic syndrome, the answer most convincing to the writer is that kingship myth and ritual were the vehicle of man's coming to awareness of his spiritual potential as an individual. Those qualities attributed to the sacral king alone in phase II, the Urban became, in Phase III the Democratic, the potential of any spiritually developed individual. The psychotic, in his reconstitutive process, evidently must travel a similar road from paranoid externalizing and concretizing to an inward realization of his potential individuality.

1. J. W. Perry, "Reconstitutive Process in the Psychopathology of the Self," *Annals of the New York Academy of Sciences* 96, art. 3 (January 27, 1962).

2. J. W. Perry, "A Jungian Formulation of Schizophrenia," *American Journal of Psychotherapy* X, no. 1 (January 1956): 54–65.

3. S. Freud, "Neurosis and Psychosis" and "The Loss of Reality in Neurosis and Psychosis," Collected Papers, vol. II. London: Hogarth, 1924.

4. C. G. Jung, "On the Importance of the Unconscious in Psychopathology," *Collected Works*, vol. 5: *The Psychogenesis of Mental Disease*, Bollingen Series XX. New York: Pantheon, 1960.

5. C. G. Jung, "Recent Thoughts on Schizophrenia," *Collected Works*, vol. 3: *The Psychogenesis of Mental Disease*, Bollingen Series XX. New York: Pantheon, 1960.

6. Perry, "Reconstitutive Process in the Psychotherapy of the Self."

7. J. W. Perry, *Lord of the Four Quarters*. New York: Braziller, 1966.

8. H. Gunkel, *Schöpfung und Chaos*. Göttingen: Vandenhoeck & Ruprecht, 1895.

9. C. G. Jung, "Mind and the Earth," *Collected Works*, vol. 10: *Civilization in Transition*, Bollingen Series XX. New York: Pantheon, 1964.

10. J. Silverman, "Shamans and Acute Schizophrenia," *American Anthropologist* 66, no. 1 (February, 1967).

11. M. Eliade, *Shamanism: Archaic Techniques of Ecstasy*, translated by W. R. Trask, Bollingen Series LXXVI. New York: Pantheon, 1964, chap. 2.

12. M. Eliade, *The Myth of the Eternal Return*, Bollingen Series XLVI. New York: Pantheon, 1954; A. M. Hocart, *Kingship*. London: Oxford University Press, 1927; A. M. Hocart, *Kings and Councillors*. Cairo: Egyptian University, Barbey, 1936.

13. S. H. Hooke, *The Labyrinth*. New York: Macmillan, 1935; *Myth and Ritual*. London: Oxford University Press, 1933; *Myth, Ritual, and Kingship*. Oxford: Clarendon, 1958; E. O. James, *Myth and Ritual in the Ancient Near East*. New York: Praeger, 1958; A. R. Johnson, *Sacral Kingship in Ancient Israel*. Cardiff: University of Wales, 1955.

14. G. Childe, *The Prehistory of European Society*. London: Penguin, 1954; E. O. James, *The Ancient Gods: The History and Diffusion of Religion in the Ancient Near East and the Eastern Mediterranean*. New York: Putnam, 1960.

15. Childe, *The Prehistory of European Society*, chap. 3.

16. Ibid., p. 36; L. Wooley, *History Unearthed*. New York: Praeger, 1958, pp. 89ff.

17. Childe, *The Prehistory of European Society*, pp. 38 and 110.

18. Ibid., chap. 6.

19 Ibid. For a formulation differing from Childe's, see J. Jacobs, *The Economy of Cities*. New York: Random House, 1969.

20. T. Jacobsen "Mesopotamia," in *Before Philosophy: The Intellectual Adventure of Ancient Man*, edited by H. Frankfort. London: Penguin, 1954.

21. C.G. Jung, *Collected Works*, vol. 12: *Psychology and Alchemy*, Bollingen Series XX. New York: Pantheon, 1953.

22. T. Jacobsen, "Mesopotamia"; Perry, *Lord of the Four Quarters*.

23. T. Jacobsen, "Mesopotamia"; Hocart, *Kingship*; E. Burrows, "Some Cosmological Patterns in Babylonian Religion," in *The Labyrinth*, edited by S.H. Hooke. New York: Macmillan, 1935; H.P. L'Orange, *Studies on the Iconograph of Cosmic Kingship in the Ancient World*. Cambridge: Harvard University Press, 1953.

24. H. Frankfort, *Kingship and the Gods: A Study of Ancient Near Eastern Religion as the Integration of Society and Nature*. Chicago: University of Chicago Press, 1948.

25. P. Wolf-Windegg, *Die Gekrönten: Sinn und Sinnbilder des Königtums*. Stuttgart: Ernst Klett Verlag, 1958; Hocart, *Kings and Councillors*.

26. O. Schrader, "Aryan Religion," in *Encyclopaedia of Religion and Ethics*, vol. 2, ed. Hastings. Edinburgh: Clark, 1909.

27. T. Jacobsen, "Mesopotamia"; Frankfort, *Kingship and the Gods*; Perry, *Lord of the Four Quarters*.

28. H.R. Ellis Davidson, *Gods and Myths of Northern Europe*. Baltimore: Penguin Books, 1964; Vilhelm Grønbech, *The Culture of the Teutons*. London: Oxford University Press, 1931.

29. T.H. Gaster, *Thespis: Ritual, Myth and Drama in the Ancient Near East*. Garden City, NY: Doubleday, 1961.

30. Ibid.; Grønbech, *The Culture of the Teutons*.

31. J.H. Breasted, *Development of Religion and Thought in Ancient Egypt*. New York: Scribners, 1912, lecture 8. See also M. Jastrow, *Die Religion Babyloniens und Assyrien*. Giessen: A. Töpelmann, 1905–12. vol. 2, pp. 106, 117.

32. Perry, *Lord of the Four Quarters.*

33. J. W. Perry, "Image, Complex and Transference in Schizophrenia," in *Psychotherapy of the Psychoses,* edited by Arthur Burton. New York: Basic Books, 1961.

34. J. W. Perry, *The Self in Psychotic Process.* Berkeley: University of California Press, 1953.

35. J. W. Perry, "Acute Catatonic Schizophrenia," *Journal of Analytical Psychology* 2, no. 2 (1957).

36. Perry, "Reconstitutive Process in the Psychopathology of the Self."

THE RITUAL DRAMA OF RENEWAL

Our modern outlook, grown out of touch with the images and processes of the inner psychic life, leads us to expect that the great myths of antiquity consist of timeless stories gleaned from an archaic imagination. The new wave of interest in the mythologies of various cultures and historical epochs brings into our hands reproductions of the great tales of gods and heroes and of the artwork that illustrates them. We read many psychological "interpretations" of them which treat them like dreams but which are apt to overlook what good dream analysis is not permitted to omit: the life context. A dream is a symbolic comment on an individual's emotional involvement at the moment, and a myth serves the same function for a collectivity of persons; that is, a culture in a moment of its history. Myth's twin component, which usually remains obscure in all these renderings, is the ritual which it originally accompanied.

At the end of the last century scholars began to observe not only that myth and ritual belong together, but also that the evidence seemed to show that ritual was more primary and more enduring through the changes wrought by history.[1] Especially in the studies of the archaic Greek forms, the two were found to be the "expression of collective emotion," the "things done" and the "things spoken" being amalgamated into ritual drama with action and script.[2] The later drama of the stage derived from these.

The imposing New Year festivals were ritual dramas of renewal that were considered essential to the vitality of the kingdom.[3] They were therefore attended by the entire corporate body of the community,

which even participated in the ritual action. The proper accomplishment of the drama was deemed necessary to the proper functioning of the society and of nature, sustaining the power of the sacral king both to give life and fertility to all living things, and to give order and justice to the social body.

In the psychotic form of the renewal process, observations indicate that the same relation of image to action holds true. The absorbing myth-styled preoccupations are said to belong to a dramatic form, to a ritual, or to a script already written. In my studies, one man believed that things were going on that looked like the acting of a play, with movie actors from Hollywood. A young woman had the same conviction, but specified the movie. A young woman enacted what she felt to be primitive rituals, dances, and chants, including certain ordeals and trials. Another, more engrossed in the Christian idiom, had a vision of a performance of the Nativity in a grotto, and at table experienced the gathering as an enactment of the Last Supper being broadcast on television to the entire world. The young lady described in Chapter 2 perceived the vexing "folly of the cross" as meaning that "we all have parts to play in this act," seeming to her "just a game."

In other words, persons in the psychotic episode tell us that they are participating in a ritual drama emerging spontaneously from the psychic depths. I am therefore going to present a reconstruction of such a rite from antiquity that closely parallels the renewal process under discussion. This is the New Year festival of early Israel, of the time of the kingdom founded by David in Jerusalem. I pick this because Israel's "royal psalms" lie at the source of the mainstream of our Judeo-Christian heritage, and more particularly because they present a deeply poetic rendering of the experience of the renewal process. They may therefore be read for their profoundly emotional quality and not merely for the intellectual stimulation derived from the knowledge of them.

The royal psalms are ones found by scholars to date back to preexilic times — that is, to the kingdom and the kingly ceremonial of the centuries before the exile into Babylonia. They reveal the characteristics of ritual texts, which then were in all probability used in the ritual dramas of the New Year festival in the so-called Jerusalem Cultus.[4] They give a glimpse of the roots of our religious tradition and our psychic makeup.

The Israelites arrived in Canaan as a desert nomad people, becoming urbanized only very gradually after poaching on the ruins of the destroyed cities of that land for a couple of centuries. [5] With the new city culture, they adopted also the sacral kingship in the manner of the entire Near East of that time. David himself was the heroic innovator, visionary, and founder of a cult based upon what he took over in Jerusalem from its previous masters. [6] Canaanite forms were readapted to the new context of Israel's faith in Yahweh. The New Year festival was akin to others of the Near East in renewing the king and the kingdom, the year and the creation. Its practice degenerated in a few centuries and was apparently put to a stop by the captivity. Yet its ideology continued to evolve first into the image of the Messiah in the prophets and then into the figure of Christ the King in the gospels. [7] The Psalms then became a book of devotions.

The enthronement festival served to reestablish Israel's kingship and hence its covenant with its God — that is, its contract of homage and fidelity to its overlord. For Yahweh was "Israel's real king," and the Davidic king only his delegate. The latter was regarded as having divine attributes as an *elohim* — that is, as a lesser divinity or angel, or as an extension of the divine personality of Yahweh, in the role of his representative and "son by adoption." [8] The enthronement rite transformed him into a more than human state, sacrosanct and inviolate. [9]

One should visualize an enthusiastic, crowded gathering of the entire populace, prepared not only to watch and listen to the colorful events, but also to enter into them in lamentations and jubilations, in walking and dancing in triumphal procession, and in worshipping. It took place at the time of the autumnal full moon (Sukkoth, the Feast of Tabernacles, or of Booths). The drama was enacted in the royal temple, as a "ritual performance or acted 'picture'"; as the Psalm puts it,

We have pictured Thy devotion in the midst of Thy Temple. [10]

This setting was the visible representation of Yahweh's Holy Mount. The protagonist was the priest-king, whose actions depicted the experience of the nation and of its king-god. In relating the progress of the fes-

tival, I will enumerate the elements of the renewal process in the same order as outlined in the foregoing chapters.

A. The locus of the rite of Yahweh's enthronement represented his Holy Mount of Zion or Zaphon.

> The joy of all the earth
> Mount Zion, the heights of Zaphon,
> The city of the mighty King![11]

This had been the Canaanite sacred mountain in the previous millennium, establishing a cosmic axis and world center, whose zenith was the sky and whose nadir was the abyss of the cosmic waters:[12]

> For He hath looked down
> From the height of His sanctuary;
> From Heaven did the Lord behold the earth . . .[13]

The cosmic waters of the abyss were thought to emerge through a stream below the temple:

> As for "The River," its streams make glad the city of God,
> The most sacred abode of the Most High.[14]

B. Here there took place a ritual humiliation of the king at the hands of his enemies (to be described under heading D):[15]

> Yet thou hast spurned and rejected,
> Thou hast been wroth with Thy Messiah
> Thou hast made glad all his enemies
> Thou hast made an end of his splendor
> And Thou hast hurled his throne to the ground . . .[16]

He was forsaken by his father in heaven, his covenant with him abandoned, and he was allowed to sink into the waters of death, the abyss:

> Death's breakers engulfed me,
> And the evil torrents o'erwhelmed me . . .[17]

The theme is reflected in a Psalm of a later century:

> Deep calleth unto deep at the noise of Thy waterspouts:
> all Thy waves and Thy billows are gone over me.
> I will say unto God my rock, Why hast Thou forgotten me?
> why go I mourning because of the oppression of my enemy? [18]

C. Time became now the mythical time of the beginning of creation and of Yahweh's heroic fight with the dragon of the waters of chaos, equated with the enemy and with death. The seven days of the festival were the same as the seven days of creation, whose events were retold in the liturgy: [19]

> It is Thou who dost rule over the swell of the sea . . .
> It was Thou who didst crush Rahab like a corpse,
> Scattering Thine enemies with Thy mighty arm. [20]

The following is taken from a royal psalm thought by some to be an actual text of the creation rite, in which the world was created by containing the flood waters: The Lord is very great,

> . . . who stretchest out the heavens like a curtain:
> Who layeth the beams of his chambers in the waters:
> who maketh the clouds his chariot:
> Who laid the foundations of the earth,
> that it should not be removed for ever.
> Thou coveredst it with the deep as with a garment:
> the waters stood above the mountains.
> Thou hast made a bound that they may not pass over,
> that they turn not again to cover the earth . . . [21]

Some find reference to Eden and the Primordial Man, Adam, as First Ancestor and First King, the Gardener of God or Keeper of the Garden of the Mountain of God, associated with the figure of the king in this context. [22]

 D. A sacred combat or cosmic conflict was enacted in some symbolic fashion, with the king as Yahweh's suffering servant in opposition to Yahweh's enemy. This formidable antagonist was a composite image of darkness and chaos, of the waters of the abyss and death; these were then embodied in the Kings of the Nations, the foreign Goyim who dwelt in the outside wastes and who represented on the earthly plane the rebellious and unrighteous lesser gods of the divine assembly over which Yahweh presided.[23] The sacral king succumbed temporarily, and there were lamentations on the part of the attending populace:

> Yahweh taketh His stand in the divine assembly;
> Amidst the gods he pronounceth judgment.
> "How long will ye deal unjustly,
> And show partiality towards the wicked? . . .
> "I admit that ye are gods,
> And all of you are sons of the Most High.
> Nevertheless ye shall die like men,
> And fall like any ordinary prince."
> Arise O Yahweh! Judge of the earth!
> For Thou shalt take possession of all the nations.[24]

Yahweh was portrayed as a mighty warrior god leading his hosts in the ritual combat, and saving them from the enemy, "Death":

> The chariots of God are thousands upon thousands;
> The Lord is amid them, the God of Sinai is in the sanctuary!
> Thou hast ascended on high, leading Thy captives; . . .
> God is for us a God who saveth,
> And through Yahweh, the Lord, "Death" is expelled.[25]

 E. For a while death and chaos had the upper hand, the normal order of things was suspended, and the covenant with Yahweh seemed to be abandoned. The king was humiliated as his enemy mocked him and lifted up his heel against him:[26]

> Thou hast repudiated the covenant with Thy Servant;
> Thou hast brought his crown to pollution in the dust . . .

All the passers by have despoiled him;
He has become a mockery to his neighbors . . .[27]

F. Now, at dawn, Yahweh manifested himself as savior, and the cry went up, "Wake!" and "Yahweh lives!"[28] He lifted the king from the abyss and from death. The epiphany of the victorious god was extolled in ecstatic verse:

The earth heaved and quaked,
While the foundation of the mountains quivered . . .
Smoke rose from His Nostril,
While fire leapt devouring from His mouth . . .
He parted the heavens, and descended,
With a cloud beneath his feet . . .
Then the channels of the sea could be seen,
And the foundations of the world were laid bare
At Thy rebuke, O Yahweh, . . .
He reached from on high, He took me,
He drew me out of the many waters.
He delivered me from my powerful enemy . . .[29]

With the rising of the sun a triumphal procession formed at "Israel's Spring," where perhaps the cosmic waters issued forth and where the king underwent a ceremonial contact with them.[30] The joyful columns bearing the Ark of the Covenant, representing the assurance of God's presence and blessing, proceeded with music and dancing, carrying festal boughs. The dance was led by the king in an ecstatic state, and passed around the temple on the Holy Mount.[31] Yahweh was enthroned as Victor, in splendor over the nether waters to control them, and seated overseeing the world from Zaphon's heights:

Yahweh is enthroned over the flood;
Yahweh is enthroned as King for ever.[32]

The king on his part was similarly enthroned and anointed, investitured and appointed priest forever, and promised universal rule over all the kings and nations of the earth for all time:

> Thou dost make me head of the nations;
> People serve me that I have not known . . .[33]

He was to rule as "son by adoption" of his heavenly father:

> I have found David, My Servant;
> With my holy oil I have anointed him . . .
> He shall cry unto Me, "Thou art my Father,
> My God and the Rock that is my salvation."
> I on My part will make him My firstborn,
> The highest of earthly kings.[34]

The universal rule is the reflection of God's supreme kingship over the lesser deities of the foreign kingdoms:

> For who . . . is like Yahweh among the gods?
> A God who is awesome in the council of the holy ones,
> He is great and terrible above all who are about Him.
> For it is Yahweh who is really our shield;
> It is the Holy One of Israel who is really our King.[35]

G. Very possibly a Sacred Marriage was performed,[36] in association with the festal booths of greenery and the ritual production of the fertilizing rains, as in other such rites of the Near East.[37] Any suggestion of the female consort of God the King, though, was expurgated in monotheistic reforms.[38]

H. However, a mother goddess was indeed in the process, for the king was delivered from death into a new birth, born of the womb of the Dawn Goddess and conceived by the God's dew (both derived from the Canaanite pantheon).[39]

> I am not to die but live,
> And relate the deeds of Yah.
> Yah hath chastened me sore,
> But He hath not given me over to "Death" . . .[40]

Two enthronement oracles are of unquestionable antiquity and function as ritual texts.[41] They tell that the king was transformed into a new

creature, begotten of his father in heaven as his firstborn with universal sovereignty:

> Yahweh doth extend thy powerful scepter;
> Rule from Zion amidst the foes!
> Thou hast the homage of thy people on the day of thy birth
> In sacred splendor from the womb of Dawn.
> Thou hast the dew wherewith I have begotten thee; . . .
> The Lord hath smitten away at the right hand,
> Judging kings in the day of His anger . . . [42]

The other oracle, after an account of the victory over the enemy, tells of the birth into universal dominion:

> Let me tell of Yahweh's decree!
> He hath said to me, "Thou art My son;
> This day have I begotten thee.
> Ask of Me, and I will make
> The nations thine inheritance,
> The ends of the earth thy possession." [43]

I. A reign was then promised full of righteousness, justice, and peace, with life-givingness in abundance and fertile rains. These were the attributes of the divine kingship:

> Righteousness and justice are the foundation of Thy throne;
> Devotion and fidelity are present before Thee. [44]

Also they were the primary concerns of the sacral king:

> O God, give Thy justice to the King,
> And Thy righteousness to the king's son;
> Through righteousness let the mountains and the hills
> Bring well-being to the people . . .
> May he descend like rain upon the crop,
> Like showers that water the earth . . . [45]

The covenant with Yahweh was reaffirmed.

J. At his enthronement the king was given affiliations with the First Ancestral King, Adam, the Primordial Man, and his idyllic reign given associations with the Paradise of Eden. This Keeper of the Garden of God was enthroned on the World Mountain, a world center with its four gates in the cardinal directions and its four rivers flowing from its midst into the world quarters.[46]

The historical parallels to the psychic renewal process do not merely present us with a cluster of tepid symbols. The myth and ritual forms consisted rather of the earnest actions of men to keep their societies vital and their productiveness vigorous, and thus they were concerned with the handling of government, ethics, and the moral order, and with the spreading of cultures by conquest. These archetypal affect-images mobilized, governed, and directed the emotional energies of the people through their expression in dramatic form. As history moved on, however, the imagery changed and the role of the sacral king evolved into that of a particular kind of hero and savior.

1. W. R. Smith, *The Religion of the Semites.* London: Black, 1901, and New York: Meridian Books, 1956, p. 18ff.

2. J. Harrison, *Themis.* Cambridge: Cambridge University Press, 1927, chap. 2.

3 T. H. Gaster, *Thespis; Ritual, Myth, and Drama in the Near East.* Garden City: Doubleday Anchor Books, 1961.

4. A. Bentzen, *King and Messiah.* London: Lutterworth, 1955, pp. 19–21; E. O. James, *Seasonal Feasts and Festivals.* New York: Barnes & Noble, 1961; E. O. James. *Myth and Ritual in the Ancient Near East.* New York: Praeger, 1958; A. R. Johnson, "The Role of the King in the Jerusalem Cultus," in *The Labyrinth,* ed. S. H. Hooke. New York: Macmillan, 1935.

5. W. F. Albright, *The Archaeology of Palestine.* Baltimore: Penguin, 1960, p. 183, and *The Biblical Period from Abraham to Ezra.* New York: Harper Torchbooks, 1965, chap. 3.

6. Bentzen, *King and Messiah,* pp. 58 and 65.

7. S. Mowinckel, *He That Cometh,* translated by G. W. Anderson. New York: Abingdon, 1954; A. Bentzen, *King and Messiah.*

8. Bentzen, *King and Messiah,* p. 19; James, *Myth and Ritual in the Ancient Near East,* p. 99ff.

9. A. R. Johnson, *Sacral Kingship in Ancient Israel.* Cardiff: University of Wales, 1955, chap. 1.

10. Ibid., pp. 77–81, quoting Psalm 48.

11. Psalm 48:2, translated by A. R. Johnson in *Sacral Kingship in Ancient Israel.* Unless otherwise noted, all translations of the psalms are taken from this source.

12 Gaster, *Thespis,* p. 188; E. Burrows, "Some Cosmological Patterns in Babylonian Religion," in *The Labyrinth,* edited by S. H. Hooke. New York: Mac-millan, 1935.

13. Psalm 102:19.

14. Psalm 46:4.

15. Johnson, *Sacral Kingship in Ancient Israel,* p. 81ff.; H. Birkeland, *The Evildoers in the Book of Psalms.* Oslo: Avhandlinger utgitt av Det Norske Videnskapsii, Akademi j Oslo, II, 1955.

16. Psalm 89:38, 44.

17. Psalm 18:4.

18. Psalm 42:7, 9, in *The Dartmouth Bible,* edited by R. B. Chamberlin et al. Boston: Houghton Muffin, 1961.

19. G. Widengren, "Early Hebrew Myths and their Interpretation," in *Myth, Ritual, and Kingship,* ed. S. H. Hooke. Oxford: Clarendon, 1958, p. 175.

20. Psalm 89: 9, 10.

21. Psalm 104: 2, 3, 5, 6, 9, in *The Dartmouth Bible.*

22. Widengren, "Early Hebrew Myths and their Interpretation."

23. Birkeland, *The Evildoers in the Book of Psalms;* Johnson, *Sacral Kingship in Ancient Israel,* chap. 4.

24. Psalm 82:1–2, 6–8.

25. Psalm 68:17–18, 20.

26. Johnson, *Sacral Kingship in Ancient Israel,* pp. 102–3, quoting Psalm 89.

27. Psalm 89:39, 41, 50.

28. Widengren, "Early Hebrew Myths and their Interpretation," p. 191, quoting Psalm 47; Bentzen, *King and Messiah,* p. 26.

29. Psalm 18:79, 15–17.

30. Johnson, *Sacral Kingship in Ancient Israel*, p. 110.

31. Psalm 118:24–27, Psalm 68:24–26.

32. Psalm 29:10.

33. Psalm 18:43, 49–50.

34. Psalm 89:20, 26–27.

35. Psalm 89:67, 18.

36. Psalm 45:12, 5–11, 13, 14–17.

37. Widengren, "Early Hebrew Myths and their Interpretation," pp. 178–83.

38. James, *Myth and Ritual in the Ancient Near East*, pp. 125–128; E.O. James, *The Cult of the Mother Goddess*. New York: Barnes and Noble, 1959, p. 79ff.; Mowinckel, *He That Cometh*, pp. 62, 75, and 103.

39. Mowinckel, *He That Cometh*, pp. 75, 103.

40. Psalm 118:17–18.

41. Bentzen, *King and Messiah*, pp. 20–24; Mowinckel, *He That Cometh*, pp. 64ff.

42. Psalm 110:2–3, 5.

43. Psalm 2:7–8.

44. Psalm 89:14.

45. Psalm 72:12, 6.

48. Widengren, "Early Hebrew Myths and their Interpretation," pp. 165ff.; Bentzen, *King and Messiah*, pp. 44–46.

THE MESSIANIC HERO

Persons undergoing an acute schizophrenic episode express ideas not only of supreme rule of some sort, but notably also of an urgent belief in their messianic calling. They find themselves in their delusional ideation set up as chief of their party or their nation or as the head of their religion, and as the inflation grows it extends to the grandiose notion of being emperor of the world or king of the universe. Yet the equally powerful companion notion — of changing the culture, and of saving the world — introduces a special note that needs further consideration.

It is easy enough to pass these psychotic notions off with the obvious comment that when these people feel weak and insignificant they have wishful fantasies of being top dog in the universe, or that when they have felt abused in the course of an unhappy and isolated existence, they feel the urge to reestablish justice and love in the world. All this is, no doubt, perfectly appropriate as an interpretation, as far as it goes, but it leaves out of account any consideration of the nature of the cultural forms of messianic ideation. It is a notable fact of history that the messianic theme of world reform and salvation arose at a certain typical juncture in various parts of the world, out of the ideology of the sacral kingship, apparently as part of its natural evolution.

FORMULATIONS OF THE ROLE OF THE HERO IMAGE

It behooves us, then, not to dismiss the theme of the messianic hero too lightly as wishful fantasy, but to look more deeply into its historical antecedents. The predominance of these ideas of ruling and of reforming the world was quite different from what I had expected to find when I

was first embarking on these studies of the schizophrenic process. I had vaguely anticipated encountering some heroic motifs along the lines of Jung's formulations in *Symbols of Transformation,* his first masterpiece on comparative symbolism, in which his emphasis was upon the regression of the libido and the consequent activation of the primordial image of the hero.[1]

Jung's thesis in this discussion was that the profound regression of psychosis leads back, not only to the infantile levels of the unconscious, but at the same time to the archaic. Thus, while the incest problem and the longing for the mother are stirred up, they represent a drive not seeking a physical possession of the personal mother so much as a psychic regeneration through the symbolic mother — that is, rebirth. Incest itself is a danger that is avoided by the work of symbol-formation, in order to release the forces bound up in the incestuous, backward-lagging ties. For this task of liberation, there becomes activated the age-old image of the hero, whose chief attributes are solar, in that characteristically he follows the pattern of the sun that dies in the west and undergoes a "night sea journey" to his rebirth in the eastern skies. He represents both the longing for the mother and also the struggle for regeneration through her, and his typical task is to face and to overcome the threat of the devouring aspect of the "terrible mother," symbolized in a dragon or other monster; in so doing, he wrests from it the "treasure-hard-to-attain." This is interpreted as the fight against the backward-longing fixation to old ties and the accompanying indolence that would lead to avoidance of life's tasks, and in the struggle, achieving the symbol of self-renewal and selfhood. The entire sequence amounts to a self-procreation and world-creation through a process of introversion, for the discovery of the world is achieved through an emanation of the libido by the sacrifice of the mother bond, thus freed for its devotion to life.

Joseph Campbell, in his early work on the theme of the heroic journey, *The Hero with a Thousand Faces,* drew illustrations from various mythologies to typify the stages of the whole process.[2] After the "call to adventure," the threshold of entry into the journey is marked by several characteristic episodes: a battle between brothers as opposites, or a battle with a dragon; a dismemberment or crucifixion, or possibly an abduc-

tion; a movement into a night sea journey, a wonder journey, or a trip in a whale's belly. There are tests and also helpers to aid the hero's progress. The heart of the venture is in a sacred marriage, an atonement with the father, an apotheosis of the hero himself, and a theft of the elixir or treasure. There is a flight from that other world, and a return over the threshold to the mundane world, possibly in the form of a resurrection or of a rescue, often accompanied by a threshold struggle. Finally, there is some application of the elixir or treasure to the questions of the mundane world. Campbell, in his later four-volume work, *The Masks of God,* took a new and deeply penetrating look at myths of various kinds, including those of the hero in the context of their historical settings. [3]

Lord Raglan (one-time head of the British anthropological society) wrote a very complete account of the hero in the setting of the myth and ritual background. [4] He found twenty-two typical elements in the myths from various parts of the ancient world, Greece, Israel, Africa, the Norse and Brythonic Lands, and Southeast Asia. These are the elements he found: The hero's mother is a royal virgin and his father a king, often the mother's near relative. The circumstances of his conception are unusual; often he is the son of a god. At birth there is an attempt by the father (or the matrilineal grandfather) to kill him, and he is spirited away and reared by foster parents. Nothing is related of his childhood. On achieving manhood he goes to his future kingdom, where he is victorious over the king, or over a giant, dragon, or beast. He marries the princess of the realm, often the daughter of his predecessor, and becomes king. He reigns uneventfully for a time and prescribes laws. In time, however, he loses favor with the gods or with men and is driven from the throne and from the city. He meets with a mysterious death, which is often at the top of a hill. His children do not succeed him, and his body is not buried, though he has one or more holy sepulchres.

This account is useful to the theme we are following, in that it relates the hero's life to the myth and ritual of kingship. Raglan observed that the narrative episodes represent only those features of the royal hero's life that appear in ritual.

THE HERO IMAGE IN THE SCHIZOPHRENIC EPISODE

In reviewing the material of my patients with a special eye to the occur-rences of the heroic theme as distinct from that of the kingship as such, I have found that in schizophrenia there is most often a special range of the hero image that happens quite regularly to be messianic: of saving the world, changing society, or reforming the nations. I must confess that I found it at first a little distasteful to explore, and that I had some revul-sion toward these grandiose claims. It was easy to regard them as a kind of parody of the adolescent fantasies accompanying the idealistic urge to reform the human race.

What turned my own impatience into a more comfortable under-standing was reminding myself that these images need transliterating in the usual way; for the statement, "I'm called by a special election to save the world," one reads instead, "There's an image appearing in my inner psychic world representing a redeemer, a messianic hero." Then one can see the idea in a quite different perspective, for this messianic figure has a very valid function in the psychic process and also has a long and rich history in its historical development.

Such an understanding of the idea involves one of the prime char-acteristics of schizophrenia, which needs to be born in mind constantly. What makes a psychotic idea sound "crazy" is that each element in the unconscious is taken perfectly concretely and in externalized form; that is, the psychotic ego identifies with each archetypal image or process as soon as it is activated in the unconscious. But as soon as we translate these images and processes into inner experience, there is nothing espe-cially crazy about them — they are just like dreams, essentially. We may translate for "world," the "inner world"; for "war," the inner "conflict of opposites"; and now for "messianic calling" we may say "the inner hero image which has a special mission in the psyche to bring transformation of one's inner world"; and for "new society" we may say "the inner sub-jective culture that stands in need of change; that is, one's structure of values and meanings, outlook and design of life."

As an inner factor of such a kind, the reforming hero represents one's motivation to participate meaningfully and effectively in the great societal issues of the times. As one is activated and takes the lead in the

psychic drama, one finds one's social orientation becoming involved in the integrative process. The part one actually takes in the social setting depends entirely upon the real gifts one happens to possess. The redeeming hero as an image describes not the specific part one is to play in life, but the potential and the motivation to fulfill it. The hero image portrays the affect and its meaning, like all other archetypal affect-images, as I prefer to call them.[5]

To put such ideation in its proper place requires a clear understanding of the principle of inflation. For example, many artists' secret ambition might be to become another Leonardo, or — these days, more aptly — another Picasso; in my field, one often hears of secret ambitions of becoming another Freud or Jung. This may all be perfectly justifiable if the notion is taken as an image, that is, as a sort of portrait of one's potential. Yet, on the other hand, if one identifies directly with the image and takes it naïvely as a statement of what one actually is, that is inflation. One becomes puffed up with a feeling of too much bigness. It represents a short circuit; there is a bright flash and glow where there ought to be a quiet flow of current to do actual work. The image should be taken as a source of energy, not a description of one's ego; as it is put to work, the energy is channeled into life. Inflation, however, stops the flow by arrogating this energy to the ego itself, or better said, to its self-image.

Therefore, as with all such imagery, the best way to gain an understanding of its import is to take it seriously enough to make a study of its phenomenology, its occurrence in the experience of persons and in the comparative material in history and culture.

MESSIANISM IN PSYCHOTIC AND HISTORICAL INDIVIDUALS

An example of the messianic role is that of a young woman [6] who entered the hospital with the conviction that she had died and that she was in an afterlife state, along with many others on the ward. The theme of crucifixion prevailed in her talk and her art work. She felt herself involved in the world conflict between communism and democracy. She felt herself to be Eve in the Garden of Eden at the beginning of time, but also believed that she was divine and had a hand in the creation:

"I thought I created the moon, and had the feeling I had the power to do this. I had the feeling of being the whole universe, and of making the peoples and the worlds — that's why they're so crowded with people — and making new stars in heaven, especially the moon . . . I knew I was divine — no doubt about it — I was Mother Earth, the source of all life, and everything grew out of me."

Thus she believed herself to be a divine creatrix and also the First Woman, but she also had the conviction that her special mission in life was to "rewrite the Bible," with a new message of love.

In the sixth week she launched into a full account of her messianic mission. She said she knew it was her duty to grow things in the earth, to plant and to sow and to reap. Working herself up into a high rage, she shouted that people should give up the evils of using metals and of working in cities. They should stop digging down into the inside of the earth to draw metals out of it; that's digging down into Mother Earth and taking things out that shouldn't be taken. All these machines and industries and cars are wrong — it should all be left in the earth, and we should be growing things on the surface of the earth, in the soil. In another interview she enthusiastically told me that she had discovered what her "beast" was, the one she had drawn in a painting a few days before, standing by the cross. She read out of her Bible a passage in the Book of Revelation: "The Beast opened the book," and there follows the account of the new heaven and new earth, and of the holy city, the New Jerusalem, the City of Peace. It would be a city without evil, with only light. She knew San Francisco to be this New Jerusalem, the City of Peace. The hospital was at the very center of this city, and was her palace, all of gold; it was where the healing takes place, which in the book is called the tree of life, with its leaves for the healing of the nations.

This was to be a four-square city, with jewels in the walls and gates. In it, the people would rule themselves in a spontaneous righteousness. All would be given to family life, living only in their homes and not having to go to work. Factories and public buildings would be given over to living quarters, and there would be no industries, or use of steel and other metals.

Now, this whole picture, set forth in her delusional fantasies under considerable pressure of emotional excitement, was not one of a wish for

power, despite the bigness of her role. Rather, it was made almost purely of Eros concerns — of family life, self-rule in a spontaneous good will, and closeness to the earth — values of generating life and nourishment. Its personal application had to do with her rebellion against her scientific profession, and especially against her mother's image of her as the working man in the family, an irritating masculinization of her that she was throwing over with a violent exasperation. She no longer wanted to play husband to her mother, but to marry and raise a family and live close to the land. That was the personal context of her imagery, and it did indeed have a most important urgency at that particular turning point in her life. However, the significance of the imagery went further.

One might think her tirade against the evils of metals to be a fairly confused and crazy notion emanating from her resentment of personal circumstances. So it was, in part. Yet, when we turn to some historical parallels, especially some scripture from our Judeo-Christian heritage, we find it to be in line with a whole development of messianic thinking of the first century B.C. A somewhat obscure apocryphal text called the "Ethiopic" Book of Enoch has in its later chapters a text called the "Book of Parables," or "Messianic Book." [7]

It says that the name of the Messiah was named from before the beginning of time: "Before the sun and the planets were created, before the stars in the heavens were made, his name was named before the God of Spirits. "In the blessed Days of the Messiah, "Wisdom" will be "as the waters [that] cover the sea." "Drastic changes will then take place in *nature:* the light of [the seven] days [of Creation] will shine upon the holy and elect ones Then, the earth will bring to life the shades, and Sheol will give back those it held"; that is, the dead will return from the underworld, so that "the distinction between heaven and earth, between angels and men, disappears . . . For the Messiah will sit upon his throne (i.e., upon the throne of God) and will reveal all the secrets of wisdom, and "dwell in the midst of the righteous as one of them." The war against the enemy is essential to the setting up of the new reign: "After the kings and tyrants are destroyed, the Righteous and Elect One [the Messiah] will cause to appear 'the house of the congregation' . . . " The war is essentially against the devil, for "The Messiah will judge Azazel and all

his host. For theare the ones who enticed men to make life beautiful and luxurious, and by this means to turn aside from following the Torah and to corrupt morals." Then the way will be clear for the new era of the Righteous.

> All of them shine like the brightness of the firmament, their appearance is like lambent fire, and their mouths are full of song and praise of the God of Spirits. Iron and copper, gold and silver, tin and lead, will melt like wax before the Messiah. There will be no need of all these things which civilization uses for moral corruption . . . There shall be no iron for war, and no material for a coat of mail; metal shall be of no value, tin shall be of no service or esteem and lead shall not be desired. All these things shall perish and be destroyed from the face of the earth, when the Elect One [Messiah] shall appear before the face of the God of Spirits.

Item by item, this person's psyche appears to be spelling out the imagery of the messianic theme just as it had been two thousand years ago.

One is reminded also, in this person's ideation about her crucifixion and her vision of a new society, of the last chapters in the Chinese *Tao-Teh-Ching,* Lao-tse's famous classic.[8] He quotes from a much older "Book of the Yellow Emperor"[9] a verse that bears directly on the role of the sacral king:

> Therefore the sage says:
> "Who receives unto himself the calumny of the world
> Is the preserver of the state.
> Who bears himself the sins of the world Is the king of the world."
> Straight words seem crooked.

Then he gives a little glimpse of the ideal society as he would see it:[10]

> Let there be a small country and a small people,
> Where the supply of goods are tenfold and a hundredfold
> More than they can use.
> Let the people value their lives and not migrate far;
> Though there be boats and carriages,

None there be to ride them.
Though there be armor and weapons,
No occasion to display them.

It thus becomes clear that what might look like a mere quirk of the individual patient, an idiosyncratic notion amid the flood of "bizarre associations and productions," turns out after all to have the sanction of a long and venerable tradition. This indicates the difference between a personal and a collective mental content; that is, between an image derived from the personal circumstances and figures of the person's own life, and one from the general archaic heritage of images expressing the universal emotional experiences of mankind. There are many kinds of evidence for the prevalence of this theme of the reformed society and its messianic agencies, not the least of which is the fact that persons in this schizophrenic process sound much like one another. Another is the evidence of history, not only that of a couple of millennia ago, but also that of today and the cultural movements that are being stirred up in the present psychic setting.

It is striking how closely parallel to the young lady's ideation are the writings of the ballet dancer Nijinski, the "god of the dance," during his psychotic episode.[11] He says of World War I, which was going on at that time:

> I love the Germans . . . I am a man. I do not belong to any party. I understand the love of mankind. I want people to love each other. I do not want horrors. I want paradise on earth. I am God in man. Everybody will be like God if they do as I say.

Then he goes on into a diatribe against science and commerce:

> I know what starts wars — they are started by commerce; it is a dreadful thing. It is the death of mankind . . . people who are engaged in commerce seldom feel God — and God does not love them . . . I want everybody to love, and to live . . . I would like all factories to be destroyed because they spoil the earth. I love the earth and want to protect it . . . I know that Mars is uninhabited

because it is a frozen body. Mars was like the earth, but that was a billion years ago. The earth will also be like Mars but in a few hundred years hence. The earth is suffocating, therefore I am asking everybody to abandon factories and listen to me. I know that this is necessary for the salvation of the earth . . . I am the Savior. I am Nijinski and not Christ. I love Christ, because he was like me . . . I want to save the entire earth from suffocation. All the scientists must leave their books and come to me, and I will help everyone because I know so much. I am a man in God. I am not afraid of Death. I beg people not to be afraid of me . . . I must not be killed because I love everyone equally.

Of the twelve cases of this syndrome that I have studied in depth,[12] three of the four men and six of the eight women experienced frankly religious messianic callings; the others, a man and two women, had ideas that were closely akin to the religious but were framing, more in political terms, the salvation of the nation or the world. It was a tendency of the men to feel themselves called to the messianic role and to undergo a rebirth process on the way toward qualifying for it. Among the women there was a different, double calling: one, to their own messianic function, and the other to the role of the New Virgin Mother giving birth to the male Divine Child who would be the new world savior.[13]

A brief review of these fantasies of things to come shows them falling into three groupings:

A. One envisioned a frankly Neolithic style of society of matriarchal and nonurban character centered on family and farm life.

B. Three kept to a political idiom of king and code with a just rule and a renewed sense of law, order, and effective government.

C. Eight had visions of moving on to a new order marked by brotherhood, peace, and spontaneous virtue.

In most of the instances the patient identified with the motif mentioned; for example, "I am elected to be the new Virgin Mother to give birth to the Savior." In some instances, especially in the case of males, they did not identify but were intimately occupied with the motif; for

example, "I am chief defender of the Virgin Mother who is to give birth to the Savior," often with the implication that he is the father. Again in a few, the motif occurred without the patient's direct identification.

The delusional themes are so repetitive from case to case as to make it a burden to write and even more to read. Therefore I am doing the more schematic work of itemizing the themes and indicating, in the following table, which ones each patient dwelt upon.

It sometimes happens that gifted persons come through a schizophrenic episode with profoundly significant insights or powerful new codes of mores for their culture, and through their messianic calling actually become prophets and leaders of social reform. Anthony Wallace has made a valuable study of two such prophets, to exemplify the capacity of certain types of personalities to undergo psychotic confusional states and resynthesize new relations between their internal psychic organization and their cultural context.[14]

A century ago, the T'ai-P'ing Rebellion was a religiously inspired movement in China that came very near to overthrowing the Manchu dynasty; though it was Christian in its ideology, the Western powers put a stop to it. Its leader was Hung Hsiu-Ch'uan, a visionary prophet and social reformer whose election to his vocation was revealed during a schizophrenic episode.

His experience followed his failure in the imperial examinations at the age of twenty-four: He became deeply grieved and morose. He had a dream which he believed to signify his imminent death, and upon loss of consciousness while talking with his family was taken to be dead. He had visions for about forty days. In one, an old woman washed him and took him to some old men who cut out his heart and other organs and replaced them with new red ones. He was elected by an old man to exterminate demons and recall the people of the world to their duty to him, and was shown the depravity of the world.

After his six weeks of psychotic visions, hallucinations, and hyperactive behavior, Hung Hsiu-Ch'uan emerged a changed man, mature, heavier and more imposing, heartier. After reading some Christian religious tracts at age thirty (six years after his first experience), things fell into place, and he embarked on his program to reform the world.

	Election to supreme rule		Election as savior		Supremacy of the Goddess
	Divine	Royal	Political	Spiritual	
1.	•				
2.	•	•	•	•	
3.	•		•	•	•
4.	•	•		•	•
5.	•			•	
6.		•			
7.	•	•		•	
8.				•	
9.			•		
10.	•	•	•	•	•
11.				•	
12.				•	•

The Bible and his own revelations became law in his new movement of reform; he was regarded as the younger brother of Jesus and as king of the whole world. The revolution was radical, both puritanical and communistic in flavor, but collapsed after a couple of decades, and its leader committed suicide.

Wallace compares with this whole pattern of events an account of the prophet Handsome Lake among the Seneca Indians of New York State, at the end of the eighteenth century. Following the grief of a bereavement, he was bedridden for a year and continually feared death; he entered a deathlike trance in which he dreamed that an angel offered to take him along if he were willing to go. He told his brother he was about to die but would return again to life. In visions, it was revealed to him that the Great Spirit was displeased over drinking and witchcraft among

	Virgin Mother giving birth to savior	Initiation to qualify for leadership		World or national reform
		Death, Rebirth	Instructions, Tests	
1.		•		•
2.	•	•	•	•
3.		•		•
4.	•	•	•	•
5.	•	•		•
6.	•	•	•	•
7.	•	•	•	•
8.	•	•		•
9.		•		•
10.	•	•		•
11.	•	•		•
12.	•	•	•	•

the people; he was also taken on a tour of heaven, where he talked with his dead relatives and was instructed in the reforms that he was called upon to effect. For a while he carried out witch-hunts and executions, but in time softened. His teachings "emphasized sobriety, pacifism, adherence to public rituals . . . and a code of simple moral virtues (honesty, kindness, chastity, generosity)." These were inspired by Quakers, and were collected into the code of a cult.

THE MESSIANIC HERO IN THE EVOLUTION OF CULTURES

It is highly significant that during the past two decades, in a time of considerable societal upheaval and change, an extensive literature has appeared in the journals of anthropology and ethnology concerning messianism.[15] It appears that prophets characteristically arise at criti-

cal times of cultural clash in various societies throughout the world. The necessary psychological reorientation and resynthesis of new forms, called acculturation, have their source in the extreme psychic turmoils and inner journeys of visionaries.

The key to an understanding of the comparative symbolism of the messianic hero as an affect-image is to be found in the observation that the nature of such archetypal representations changes together with history. As a culture evolves and matures psychologically, so do its leading archetypal figures. I have described elsewhere how the role of the sacral king arrived upon the scene of history in various parts of the world hand in hand with the Urban Revolution.[16] In its earliest form, the kingly myth was perfectly and concretely externalized in the city's structure and personnel, in stone, in functionaries, and in dramatic ceremonial. The moral order, values, ethics, and justice were all mediated and handled directly by the sacral king as the representative of Heaven and of the Cosmic Order; they were imposed upon the people from this source, as the personification of the world center, in gradations of authority through the realm's hierarchy.

So real was the faith of the people of that era in the potent sacrality of the kingship that in Egypt, in Mesopotamia, and in China, the burial of kings was accompanied by the sacrifice of dozens of their retinue — but this happened only in the beginning years. This holocaust was more a sign of the awesomeness of this spiritual potency than of their power to bully their subordinates, for the practice dwindled away even while the authority of the kings was growing in scope and absoluteness. This was indicative of the fate of the sacrality of the kingship in general; for its genuineness lasted only a few centuries in any one culture. That is, the earnest and wholehearted belief in its sacredness as vital, in its myth and ritual practices as necessary to the life and wellbeing of the realm, was characteristic of it only during the first flush of its newness.

It appears that archetypal forms come into cultural expression when new departures and ventures are under way, to render their meaning and to steer their dynamic energies into the new avenues. History hints that the insights of great men of visionary spirit give shape to these cultural forms, as for example Egypt's first king, Menes, who laid down the basic new for-

mulas of the royal mythology that would last several millennia.[17] Then it is not long before such forms lose their effective vitality and become stale and sterile outward shapes of habit. The living dynamism that had been there at the start passes over into renewed forms and modifications.

In the case of the sacral kingship, as its political aspect became increasingly secular, its claim to its divine implications became empty and hardly more than an expression of grandiosity. Meanwhile this sacred aspect became increasingly democratized. This meant that what had been so concretely externalized in outward forms now underwent a process of internalization — that is, of a realization that the qualities and attributes of kingship could now belong to men in general. The kingly image of the "unique man," the heroic vehicle of the vigor of life's potency and its renewal, and the sacred agency of the will of heaven and its gods, now became an image that expressed the potential of any soul aspiring to spiritual fulfillment. The fully accomplished individual became then the counterpart of the sacral king. In the transition, the myth and ritual statements were carried over as applicable to the ordinary man in his spiritual purposes.

The middle of the first millennium B.C., was the great era of the Revolution of Democratization[18] in many parts of the ancient world, and its creators were the uniquely endowed visionaries; that is, prophets, philosophers, and religious founders. It was in the nature of prophets to point to the advent of messiahs. The first development of democratization was in Egypt,[19] anticipating that of its Middle Eastern neighbors by a millennium and a half. There, the sense of the moral responsibility of the individual first began to develop out of the mortuary myth and ritual of Osiris, judge of the dead, as this practice passed from royal prerogative down to the commoners. At first, only the deceased king was transfigured into Osiris. As the sure faith in the absolute order of the kingship began to crumble in the final years of the Old Kingdom, the commoner began to assume his right to have an immortal soul and to "become an Osiris." A philosopher prophet arose in this time of upheaval and transition, Ipuwer, who rebuked the king and foretold the advent of a new ruler and good shepherd who would restore the pristine virtue of the realm comparable to the first golden age, to be a time without evil or violence.[20]

In the other most sophisticated civilization of the ancient world, apart from Egypt, the mid-first millennium B.C. was the turning point in which was shaped a new image in the vision of the great seers: in China, Confucius, Lao-tse and Mo-tse; in India, Gautama the Buddha; in Iran, Zarathustra; and in Israel, the prophets Jeremiah, Ezekiel, and particularly the poetic visionary, Second Isaiah. It amounted to a new dimension of kingship, marked by the quality of personal righteousness, in a two-fold sense: on the one hand, they visualized the figure of an ideal ruler over a new golden age, and on the other, a condition of mankind in which the kingly qualities and functions were seen as belonging to any accomplished man.

Thus, the Buddha made explicit his doctrine that any Enlightened One would be the full equivalent of a sacral king. He himself was a prince who had the choice, as he declared, to become either a Universal King (*Chakravartin,* "Wheel King") or an Enlightened One (*Buddha,* "Awakened One").[21]

In the teachings of the great philosophers of China in the same era, their admonitions were directed toward the governing of the inner life or of the outer kingdom, all in the same terms. Somewhat like the Buddha, they declared that a True Man (*Chen Jen*), or authentic individual, had a similar choice: between the path of the kingship as Son of Heaven, and its equivalent as a Sage, possessed of the same kinship with the Way of Heaven.[22]

The Gathas of the Iranian prophet Zarathustra envisioned a new kingdom to come,[23] effecting a renewal of the order of the world and the cosmos. A prince would arise, ushering in a kingdom of righteousness, a new golden age resembling the first one. Any man could become a savior if he found this righteousness, and the new redeemer would be a *Saoshyant*. This messianic figure made an imprint upon the messianic expectations of Israel.[24]

Only a couple of centuries after the fully developed form of the sacral kingship of David and Solomon, the early prophets of Israel began to formulate the advent of a messiah as a new David, liberating the nation from its enemies.[25] Soon it became a vision of the messianic expectation, of a golden age of the future in which God would reign over a

universal peace from the world's center in Zion. This would come when "all the people of the Lord shall be prophets." In the course of a few centuries the concept of a new moral responsibility of the individual grew into eloquent expression, along with that of a spontaneous righteousness such that the law would be written in the hearts of the people. The Messiah became less and less the strong monarch and increasingly a princely good shepherd, whose seat would be a spiritual New Jerusalem.

Christianity was heir to this entire tradition of the Davidic kingship and its transformation into the messianic expectation. Its evangelist made it clear that the mission of Jesus in this capacity was based upon the servant songs of Second Isaiah.[26] The kingdom became progressively of a spiritual order, and in the visionary writings of Paul, Christ the King had an inward existence in the souls of men, and the Law became transformed into a spontaneous impulse of grace among the elect.[27]

Now, the broad gist of these developments is the same that belongs to most categories of psychological experience. It is that whenever a new content is rising into activation from the emotional psyche, it tends to be projected out and acted upon in a most concrete manner at first. It is certainly all too obvious in the emotional life of individuals that we encounter our unconscious contents as they lie projected in the emotional field, and we put these affect-images onto the persons and objects of our environment and act upon them with blindness until we become aware of their meaning. And so it seems to be for the collective emotional life of a culture. The history of the sacral kingship shows that what had been projected into the structure of cities and into personages, functions, and ceremonies in time were realized as inner and spiritual realities. The accomplished man was recognized as possessed of a *mana* or a *numen* that was the same in kind and in degree as that which had been solely found in kings, and the inner potential for such accomplishment of soul appeared thereafter in the image of kingship and all its myth and ritual appurtenances as purely symbolic expressions in the individual psyche. Only now, it took the form specifically of the messianic kingship and its fruit, the "new society."

GENERAL OBSERVATIONS ON THE NATURE
OF THE HERO IMAGE

To turn now to some general observations about the nature of the hero image, I find that the closer one looks into its phenomenology, the more it becomes clear that it always belongs specifically to a place in the setting of its own time and its own culture. It has a life context in which it plays an essential part. For example, the heros of the Arthurian cycle embodied and exemplified the values and the way of life of the courtly culture of Europe of the twelfth and thirteenth centuries. These epics were sung and recited to courtiers, telling of "courtoisie," of "courtly love" and of knightly valor; also they were the great vehicles by which the "New Law," that is, Christianity, was exemplified and dramatized for a culture that was barely emerging out of its pre-Christian religion.[28] The great heroic epics of ancient times, like Homer's *Iliad*[29] or the Indian *Mahabharata*,[30] were similarly designed to be sung by bards to the members of the courtly entourage of kings and exemplified for them the virtues and vices that belonged to their way of life — in feats of arms, deeds of valor, in championing the king, and defeating death in symbol and in action, all with an absorption in the technology of warfare that leaves the modern reader a little outside its world. Especially revealing are the medieval epic retellings of more ancient myths and legends, such as the Iranian *Shar Nameh*, or *Book of Kings*,[31] drawn from the ancient *Zend Avesta;* or the Teutonic *Nibelungenlied*,[32] drawn from the Norse edda. These are reshapings of older themes to serve a wholly new purpose in the changed conditions of courtly culture.

The hero, then, embodies the specific values of the times, dealing with the pressing emotional issues to which the psyche needs to respond with the effective means at its disposal.[33] He personifies the image of the potential ego-consciousness that is in the making at the time, and must go through the archetypal processes of death and renewal in order to become the most fitting vehicle for this new way. When the heroic image does reach its full form, it renders its meaning in ideal terms. That which makes its appearance in such idyllic coloring as symbolic statements of meaning is then carried into life in greater or less degree, and thus becomes mundane. The ideal portrays the potential, the mundane its actualization.

1. C.G. Jung, *Collected Works,* vol. 5: *Symbols of Transformation,* Bollingen Series XX. New York: Pantheon, 1956.

2. J. Campbell, *The Hero with a Thousand Faces,* Bollingen Series XVII. New York: Pantheon, 1949.

3. J. Campbell, *The Masks of* God, vols. 1–4. New York: Viking Press, 1959–68.

4. Lord Raglan, *The Hero: A Study in Tradition, Myth, and Drama.* London: Methuen, 1936.

5. J.W. Perry, "Emotions and Object Relations," *Journal of Analytical Psychology* XV, no. 1 (1970).

6. J.W. Perry, "Image, Complex and Transference in Schizophrenia," in *Psychotherapy of the Psychoses,* edited by A. Burton. New York: Basic Books, 1961, giving a full account of this case.

7. J. Klausner, *The Messianic Idea in Israel,* translated by W. F. Stinespring, New York: Macmillan, 1955, p. 277ff.

8 Lao-tse, "The Tao-Teh-Ching," in *The Wisdom of Lao-tse,* edited by Lin Yutang. New York. Modern Library, 1948.

9. Ibid., verse 78.

10. Ibid., verse 80.

11. V. Nijinsky, *The Diary of Vaslav Nijinski,* edited by Romola Nijinsky. Berkeley: University of California Press, 1968.

12. J.W. Perry, "Reconstitutive Process in the Psychopathology of the Self," *Annals of the New York Academy of Science* 96, art. 3 (January 1962).

13. J.W. Perry, "Reflections on the Nature of the Kingship Archetype," *Journal of Analytical Psychology* XI, no. 2 (1966).

14. A.F.C. Wallace, "Stress and Rapid Personality Changes, *International Record of Medicine and General Pract. Clinics* 169, no. 12 (1956).

15. W. LaBarre, "Materials for a History of Studies of Crisis Cults: A Bibliographic Essay," *Current Anthropology* 13, no. 1 (1971).

16. J.W. Perry, *Lord of the Four Quarters.* New York: Braziller, 1966.

17. H. Frankfort, *Kingship and the Gods.* Chicago: University of Chicago Press, 1948, p. 18ff.

18. Perry, "Reflections on the Nature of the Kingship Archetype."

19. J.H. Breasted, *Development of Religion and Thought in Ancient Egypt.* New York: Scribners, 1912.

20. J. B. Pritchard, *Ancient Near Eastern Texts Relating to the Old Testament.* Princeton: Princeton University Press, 1958, p. 441ff.

21. Perry, *Lord of the Four Quarters,* part 3, chap. 1.

22. D. Bodde, "Harmony and Conflict in Chinese Philosophy," in *Studies and Thought in Chinese Philosophy,* ed. Arthur Wright. Chicago: Chicago University Press, 1953. See also the *I Ching,* translated by R. Wilhelm, Bollingen Series XIX. New York: Pantheon, 1950, pp. 7–8.

23. J. Duchesne-Guillemin, *The Hymns of Zarathustra.* Boston: Beacon Paperback, 1963.

24. D. Winston, "The Iranian Component in the Bible, Apocrypha, and Qumran: A Review of the Evidence," *History of Religions* (Winter 1966), v, no. 1, 183–216.

25. Klausner, *The Messianic Ideal in Israel,* p. 277ff.

26. A. Bentzen, *King and Messiah.* London: Lutterworth, 1955.

27. Paul, "Epistle to the Romans," in R. B. Chamberlin and H. Feldman, *The Dartmouth Bible.* Boston: Houghton Muffin, 1961, p. 1088ff.

28. R. S. Loomis, *The Grail: From Celtic Myth to Christian Symbol.* New York: Columbia University Press, 1963.

29. Homer, *The Iliad,* translated by A. T. Murray. Cambridge: Loeb Classics, 1924.

30. R. C. Dutt, *The Mahabharata,* abr. New York: Everyman, Dutton, 1955.

31. Firdausi, "The Shah Nameh," abr., *The World's Great Classics,* Oriental Literature, vol. 1. New York: Colonial Press, 1899.

32. *The Nibelungenlied,* translated by W. N. Lettsom. New York: Colonial Press, 1901.

83. J. W. Perry, "Societal Implications of the Renewal Process," *Spring* (1971).

MYSTICISM AND ITS HEROES

One of the most vital movements of our decade, which is promising to transform our culture if it continues in the current vein among the youthful members of our Western world, is the new enthusiastic exploration of the dimension of psychic depth that has been introduced through the psychedelic drugs and is now being sought in various disciplines of meditation. Twenty years ago one would never have been able to guess that there could occur so widespread a movement of such a nature, with such a massive participating population of such an age, with so powerful a revolutionary potential. It would have been unthinkable that the Chinese book of oracles, the *I Ching,* should be consulted by the kinds of people who are now flipping ancient coins and counting off yarrow stalks to obtain a reading of the circumstances of the moment, along with the tarot cards and horoscopes, and consultations of clairvoyants and mediums.

This impressive demonstration of widespread fascination with the nonrational psyche and the transpersonal depth dimension of experience, with its frank quest of the mystical wonderment, forces upon us the question, What human need is being served by this probing into the unfamiliar psychic space? Its bearing on the exploration of psychosis that I have been conducting is evident enough; for what the psychedelic trip amounts to, after all, is an artificially induced state which leads the individual directly into the same dimension of inner experience as the psychotic episode we are studying. I refrain from calling it "hallucinogenic" or "psychotomimetic," or an "artificially induced psychosis," since these terms are prejudicial and are very likely unsound; it might be more accurate to call many "psychotic" states by the designation "spontaneously induced psychedelic experiences."

To investigate this issue in depth we will look into the phenomenology of the mystical experience, as it has been described and formulated by persons who have been through it. (I will cleave again mainly to our Judeo-Christian heritage.) In so doing we will find the border between healthy religious experience and what we customarily regard as psychopathological states becoming so fuzzy and indeterminate that the current definitions in the vein of psychiatric labels and categories of disorders will seem inadequate.

THE NATURE OF MYSTICAL EXPERIENCE

Mysticism is a term that means many things to many people. It has derogatory connotation to the rationalistic kinds of mentality, paraphrased by Frye as something between "misty" and "mysterious";[1] to the ecclesiastical mind there is a handy quip to dispense with mysticism as "something that begins with mist and ends in schism." But there is a nobler and more objective handling of the topic that gives it precise definitions and descriptions of types and stages of the experience.

A foremost scholar in the field, Leuba,[2] defines it as an experience taken by the experiencer to be an immediate contact or union of the self with the "larger-than-self," be it called the World Spirit, God, the Absolute, or whatever. One of the most respected spokesmen for the religious treatment of the topic, Evelyn Underhill,[3] defines mysticism as the art of establishing one's conscious relation with the Absolute, being an ordered movement toward ever higher levels of reality and ever closer identification with the Infinite. Another scholar, Récéjac[4] summarizes the mystic way thus: Early, the mystic consciousness feels the Absolute to be in opposition to the self; further on, the mystic activity tends to abolish this opposition; when it has reached its fulfilment, consciousness finds itself possessed by a "sense of a Being greater than the self and identical with it, great enough to be God, and intimate enough to be me."

Again Underhill formulates the quality of the experience in this fashion:[5] True mysticism is active and practical, not passive and theoretical; its aims are wholly transcendental, with the heart set on the Changeless One; this One is not merely the reality of all, but a personal and living object of love; the living union with the One is a form of enhanced

life. She sees the mystic way as an arduous psychological process that entails a complete remaking of character and a liberation of a new form of consciousness, which had been latent and now imposes on the self a condition called "ecstasy," but better called the "Unitive State." This latter is the final outcome of the mystic way, and is recognizable in the lives of the great mystics as a state in which there is no longer a taste for trances, ecstasies, and raptures, but rather a release of a superabundant energy for work in the mundane world of ordinary affairs, especially for efforts toward improvement in the society in which such people are involved.

Indeed, something happens. There is a goal reached, a transformation of character effected, and a new plentiful source of energy for effective living and working tapped at the deepest levels of the experience. While the religious person can say to this "Of course!" the psychiatrist cannot come up with any such recognition of familiar events, and must ask many questions. The safest ground being the firm terrain of actual experience, we will look into the first-hand accounts of individuals who went through such experiences.

Not all the great mystics have left accounts of their personal experience, most preferring formulations of the mystic way arranged and schematized in steps. However, there are descriptions of the actual psychic events in many cases, and these afford some valuable data of experience. Before launching into these, however, various kinds and degrees of the experience must be recognized. Some of the ones of greatest interest for our discussion are not those that come as the achievement of a known method, but rather arrive unexpectedly and overwhelm the subject with an unforeseen power. It is in the area of these spontaneous mystical experiences that Bucke[6] has made his formulation of the type he calls Cosmic Consciousness.

Laski,[7] in her psychological study of ecstasy, finds a group of such psychic events that are considered low on the scale of mystic achievement and that are termed "Adamic States" in accord with a statement of George Fox (the founder of the Quaker Society of Friends): "I was come up to the state of Adam in which he was before he fell. The creation was opened to me, etc." That is, as Laski defines this state,

> Adam was as people feel themselves in this state to be, happy and
> innocent, knowing nothing of sin or toil or change or sorrow . . .
> States to which they feel they are brought by adamic ecstasy in-
> clude the Noble Savage, primitive man, the Arcadian shepherd,
> the craftsman, the Worker of the World, certain animals, the in-
> nocent child . . .

These ecstasies are "characterized by feelings that life is joyful, purified,
renewed, but which lack feelings of knowledge gained or contact made . . .
feelings of a new life, another world, joy, salvation, perfection, satisfac-
tion, glory.[8]

In contrast to these are the sudden and overwhelming occurrences
of illumination, in which one receives an insight into the innermost na-
ture of things, or of rapture, in which one is drawn into a loving union
with the innermost heart of things. It is to these phenomena of illumi-
nation and rapture that we now devote our attention, always with the
question before us, What is it about such ecstasies and experiences that
provides these individuals with the extraordinary drive to work creative-
ly for their particular cultures, religious or political as the case may be?
For the data of experience, then, we will look at these events in the lives
of some of the great founders, prophets, and mystics.

EXPERIENCES OF ILLUMINATION

Perhaps the purest example of the illuminative type of experience is that
of Jacob Boehme, an early seventeenth-century shoemaker who, by virtue
of his ecstasy, became one of the leading nature philosophers of his time.

> Sitting one day in his room his eyes fell upon a burnished pew-
> ter dish, which reflected the sunshine with such marvelous splen-
> dor that he fell into an inward ecstasy, and it seemed to him as if
> he could now look into the principles and deepest foundation of
> things . . . He was "surrounded by the divine light, and replenished
> with the heavenly knowledge . . ."[9]

Clearly, for Boehme, the illumination was accompanied by a dramatic revelation to his understanding which provided him with a key to the meaning of things, to a grasp of the inner workings of creation. He spent the rest of his life investigating and writing to make explicit the things he grasped in a few moments in his youth. In doing so, he became a spokesman for a powerful movement of fresh religious vigor opposed to a calcified church establishment: "He found many friends and followers among the high and the lowly, the rich and the poor, and it seemed, indeed, as if a new outpouring of the Spirit of Truth was intended to take place in priest-ridden and bigoted Germany."[10]

Mohammed's illumination is instructive not only in this strong element of presenting to the understanding a new dimension of revealed knowledge, but also, in consequence, in releasing in him a vast fund of creative zeal, which in turn fired the Moslem world with a fervor to go forth and subdue the surrounding world to its religious discipline and culture. While fasting, praying, and meditating in a cavern of a holy mountain:

> . . . wrapped in his mantle, he heard a voice calling upon him. Uncovering his head, a flood of light broke upon him of such intolerable splendor that he swooned away. On regaining his senses he beheld an angel in human form, which . . . displayed a silken cloth covered with written characters. "Read!" said the angel. "I know not how to read!" replied Mohammed. "Read!" repeated the angel . . . Upon this Mohammed instantly felt his understanding illumined with celestial light and read what was written on the cloth . . .[11]

This is an instance of the translation of a religious revelation into political structure, such that its whole hierarchy of caliphates found their center and pinnacle at the place of their founder's activity.

No less did the illumination of Paul, a few centuries earlier than that of Mohammed, effect the release of a gigantic force in the man himself and thence in the Mediterranean world around him. I will put together a couple of accounts of the event. While pursuing the followers of Jesus without mercy to persecute them, on the road to Damascus:

> . . . suddenly there shone round about him a light out of heaven:
> and he fell upon the earth and heard a voice saying unto him, Paul,
> Paul, why persecutest thou me? . . . [T]o this end have I appeared
> to thee, to appoint thee a minister and a witness . . . And he was
> three days without sight, and did neither eat nor drink.[12]

In addition, Paul tells of his being "taken up into a third heaven:"

> (whether in the body or out of the body, I cannot tell: God
> knoweth:) How that he was caught up into paradise, and heard
> unspeakable words which it is not lawful for a man to utter.[13]

This illumination altered the basis of Paul's religious outlook and
allegiance and provided the foundation upon which he made the new
doctrine of Christianity explicit and eloquent. He often said later that
the Jesus that he preached was not the one that the apostles in Jerusa-
lem knew, but was the one of his own vision on the road to Damascus.[14]
The church that sprang up in the various gentile countries around the
Mediterranean was the creation of this man, who traveled about with in-
credible and untiring energy instituting and tending these new flocks.[15]
This new church in time also became a political structure, inheriting
the Roman Empire's legacy and dominating the affairs of Europe for a
millennium.

In the late medieval Christian era, St. John of the Cross and Brother
Klaus (Nicholas von Flüe) had contrasting experiences of illumination.

St. John was being imprisoned by the Church establishment for his
work of reforms, when he was filled with light such that its rays shone from
his face and gave a glow to his cell of such intensity that he was blinded for
several days, like Paul. He was passing through a period of

> . . . internal trouble of mind, scruples, and disrelish of spiritual
> exercises . . . After some time certain rays of light, comfort and
> divine sweetness scattered these mists and translated the soul of
> the servant of God into a paradise of interior delights and heav-
> enly sweetness.

When under the discipline of imprisonment while his views were being brought under question,

> His cell became filled with light seen by the bodily eye ... [I]t filled his soul with joy and made the night pass away as if it were but a moment.[16]

Brother Klaus, on the other hand, had a vision of light of surpassing intensity and in it a face of the divinity in human form so terrifying that his own visage bore the imprint of this terror the rest of his life, so intensely that people looking at his face were terrified by the expression. His "Trinity Vision" was in time elaborated into a "figure, drawn like a wheel with six spokes." The vision, though, was pure illumination. Jung says of it that "the firsthand reports make no mention of a 'wheel.' This seems to have been a subsequent addition for the purpose of clarifying the vision."[17] An early account of the phenomenon says:

> ... he himself used to say that he had seen a piercing light resembling a human face. At the sight of it he feared that his heart would burst into little pieces. Overcome with terror, he instantly turned his face away and fell to the ground.[18]

While Paul and St. John were both great founders of religious movements, Brother Klaus is of interest especially for the impact his vision had upon his career. For this man was not only vouchsafed by his vision an understanding of the nature of the Trinity, but also was so affected by it that he became one of the dynamic forces in the political life of his time, helping to shape the Swiss Republic at its incipience to such an extent that he became its patron saint, counted among its founding fathers as a national hero.

EXPERIENCES OF RAPTURE

Now the companion piece to the advent of boundless light in ecstatic experience has been the corresponding rapture of boundless love. Again to begin with Jacob Boehme, he could find only paradoxical language to hint at the ineffable:

... thou art in that eternal One, which is God himself, and then thou shalt feel within thee the highest virtue of Love[19] [i.e., "power" or "strength" of love].

Bucke himself is one who was so moved by his experience of illumination that he was led into extensive researches on the nature of the phenomenon he called Cosmic Consciousness, and made one of the great contributions to the field of the psychology of depth experience. For him as for Boehme, both illumination and rapture were there, giving an intellectual comprehension of a new kind, and also a sense of relationship in love to a living cosmic presence.

> All at once, without warning of any kind, he found himself wrapped around as it were by a flame-colored cloud ... Directly afterwards came upon him a sense of exultation, of immense joyousness accompanied or immediately followed by an intellectual illumination quite impossible to describe ... [H]e saw and knew that the Cosmos is not dead matter but a living Presence, that the soul of man is immortal ... that the foundation principle of the world is what we call love.[20]

St. John of the Cross in his *Dark Night* of *the Soul* renders a poem with a commentary which describes in symbolic imagery the rapturous union of the soul with its Divine Lover:

> Oh, night that guided me, Oh, night more lovely than
> the dawn,
> Oh, night that joined Beloved with lover, Lover
> transformed in the Beloved!
> Upon my flowery breast, Kept wholly for himself alone,
> There he stayed sleeping, and I caressed him,
> And the fanning of the cedars made a breeze.[21]

He said in another place that

> divine love inflames the will so that it becomes nothing less than divine, loving in a divine way ...[22]

The language of this sort of mystical love is often extravagant, but hardly more so than the intensity of the experience of the ecstasies. In the life of St. Catherine of Genoa we find that the manifestation of the love trance was so intense that her health suffered. In her first phase, she practiced austerities with severity, but afterwards she relinquished these and "her life gained correspondingly in joy and expansive benevolence. Her relation with God passed more frequently than before into a love-trance."

> She would at times have her mind so full of divine love, as to be all but incapable of speaking . . . She would lose the use of her senses and remain as one dead . . . at times her hands would sink, unable to go on, and weeping she would say, "O my love, I can no more"; and would thus sit for a while with her senses alienated.

She suffered an acute hypersensitivity at times:

> She was like a creature placed in a great flame of fire, and it was impossible to touch her skin, because of the acute pain which she felt from any touch.[23]

Equally powerful was the illumination of Heinrich Suso, who lost himself in contemplation of a Shining Brightness. In the ecstasy he could experience the essence of all understanding.

> It was without form or mode, and yet it contained within itself the entrancing delightfulness of all forms and modes.

It became personified in the figure of "Eternal Wisdom in an ineffable form who displayed her charms to him as a gracious loving mistress." This rapture of love assumed cosmic proportions:

> She shone like the morning star and her radiance was as dazzling as the rising sun . . . She reaches above the summit of the heavens and touches the depths of the abyss . . . [In such ecstasy] the arms, as it were, of his soul stretched themselves forth, out of the unfathomed fullness of his heart, the far ends of the universe.[24]

In the same vein the English mystic, Rolle, spoke of the burning heat of the soul's ardor in this rapture:

> Heat soothly [verily] I call [it] when the mind truly is kindled in Love Everlasting, and the heart on the same manner to burn not hopingly but verily is felt. The heart truly turned into fire, gives feeling of burning love . . .[25]

THE RELEASE OF ENERGY

When we return now to our question of what ecstasies and raptures do to the individual that releases a superabundant energy, we find among these documentations something of an answer. The goal of the progress along the mystical way is "union with the divine." This achievement is expressed as either an identification with, or a love relation with, the godhead — called "deification" on the one hand and the "spiritual marriage" on the other. The names, as Leuba puts it,

> are intended to indicate the completeness and the permanence of the union that has now taken place . . . Instead of wishing to die in order to enjoy more fully the bridegroom, the soul is now desirous of remaining on earth in order to serve the divine Master; altogether steadfast, she is continuously absorbed in planning and performing good works.[26]

Underhill writes of this as the "Unitive Life": Contrary to the popular expectation, it proves the mystic to be "a pioneer of humanity, a sharply intuitive and painfully practical person: an artist, a discoverer, a religious or social reformer, a national hero, a 'great active' amongst the saints."[27] The two opposite modes of union she describes this way:

> (1) The metaphysical mystic, for whom the Absolute is impersonal and transcendent, describes his final attainment of that Absolute as deification, or the utter transmutation of the self in God. (2) The mystic for whom intimate and personal communion has been the mode under which he best apprehended reality, speaks of the consummation . . . as the Spiritual Marriage of his soul with God.[28]

The mystic, she says, draws from this state "that amazing strength, that immovable peace, that power of dealing with circumstance, which is one of the most marked characteristics of the Unitive Life." She finds that "in each, a character of the heroic type, of great vitality, deep enthusiasms, unconquerable will, was raised to the spiritual plane, remade on higher levels of consciousness."[29] An outstanding instance is the life of St. Catherine of Siena, "an illiterate daughter of the people, [who] after three years' retreat, consummates the mystic marriage, and emerges from the cell of self-knowledge to dominate the politics of Italy."[30] St. Theresa said of this state, "It is to this point, my daughters, that orison tends; and, in the design of God, this spiritual marriage is destined to no other purpose but the incessant production of work, work!"[31] Underhill sees the sense of the mystic marriage as like that of the mundane matrimony of a couple in love, in that mystics thereby assume the permanence of union, the undertaking of responsibilities in the world, and the parental functions in the spiritual sense: "The self . . . is to be an agent of the divine fecundity: an energizing center, a parent of transcendental life."[32]

INEFFABILITY OF THE EXPERIENCE

An important comment that most of the great mystics make, in their efforts to describe their experiences, concerns one of the four qualities of the mystical experience as formulated by William James: the noetic, the passive, the transient, and the ineffable character of the experience. The deeper the ecstasy, apparently, the less there is any way to give it words. One is reminded of the saying of the founder of Chinese Taoism, Lao-tse:

> The Tao that can be told of
> Is not the Absolute Tao; . . .
> The Nameless is the origin of Heaven and Earth;
> The Named is the Mother of All Things.[33]

In our Western tradition the words of the mystic Paul say something of the same:

We speak the wisdom of God in a mystery, even the hidden wisdom
... If any man among you seemeth to be wise in this world, let him
become a fool, that he may be wise.[34]

Jacob Boehme indicated in verbal paradoxes how utterly undefin-
able is the experience of the rapture:

[Love] may fitly be compared to Nothing, ... it is not comprehen-
sible by any of them ... and is that only good, which man cannot
express or utter what it is ...[35]

St. John of the Cross, a very verbal man who spared no efforts to clarify
and comment on spiritual experiences, said of these attempts:

It is not without some unwillingness that I enter at the requests
of others upon the explanation of the four stanzas, because they
relate to matters so interior and spiritual as to baffle the powers
of language. All I say falls far short of that which passes in this
intimate union of the soul with God.[36]

In his more poetic vein he goes on to give the sense of paradox:

I stood enraptured in ecstasy, beside myself, and in my every sense
no sense remained. My spirit was endowed with understanding,
understanding nought, all science transcending.

The higher I ascended the less I understood. It is the dark cloud
illuminating the night. Therefore he who understands knows
nothing, ever all science transcending.[37]

The poet Dante, who had eloquent words for most things, was transport-
ed into a new vision of the cosmos where, as Bucke comments, he had "a
vision of the 'Eternal Wheels' ... the universal order — a vision infinitely
beyond expression by human words ... Gazing thereupon, the Cos-
mic Vision and the Cosmic rapture transhumanized him into a god."[38]
Dante said, "Transhumanizing cannot be signified in words."

In the heaven that receives most of its light I have been, and have
seen things which he who descends from there above neither
knows how nor is able to recount.[39]

And again St. Theresa, who had much to narrate and formulate with great clarity of mind in her schematizing of the stages of the "mystic way" and the "ladder of love," said of the third stage — which she called "the sleep of the powers" — that "it is a glorious delirium, a celestial madness," the soul feeling herself dying to the world while reposing rapturously in the enjoyment of God. Then of the fourth stage, the "Ecstasy of Rapture, or Flight of the Soul," she comments:

> The will is doubtless occupied with loving, but it does not understand how it loves. As to the understanding, if it understands, it is by a mode of activity not understood by it; and it can understand nothing of that which it hears.[40]

In the mystical way, then, we observe that the deeper it goes, the more it consists of overwhelming and raw affective or cognitive experience, so boundless and so formless that the subject finds no way of giving it adequate words.[41]

FINDING FORM FOR THE FORMLESS

From this inchoate state of ineffability, the mystic is left with the need to give form to the formless through work — usually the work of writing and conceptualizing. As Gershom Scholem has said of the mystical experience,

> In itself, it is fundamentally amorphous . . . when he attempts to communicate it to others, he cannot help imposing a framework of conventional symbols and ideas upon it . . . [These] then are projected into his mystical experience . . . The center of what a mystic has to say always remains a shapeless experience, spurring the mystic on to his understanding of his religious world and its values.[42]

Jacob Boehme said of his illumination:

> In one quarter of an hour I saw and knew more than if I had been many years together at an university. For I saw and knew the being of all things . . . So that I did not only greatly wonder at it, but did

also exceedingly rejoice, albeit I could very hardly apprehend the same in my external man and set it down with the pen.[43]

He did so explicate in many volumes throughout his life, drawing upon the material of his visions.

Dante had such an experience of a revelation, to which he gave many years of work to express in verse in the *Divina Commedia*. In a sonnet, he wrote that a sigh from his heart was drawn upward by love to beyond the farthest cosmic sphere: "When it has come to where it desires to be, it sees a lady so honored and so shining that this pilgrim spirit wonders at her splendor!" As comment he added, "My thought rises to her quality in such degree that my intellect cannot comprehend it, for our intellect is to those blessed souls as our weak eyes are to the sun . . .[44] Williams relates that, "It was directly after this that there was given to him a 'very wonderful vision' — and he determined to write no more of her till he could write worthily, and then 'such things as have never yet been written of any woman.' "[45]

In telling of the Swiss patron saint, Brother Klaus, and his vision of the terrifying aspect of the deity, Jung emphasized this work of elaboration. Considering that orthodox belief required

> that God signified the *summum bonum,* Absolute Perfection, then it is clear that such a vision must, by its violent contrast, have had a profound and shattering effect, whose assimilation into consciousness required years of the most strenuous spiritual effort. Through subsequent elaboration this vision then became the so-called Trinity Vision . . . Later, as a result of further mental elaboration, there were added the spokes of the wheel and the six secondary circles, as shown in the old picture of the vision in the parish church at Sachseln.[46]

Sometimes the formulating and assimilating come from outside the subject. Of the Chinese T'ai-Ping rebellion's Christian messianic leader, Hung Hsiu-Ch'uan, Wallace narrates that for six years following his visionary experiences in his psychosis, nothing much happened except that he seemed more mature and imposing, hearty but severe. Then "he read

some Christian religious tracts and felt that they 'explained' his visions. The whole pattern now fell into place and he embarked on his program to reform the world."[47] Once the framework for formulating the mystical experience was provided from the outside, he proceeded to write creatively, just as other mystics have done, and these works were revered as words of scripture attached to the main body of Christian scripture.

Many and prolific are the writings and formulations of the great founders and mystics who had their start in ecstatic and ineffable revelation: Mohammed, Paul, St. John of the Cross, St. Theresa, Meister Eckhart, Suso, and a host of others. One might make the safe generalization that one of the major wellsprings of creative work of the mind lies in the mystical experience, and especially in the drive to make of its inexpressible character something that can be expressed and communicated.

EVENTUALITIES OF THE EXPERIENCE

But the rest of the story is less happy. What begins as the drive to make communicable the good news that the mystic vision is there and can be reached, becomes in time a need to gather a following. There is a contagious quality along with the communicability; souls are touched with fire, and a blaze of enthusiasm spreads rapidly, with a tremendous uprush of energy. Paul's church spreads rapidly over the Mediterranean world, Mohammed's legions fan out over the outer reaches of that world, Hung's columns march toward the Manchu capital to overthrow the dynasty, or in contrast, George Fox's followers take their stand in numbers against the Wars of the Commonwealth; and in the train of experiences of the great mystics in the late medieval church, droves of men and women take vows in innumerable monasteries founded by those dynamic souls.

With a following comes also the requirement for structuring and codifying, or institutionalized form and doctrine, and on the heels of that, the distinguishing of true and false following in the form of orthodoxy and heresy. Finally the generally agreed conventions congeal, and we have the authoritarian "establishment" as the final plight.

Such is the evolution of the vision over the years, from an original, raw, affective, and fluid experience into a cold and static institution frozen in formalities. In time, too many questions which arise find no answers.

These are the circumstances in which the collective psyche becomes restless. The culture is ready for renewal and reinvigoration through fresh original experiences once more. Souls sensitive to the pressures and movements of the collective psyche feel these impulses toward renewal, and make the mystical journey, often in consequence transforming the religious authority[48] or cultural canon.[49] Others who are not so vigorous or resilient in their capacity for resynthesizing go through such a turmoil in this journey that they become "psychotic" (psychoticoid?) along the way, before they can make of it something creative. And then again, there are the less fortunate ones who need more help to resynthesize, and unless they receive it, are threatened with submersion in psychosis.

1. N. Frye, *Fearful Symmetry.* Princeton: Princeton University Press, 1969, p. 7.

2. J.H. Leuba, *Psychology of Religious Mysticism.* New York: Harcourt, Brace, 1929, p. 1.

3. E. Underhill, *Mysticism.* London: Methuen, 1912, p. 97.

4. E. Récéjac, *Essay on the Bases of Mystic Knowledge,* translated by S. C. Upton. London: Kegan Paul, Trench, and Trubner, 1899, p. 45.

5. Underhill, *Mysticism,* pp. 96−97.

6. R.M. Bucke, *Cosmic Consciousness.* New York: Dutton paperback, 1969.

7. M. Laski, *Ecstasy.* New York: Greenwood Press, 1968.

8. I am tempted to identify these "adamic states" with Maslow's "peak experiences."

9. H.L. Martensen, *Jacob Behmen: His Life and Teaching: or Studies in Theosophy,* trans. T. Rhys Evans. London: Hodder and Stoughton, 1855, p. 7.

10. F. Hartmann, *The Life and Doctrines of Jacob Boehme.* London: Kegan Paul, Trench and Trubner, 1891.

11. Bucke, *Cosmic Consciousness,* p. 126.

12. Acts 9:3−4, 26:14; 9:9.

13. 2 Cor. 12:2, 3, 4.

14. Gal. 1:11−24.

15. Acts 9−21.

16. Bucke, Cosmic *Consciousness,* p. 114.

17. C. G. Jung, *Collected Works,* vol. 11: *Psychology and Religion: West and East,* Bollingen Series XX. New York: Pantheon, 1958, part 1, p. 318.

18. Ibid., p. 319.

19. J. Behmen, *Dialogues on the Supersensuous Life,* translated by B. Holland. London: Methuen, 1901, p. 42.

20. Bucke, *Cosmic Consciousness,* pp. 9–10.

21. St. John of the Cross, "Dark Night of the Soul," in *Complete Works of Saint John of the Cross,* translated by E. A. Peers. London: Burns, Oates, and Washburn, 1943, 1, 326.

22. St. John of the Cross, *Life and Works,* translated by D. Lewis. London: Thomas Baker, 1889–91, p. III.

23. Leuba, *Psychology of Religious Mysticism,* pp. 69–72.

24. H. Suso, *The Life of Blessed Henry Suso by Himself,* translated by T. F. Knox. London: Methuen, 1913, p. 8 and chap. 3.

25. Underhill, *Mysticism,* p. 233.

26. Leuba, *Psychology of Religious Mysticism,* p. 174.

27. Underhill, *Mysticism,* p. 495.

28. Ibid., p. 496.

29. Ibid., p. 499.

30. Ibid., p. 515.

31. Ibid., p. 514.

32. Ibid., p. 512.

33. Lao-tse, "Tao-Teh Ching," in *The Wisdom of Lao-tse,* translated by Lin Yutang. New York: Modern Library, 1948, 1, p. 41.

34. 1 Cor. 2:7, 3:18.

35. J. Behmen, *Dialogues on the Supersensual Life,* translated by B. Holland. London: Methuen, 1901, p. 48.

36. St. John of the Cross, "The Living Flame of Love," *Life and Works,* II, 407.

37. St. John of the Cross, "Poems," *Life and Works,* pp. 624–25.

38. Bucke, *Cosmic Consciousness,* p. 137.

39. Bucke, *Cosmic Consciousness,* p. 136, citing Dante, *Paradise,* translated by C. E. Norton. Boston and New York: Houghton, Muffin & Company, 1892, canto 4.

40. Leuba, *Psychology of Religious Mysticism,* pp. 163–66.

41. G. Scholem, "Religious Authority and Mysticism," *Commentary* (November 1964): 32.

42. Scholem, "Religious Authority and Mysticism," p. 32.

43. J. Behmen, "The Life of Jacob Behmen," revised by W. Law, *Works of Jacob Behmen.* London: Mr. Richardson, 1764–81, I, 15.

44. Dante, *Vita Nuova,* 61, quoted in C. Williams, *The Figure of Beatrice.* New York: Noonday Press, 1961, p. 43.

45. Williams, *The Figure of Beatrice,* p. 43.

46. Jung, *Psychology and Religion: West and East,* p. 319.

47. A. F. C. Wallace, "Stress and Rapid Personality Changes," *International Rec. Med. Gen. Practice Clinics* 169, no. 12 (1956).

48. Scholem, "Religious Authority and Mysticism," p. 32.

49. E. Neumann, "Art and Time," in *Art and the Creative Unconscious,* Bollingen Series LXI. Princeton: Princeton University Press. 1959, chap. 2.

MYSTICISM AND MADNESS

I f one cares to drop into the psychiatric framework of symptom-hunting, one can find in mystic experiences every manner of psychotic and hysterical manifestation, as well as painful psychosomatic suffering. One is not, however, entitled to conclude much from them. For these people emerge as the giants of their age with greater impact on their times than they could have had, had they remained within the confines of the usual norms. When a turbulent process eventuates in a superlative outcome, the point of interest is not what manner of pathology this is, or how we can apply our diagnostic skills to determine what has really gone wrong; rather, the real issue is how to determine the relation of these mystical states to the developmental needs of certain personalities in certain cultural contexts.

The mystic slips into most unusual states of being: He may swoon, fall to the ground, drop into a death-like trance, levitate, or stand rapt in an ecstasy, unmindful of his surroundings.

Heinrich Suso gave a dramatic account of his own ecstasy and his sense of being overwhelmed:

> This ecstasy lasted from half an hour to an hour, and whether his soul were in the body or out of the body he could not tell. But when he came to his senses it seemed to him that he returned from another world. And so greatly did his body suffer in this short rapture that it seemed to him that none, even in dying, could suffer so greatly in so short a time. The Servitor came to himself moaning, and fell down upon the ground like a man who swoons . . . He walked, but it was but his body that walked, as a machine might do . . . It seemed to him that he walked on air.[1]

George Fox describes in his journal the violence of his being seized by the spirit. He was walking toward Lichfield on a snowy, cold day:

> Then I was commanded by the Lord to pull off my shoes. I stood still, for it was winter: but the word of the Lord was like a fire in me. So I put off my shoes and left them with the shepherds; and the poor shepherds trembled, and were astonished. Then I walked about a mile, and as soon as I was got within the city, the word of the Lord came to me again, saying: "Cry, 'Woe to the bloody city of Lichfield!'" So I went up and down the streets, crying with a loud voice ... And no one laid hands on me. As I went thus crying through the streets, there seemed to me to be a channel of blood running down the streets, and the marketplace appeared like a pool of blood ... [2]

The clinical eye is apt to look on critically and observe the stupor and the machinelike depersonalization in Suso's episode, or to pronounce Fox, with his auditory and visual hallucinations, distinctly psychotic. An appraisal from the developmental point of view, on the other hand, seeks out another kind of observation. Then the more difficult but more pertinent question arises: Rather than what is pathological in mysticism, we ask what is mystical in its intent in psychosis? Among the twelve individuals in schizophrenic episodes that I have studied in depth, there were many experiences that were manifestly mystical in their character and import.[3] Here are some of these:

My first case, a young lady, at Easter came to a realization while attending chapel service that it is really the Christ in all of us who dies and is resurrected, and that He was the real center, not she. She saw an image of Him as a red center surrounded by the souls of all people, those close to him in intense red being those who love most, those more distant in paler reds the ones that were less developed in love.

The young man described in Chapter 1 [No. 3] experienced a reenactment of the ceremony of founding the World Mission of Our Lady of Fatima. In the evening, candles were lit from the altar and the flame distributed from person to person throughout the multitudes who should then go out into the world with the gospel. He found himself appointed by a special mandate from Our Lady to be her chosen hero and defender of the faith and leader of the World Mission as a new Christ.

The young lady described in Chapter 3 [No. 7] looked out of the window during a storm, and in a sort of transport brought about by the play of thunder, saw herself as a new Moses, called upon by the Almighty to be the fourth in a series of great founders of religion — Moses, David, and Luther being, along with her, reincarnations of the same divine spirit.

The young lady with the messianic vision in Chapter 6 [No. 10] had an "epiphany" type of experience one day, in which she saw herself standing at the head of a sweeping stairway, and toward her climbed a multitude of people to adore her as a holy person, Christlike, and dressed in symbolic colors: blue for her maleness, white for her Christlikeness, and black for her devil aspect, while a fourth color was a blanket over her standing for her womanly nature as Mother Eve.

The young lady of Chapter 2, it will be recalled, [No. 12] had found herself to be specially called and chosen by the Blessed Mother and thence drawn into a special kind of exaltation, feeling herself to be "not quite of this world," and her heart to be "lifted up as if floating on a cloud." This was a more or less sustained ecstasy. She sensed "odors of death" and of evil, sent by the devil and signifying her imminent death; later she was visited by "sweet odors" of life, signifying the presence of the Blessed Mother calling upon her to inaugurate a special mission.

The literature of mystics is filled with parallels to such episodes as these. A noteworthy one is a twin to the first, with the vision of the souls surrounding Christ at the center: As Underhill explains, the mystic's identification with the deity — not usurping the place of God, but becoming one substance with him — was a "fact of which Dante perceived the 'shadowy preface' when he saw the saints as petals of the Sempiternal Rose" — that ultimate vision in the Paradiso of the Mystic Rose as the clustering of souls around the Deity at its center (again, those closest being the brightest and nearest in the quality of love).[4] She says, again, that Dante "saw the Deity as a flame or river of fire that filled the Universe; and the 'deified' souls of the saints as ardent sparks therein, ablaze with that fire, one thing with it, yet distinct."[5] Another interesting parallel is an observation by Leuba of the inordinate sense of exaltation on the part of some mystics, notably an event in St. Theresa's life that is close to the epiphany experience of the fourth example just mentioned. He says of St. Theresa,

The conviction of her greatness welled up more than once, but never so badly as in the vision in which she saw herself being clothed by the Virgin Mary, assisted by St. Joseph, with a gown of dazzling whiteness. They decorated her with priceless jewels and told her that she was altogether free from sin . . . Instead of being inexpressibly shocked by this lurid burst of pride, she complaisantly and unhesitatingly accepts it.[6]

Where indeed are the boundaries between mystical union, gross inflation, and psychotic identification?

THE ELEMENTS OF THE RENEWAL PROCESS

In reviewing the accounts of the Christian mystics' experiences, I have been struck by the frequent occurrence of the same ten elements defined and delineated in my formulation of the "renewal process" in the schizophrenic episode. I will select a few instances to speak for each one of them.

The Center

In the study of the mystical tradition, Rufus Jones points to the importance of Plotinus's concept of "the center of the soul," a phrase that

went across the world like winged steed to spring up and bear fruit wherever there was suitable soil for it . . . It is obvious what Plotinus meant by it in the context where it occurs, the "soul-center" which attaches — is "bound by gold chains" — to its eternal source. But *kentron* in biblical Greek . . . means a sharp point . . . There naturally sprang from it the idea of the "apex of the soul" as its point of contact with the divine.[7]

Plotinus, the Neoplatonist who was the first architect of the structuring of the mystical way for the Western world, said this of the center:

Self-knowledge reveals to the soul that its natural motion is not, if uninterrupted, in a straight line, but circular, as around some inner object, about a center, the point to which it owes its origin.

If the soul knows this, it will move around this center from which it came, will cling to it and commune with it as indeed all souls should but only divine souls do. This is the secret of their divinity, for divinity consists in being attached to the center.[8]

Underhill notes this theme in the tradition of the elements of character: "The focal point is the old self, the lower center of consciousness; and the object of mortification is to kill that old self — remove that lower center, in order that the higher center, the 'new man,' may live and breathe."[9]

Death

In regard to this mortification, Underhill further says, "The old paths, left to themselves, must fade and at last die. When they are dead, and the new life has triumphed, mortification is at an end. The mystics always know when this moment comes."[10] Tauler extolled such mystic death in these words:

> In the truest death of all created things, the sweetest and most natural life is hidden . . . A great life makes reply to him who dies in earnest even in the least of things, a life which strengthens him immediately to die a greater death; a death so long and strong that it seems to him hereafter more joyful, good, and pleasant to die than to live, for he finds life in death and light shining in darkness.[11]

What to the schizophrenic is an occasion for panic in the face of a little understood "death trip" is to the mystic who is acquainted with death a welcome advent.

Return to the Beginnings

The love-inebriated Suso described graphically the experience of feeling like an infant in its mother's arms when he "recollected himself in the depths of his heart and soul, and thought on that Beloved Object, whence comes all love."[12] He said of himself:

He was like a baby which a mother holds upright on her knees, supporting it with her hands beneath its arms. The baby, by the movements of its little head, and all its little body, tries to get closer and closer to its dear mother, and shows by its little laughing gestures the gladness in its heart. Thus did the heart of the Servitor ever seek the sweet neighborhood of the Divine Wisdom, and thus he was as it were altogether filled with delight.[13]

Jacob Boehme, more inclined to the cosmic vision in his experience of illumination, wrote that in the face of the great mysteries — which he beheld in the form of the birth of creation out of the primordial chaos — he felt like a schoolchild learning things from the starting point. He saw and knew

the *external* and *visible* World, being a Procreation or external Birth from both the internal and spiritual Worlds. And I saw and knew the whole working Essence in the Evil and the Good . . . and likewise how the fruitful bearing Womb of Eternity brought forth . . . Yet however I must begin to labour in these great mysteries, as a Child that goes to School. I saw it as in a great Deep in the Internal [sic]. For I had a thorough view of the Universe, as in a Chaos, wherein all things are couched and wrapped up. Yet it opened itself to me, from Time to Time, as in a Young Plant.[14]

The Adamic state defined by Laski has reference to a return to the Creation. In view of the frequent mention among psychotic persons, in the course of this "renewal process," of the return to the time and conditions of the first paradise of Eden, the experience of George Fox is of interest. Of his illumination he says:

Now was I come up in spirit through the flaming sword into the Paradise of God. All things were new: and all the creation gave another smell unto me than before, beyond what words can utter . . . The creation was opened unto me.[15]

Cosmic Conflict

In the stage of the mystic journey that is described by Underhill as the Purgative state or way, we find the battle joined between the higher and lower natures of man — the spirit warring against the flesh, as Paul had it. Jacob Boehme, whom she calls the least ascetic of visionaries, told of his struggle between good and evil in this manner:

> Finding within myself a powerful contrarium, namely the desires that belong to the flesh and blood, I began to fight a hard battle against my corrupted nature, and with the aid of God I made up my mind to overcome the inherited evil will, to break it, and to enter wholly into the Love of God . . . and fought a hard battle with myself. Now while I was wrestling and battling, being aided by God, a wonderful light arose within my soul.[16]

It must be recalled about the theme of the ritual combat or cosmic conflict that the qualities assigned to the light and dark opposites would vary with the cultural setting; the enemy might be bitter winter or summer drought, chaos or death.[17] In the mystical tradition, the antagonist is the life of the senses and appetites, which threaten the ascendancy and freedom of the spirit.

The Opposite Sex

The mortal fear of the power of the opposite sex and of the reversal of opposites that one sees in the psychotic episode is not found in the mystic way, but there is a different way of encountering the analogous fear. This is that the soul, among the male mystics, is experienced as feminine, and may be ravished by the divine lover without giving rise to the threat of homosexual panic that is so characteristic of the psychotic relation to this same quantity. Thus there is little that is related as problematic when St. John of the Gross, for example, comments upon the mystic verse that says (as already quoted above):

> Oh, night that joined Beloved with Lover,
> Lover transformed in the Beloved!

Upon my flowery breast, Kept wholly for himself alone,
There he stayed sleeping, and I caressed him . . .[18]

Apotheosis

We have noted already that the mystic of the impersonal type, the seeker
of the Transcendent Absolute, tends to describe the consummation of
his quest in the language of "Deification." Thus the *Theologica Germanica*
proclaims:

> He who is imbued with or illuminated by the Eternal or Divine
> Light and inflamed or consumed with the Eternal or Divine Love,
> he is a deified man and a partaker of the Divine Nature.[19]

This, Underhill assures us, is no arrogant claim to identification with
God, such as would be the case in the psychotic inflation, but is to be un-
derstood as a transfusion of selves by the Divine Self.[20] The most com-
mon metaphor among the mystic writers for this state is glowing fire.
Mechthild von Magdeburg, and later Dante, "saw Deity as a flame or
river of fire that filled the universe; and the 'deified' souls of the saints
as ardent sparks therein, ablaze with that fire, one thing with it, yet dis-
tinct."[21] Boehme used the simile of red hot iron, as had Richard of St.
Victor much earlier:

> Behold a bright flaming piece of iron, which of itself is dark and
> black, and the fire so penetrateth and shineth through the iron,
> that it giveth light. Now, the iron doth not cease to be; it is iron
> still . . . In such a manner is the soul set in the Deity; the Deity
> penetrateth through the soul, and dwelleth in the soul.[22]

Finally, Suso speaks in his own passionate idiom:

> For he feels, in an ineffable degree, that which is felt by an ine-
> briated man. He forgets himself, he is no longer conscious of his
> selfhood; he disappears and loses himself in God, and becomes
> one spirit with him, as a drop of water which is drowned in a great
> quantity of wine . . . His being remains, but in another form, in
> another glory, and in another power.[23]

The Sacred Marriage: or Spiritual or Mystic Marriage

The counterpart of those "metaphysical mystics" that were mentioned above as tending toward the way of "Deification" was the mystic for whom intimate and personal communion has been made, under which he best apprehended the Absolute. These spoke of the consummation as a "Spiritual Marriage" of the soul with God. We are told, for instance, of St. Catherine of Siena, whose life of solitude was brought to an abrupt end by the experience symbolized in the vision of the Mystic Marriage and the Voice which said, "Now will I wed thy soul, which shall ever be conjoined and united to Mel."[24] She thus entered upon the "Unitive State" in which the whole of her public life was passed. Boehme speaks in a more complex visionary image of the union of the Virgin Sophia with the soul:

> But the noble Sophia draweth near in the essence of the Soul, and kisseth it in friendly manner, and tinctureth its dark Fire with her Rays of Love, and shineth through it with her bright and powerful Influence.[25]

Boehme then embarks upon an account of the Spiritual Marriage:

> I will set down here a short description how it is when the Bride thus embraceth the Bridegroom, for the consideration of the Reader, who perhaps bath not yet been in this wedding chamber . . . to enter into the Inner Choir, where the Soul joineth hands and danceth with Sophia, or the Divine Wisdom.[26]

New Birth

Mystical writers speak of a Nativity, which "concerns the Eternal Birth or Generation of the Son or Divine Word";[27] that is, the affect-image of the Divine Child. Underhill says of it that it "is in its first, or Cosmic sense, the welling forth of the Spirit of Life from the Divine Abyss of the unconditioned Godhead."[28] Meister Eckhart pointed to a perpetual generation of the Word in his Christmas sermon:

We are celebrating the feast of the Eternal Birth which God the
Father has borne and never ceases to bear in all Eternity: whilst
this birth also comes to pass in Time and in human nature. St.
Augustine says this Birth is ever taking place ... But if it takes not
place in me, what avails it? Everything lies in this, that it should
take place in me.[29]

There is a certain overlap of the image of the return to the beginnings
with that of the new birth, for as Jung has pointed out, the regression to
infancy is also to achieve rebirth.[30] Thus Boehme can make the state-
ment that "Paradise is still in the world, but man is not in Paradise un-
less he be born again. In that case, he stands there in the New Birth."[31]
Underhill adds, "That Divine Child which was, in the hour of the mystic
conversion, born in the spark of the soul, must learn like other children
to walk alone,"[32] alluding to the many trials and errors and fumblings of
the soul in trying its new powers.

The New Society

The impact of the great mystics and visionaries and prophets upon the
societies of their times has been impressive in the history of cultural ren-
ovation, notably that of Paul and of Brother Klaus in the West, of Mo-
hammed in the Near East, and of Hung Hsiu-Ch'uan in the Far East.[33]
In the medieval setting of Europe, the energetic reforms and institutions
of new monastic communities by St. Catherine of Siena, St. Theresa, and
St. John of the Cross make a fitting parallel, though their vision was less
revolutionary and more in keeping with the traditional forms.

The Quadrated World-Image

This is a theme not given as much mention in the traditional mystical lit-
erature as in the image of the "center" or "apex" of the soul. An exception
is Boehme, whose work is filled with imagery of the quadrated schema of
the world and of creation. This may be seen in some of the illustrations
of his works.[34]

LOGOS AND EROS MODES

What, then, is the goal of the mystical way and what do we learn from it about the goal of the psychotic way? Essentially, it is a descent into depth, or perhaps an advent into consciousness of elements from depth, whose nature is such that the "deeper" it goes, the more it is experienced as formless affect. The ineffability seems to consist of this inexpressibility in the terms of ordinary mundane experience. Yet through imagery and metaphor we are told that the content of the depths reached in the ulti-mate ecstasies is on the one hand illumination that enlarges the under-standing, and on the other, rapture that fills the heart with lovingness. These are clearly the sources of the Logos and Eros modes of experi-ence.[35] St. John of the Cross says of illumination and rapture:

> Now this is nothing else but the supernatural light giving light to the understanding, so that the human understanding becomes divine, made one with the divine. In the same way divine love in-flames the will so that it becomes nothing less than divine, loving in a divine way, united and made one with the divine will and the divine love.[36]

Or again Hugo of St. Victor, in his dialogue of the Soul and the Self, has the Soul speak thus:

> I am suddenly renewed: I am changed: I am plunged into an inef-fable peace. My mind is full of gladness, all my past wretchedness and pain is forgot. My soul exults: my intellect is illuminated: my heart is afire: my desires have become kindly and gentle: I know not where I am, because my Love has embraced me.[37]

Jacob Boehme describes a return to the source and center of our spiritual existence, where the Logos and love reside:

> He alone is a true Christian whose soul and mind has entered again into the original matrix, out of which the life of man has taken its origin; that is to say, the Eternal Word [Logos] . . . [He] Who absorbs this Word with his hungry soul, and thereby returns

to the original spiritual state in which humanity took its origin, his soul will become a temple of divine love.[38]

Again he says it another way:

> God's mysteries can be known only by God, and to know them we must first seek God in our own center. Our reason and will must return to the inner source from which they originated; then will we arrive at a true science of God and His attributes.[39]

The "mystic way" as formulated in this fashion might be seen as an inner drama of renewal corresponding to the ancient ritual drama. What had at first been put into collective external form became, after a couple of millennia of psychic evolution of the Judeo-Christian tradition, gradually internalized and individualized. It must be asked, however, what became of the function that the ritual process once served for the community?

1. H. Suso, *The Life of Blessed Henry Suso by Himself,* translated by T.F. Knox. London: Methuen, 1913, chap. 3.

2. G. Fox, *The Journal of George Fox,* edited by J.L. Nickalls. Cambridge: Cambridge University Press, 1952, p. 71, cited in W. James, *Varieties of Religious Experience.* New York: Modern Library, 1902, p. 9.

3. J.W. Perry, "Reconstitutive Process in the Psychopathology of the *Self,*" *Annals of the New York Academy of Science* 46, art. 3 (1962).

4. E. Underhill, *Mysticism.* London: Methuen, 1912, p. 501, citing Dante, *The Inferno, Purgatorio, and Paradiso,* with translations by Carlyle, Okey, and Wicksteed. London: Temple Classics, 1900, 3 vols., par. 30, pp. 115–30, and 31, pp. 112.

5. Underhill, *Mysticism,* p. 503.

6. J.H. Leuba, *Psychology of Religious Mysticism.* New York: Harcourt, Brace, 1929, p. 109.

7. R.M. Jones, "Liberalism in the Mystical Tradition," in D. Roberts and H. van Dusen, *Liberal Theology: An Appraisal.* New York: Scribner's, 1942, p. 130.

8. Plotinus, *Ennead* VI, 9:8, in J. Katz, *The Philosophy of Plotinus.* New York: Appleton-Century-Crofts, 1950, p. 151ff.

9. Underhill, *Mysticism,* p. 261.

10. Ibid., p. 262.

11. Ibid., pp. 262–63.

12. Ibid., p. 304.

13. Ibid.

14. Ibid., p. 308.

15. Ibid., p. 309.

16. Ibid., p. 273.

17. J.W. Perry, *Lord of the Four Quarters.* New York: Braziller, 1965, pp. 28–30.

18. St. John of the Cross, "Dark Night of the Soul," in *Complete Works of Saint John of the Cross,* translated by E.A. Peers. London: Burns, Oates, and Washburn, 1943, I, 326.

19. Underhill, *Mysticism,* p. 500.

20. Ibid., p. 503.

21. Ibid.

22. Ibid., p. 504.

23. Ibid., p. 507.

24. Ibid., p. 211.

25. Ibid., p. 277.

26. Ibid., p. 278.

27. Ibid., p. 146.

28. Ibid.

29. Ibid.

30. C.G. Jung, *Collected Works,* vol. 5: *Symbols of Transformation,* Bollingen Series XX. New York: Pantheon, 1956, part 2, chap. 5.

31. Underhill, *Mysticism,* p. 148.

32. Ibid., p. 277.

33. K.S. Latourette, *The Chinese: Their History and Culture.* New York: Macmillan, 1946, pp. 354–56.

34. J. Boehme, *Des gottseeligen, hocherleuchteten . . . alletheosophische Wercken .* Amsterdam, 1682. One is reproduced in C.G. Jung, *Collected Works,* vol. 12: *Psychology and Alchemy,* Bollingen Series XX. New York: Pantheon, 1953, p. 342.

35. C.G. Jung and R. Wilhelm, *The Secret of the Golden Flower,* translated by C. Baynes. London: Kegan Paul, Trench, and Trubner, 1931, Commentary.

36. J. Yepes, called St. John of the Cross, "The Dark Night of the Soul," in *Life and Works*, translated by D. Lewis. London: Thomas Baker, 1891, Vol. II, p. III.

37. Underhill, *Mysticism*, p. 294.

38. F. Hartmann, *The Life and Doctrines of Jacob Boehme*. London: Kegan Paul, Trench, and Trubner, 1891.

39. F. Hartmann, *The Life and Doctrines of Jacob Boehme*.

SOCIETAL IMPLICATIONS OF THE
RENEWAL PROCESS

I t is in the nature of cultures to be founded by heroes with a vision, who then structure that vision increasingly, to the point of freezing that which had been fiery and inchoate. Each culture — the early Christian, the Mohammedan, the monastic, the T'ai Ping, the Seneca — is so structured as to include a certain configuration of *ethos* and *eidos* and also, to exclude other possibilities. The individual personality does the same: It integrates a certain assortment of traits and leaves out others, either those it does not find compatible or those it does not have occasion to activate. The more firmly structured a society becomes in its conventions and traditions, the more it distrusts innovation, deviance, change, and intrusion by the unfamiliar. One is reminded of Eliade's[1] attractive formulation of the habit of tribal societies to regard as meaningful the ways that have been sanctified by myths telling of their having been established by the heroes of the beginning times, and correspondingly to hold as relatively meaningless and wrong the ways that are random and not so sanctified; innovations in this case are suspect.

It seems to be the lesson of history that the more solidly a culture identifies itself with its tradition and becomes conservative of its conventions, the sharper grow its distinctions between inside and outside, between what does and does not belong to it, and the more its fears deviate. But this deviance, after all, is but the natural attempt on the part of creative innovators to compensate the culture's biases.[2] It is a natural law of psychic process that one-sidedness gives rise to compensation, since the psyche has an impulse to introduce the potentials that have been left out of the pattern of integration. Yet when a culture congeals in its struc-

ture and grows defensive, it does what the paranoid individual does: It identifies with the archetype of order and develops an inordinate fear of deviance or outsideness, which it sees as disorder.

Now, the archetypal image of the traditional, conventional, structured society exactly describes its nature. It is the city kingdom in the form of a cosmos; that is, a quadrated circle and square oriented to the four cardinal directions and centered upon a world axis. Inside is the sanctified order bequeathed by heaven, endowed with its light and the "right"; outside is the area of demonic disorder and chaos, full of darkness and the "wrong," or death.[3]

In the paranoid reaction of individuals, the archetypes of the sacral kingdom are apparently all activated, and what belongs outside the pale of its little cosmos is seen as the enemy: innovations, oppositions, and compensations are perceived in the image of demonic darkness and chaos. Societies can also react in this paranoid way. Then follow the burnings at the stake in the age of the Inquisition, or the lynchings in the Deep South.

Hence it takes a truly heroic individual to break free of the binding collective consensus in such a society. The hero's journey dares this outsideness, it dips down into the darkness of that which is left out of conscious recognition and fetches up from there the treasures of new insights and fresh experiences. Society's judgment makes a great difference as to how it goes with such heroes. St. Francis was opposed by Pope Innocent III, yet seen by him as the man sent to restore a tottering Church. Meister Eckhart was pronounced a heretic by his pope for his brilliant insights into the nature of spiritual things. Boehme was hounded by the priestly establishment of his church for being a raving, demonic, dangerous heretic, unfit even to be contained in his home city. So direct and unsoftened was the vision of the poet-artist-philosopher Blake that he was considered mad by his conventional contemporaries.

There is only a short step from the fate of these mighty spirits to that of the gentle Perceval, born of a conventional aristocratic family in nineteenth-century England, who, when he went seeking a religious renovation, ran into madness and was locked up for some years. He clearly narrates that when his experience became too different and unrecognizable, the persons around him shrank away from his strangeness, and

their withdrawal drove him into his turmoil.[4] His autobiography was a protest against this lack of understanding toward his kind.

Madness springs from the panic of such isolation. It is fortunate, as Boisen has often remarked,[5] that there were no psychiatrists around who might have locked up Paul or Brother Klaus, Joan of Arc or George Fox for their auditory and visual hallucinations. Is our problem, perhaps, to be found more in our conception of what is normal than in what is called sick?

We are living in an age of transition, still under the spell of an era of reason and positivism, but entering a new one of tolerance for the nonrational. Our psychiatry still belongs to the era we are leaving. Then, men looked on mind as consisting of the rational functioning of consciousness, assuming a right way and a wrong way to think and feel. A mental "normal" was assumed by a general consensus and would be demonstrated statistically, such that all so favored could be properly alike, adapted and adjusted one to another. In contrast to such norms were the unusual and nonrational ways, which then were "disorders." There could be no room for the Pauls, Foxes, and Blakes in this world of norms; imagine anyone talking with his visions! Things must be called by their proper designations: Trances were hysterical, visions and voices were visual and auditory hallucinations — and nothing more. All that departed from the normal was by definition symptomatic of the abnormal, the pathological.

In a new age that has a degree of tolerance and understanding for the nonrational, how far can we go with it? Have we room in our new world for divine possession, like the Balinese ecstatic dancer or the whirling dervish? If we are not going to expect that all should be alike and are to agree instead that the psyche has its own strange ways of accomplishing its ends, then perhaps what were called symptoms and syndromes may call for a different interpretation and evaluation.

Symptoms are judged by the fact of departure from the norms. If we look upon these same phenomena as expressions of inner experience, as valid psychic process and content, then a thorough reassessment of them is called for.

We might compare this problem with experience in the arts. If we were so governed by a rationalistic age that we expected painting to depict the objective world realistically, then the photographic would be

"normal" and the Chagalls and Blakes "abnormal." Or in literature, if it were expected that "normal" meant clear descriptive and narrative prose, then Goethe's *Faust,* Part 2, would be considered crazy. So with psychic life. If health means stark reality-orientation and adjustment, then the adolescent storms have no place; they are sickness, not creative turmoils. If the psyche is expected to grow smoothly in its developmental stages, in gradually ascending steps, like the grades in schooling, there is no place for turbulence. But if we grant recognition to the empirical facts — that the psyche grows instead by cataclysmic upheavals — we must change our model. It is an organism that grows more like the deciduous tree than the evergreen periods of leafing and flowering alternate with periods of recession and resorption. The psyche grows by renewals — death and new life, revolutions and overthrows of what has been, and the burgeoning of new forms dislodging the old ones.

SCHIZOPHRENIA AND CULTURAL CHANGE

The extraordinary thing about schizophrenia is that it is a condition of the subliminal psyche making itself manifest in the clear light of day. Like the depths of the psyche it is so alien and unknown to us that it appears to be just exactly whatever we make of it. Schizophrenia acts as a kind of mirror held up before us, reflecting what we project upon it. In this way it becomes also a sort of eerie touchstone for psychiatrists by virtue of which they discover and establish their view of human nature and of the deviances from its norms. On the other hand, the schizophrenic person is in an equally extraordinary state. He so loses his identity that he becomes highly suggestible and identifies with any powerful impact from inside or outside. So, when society says to him, "You're too different, a menace, sick, and we'll have to lock you up," he feels correspondingly crazy and reprehensible, dangerous and unmanageable. Hence, he reflects like a mirror what is expected of him. We have only to convey to a patient the tacit message, "You're so sick you need my help to make you sane," to convince him that he is beyond the pale and isolated. The more sane-making we become in our good will, the more crazy-making we find ourselves; we entangle ourselves in our own preconceptions, and the patient becomes hopelessly ensnared along with us.

In our cultural transition toward tolerance for the nonrational and natural, might it not make all the difference to forego our presuppositions about normality and cure? If the psyche were allowed to be what it is and to act as it is inclined, to further its own ends, how much of what now leads to psychosis would resolve itself before coming to that unhappy pass? Might we come to view even "psychosis" as something awaiting a person on the forward path rather than on the regressive road away from the challenge of life?

The various historical studies of the renewal processes lead us to recognize that in times of change of *Zeitgeist,* with the accompanying need for new orientation to new conditions, the psyche is stirred into activity. New meanings for new times are produced by its myth-making function. Sensitive souls receive the impact of these activities from the psychic depths. They may become mystics, who, if they can formulate their vision for their culture, may in turn become prophets; further, if their vision can command leadership in their society, they may become messiahs, who then form new societal structures.[6] Any of these may pass through psychoticoid states on the way to their transformation.[7] However, those who do not have the gift or the cognitive wherewithal to resynthesize, integrate, and communicate their experience may become trapped in the psychoticoid state and become indeed psychotic when they realize their isolation and drop into panic. The unfortunate ones then experience their transformation "delusionally," meaning simply that they have a wrong relation to it, by identifying with, rather than being nourished by, the powerful forces at work. The process as such is in all probability a natural one, and on that account has the innumerable close parallels in myth and ritual and mystical forms that have been reviewed in this discussion.

Accordingly, if the role of culture is largely to structure psychic experience so that it aids the psyche to channel its energies into creative and effective expression, then our culture stands in urgent need of formulating this issue of psychic turmoils. In psychic upheavals, vast amounts of energy are liberated, needing to be brought from their inchoate and overwhelming forms into more livable and workable manifestations. Harmonious cultural conditions are those in which there is a good

working relation between the outer collective forms and the inner collective roots of those forms — in brief, between the outer myth and the inner one.[8] This would imply a relation of such trust toward the chaotic turbulence of inner psychic processes that they may then be experienced as creative innovation and experimentation, without sinking into the disruptiveness of a chaos without transformation.

The function of relationship comes into play in this regard. The Eros mode relates to things as they are, not only toward the outside, in object relations, but toward the inside as well, in a trusting relation to the inner life. It is no accident that the mystics have found in the spiritual marriage the fruition of their experience; it expresses this Eros relation which releases superabundant energy for effective living and working. For if the psyche is to live in health and well being, the relation to the inner life must be as "loving" or "related" as to the outer.

The opposite alternative is the power-oriented way that refuses to relate in this manner. The Logos mode is brought to bear in such a rigid way as to systematize, rationalize, and elaborate with logic until the affective immediacy has gone out of the experience of the inner life and the vital inner processes of transformation, robbing them of life and bringing them to a halt. This is the paranoid way, whether it be in cultures or in individuals. The psychic compensations, the overturnings of older forms to allow for new ones, and the transformations, are looked upon as dangerous threats to the structured and accepted *status quo* and are renounced. Such structure then serves the purpose of formulating not in order to clarify, but to defend, or even to deny. There is the recoil at the possibility of change and transformation, in misgiving, distrust, or fear.

EROS AND THE DEMOCRATIZATION OF KINGLY FORMS

Myth and ritual originally arise to form part of a culture's essential structure. These components in the psychic life of a people represent its "collective emotion," as Jane Harrison,[9] Gilbert Murray,[10] Cornford,[11] Cassirer,[12] and other scholars in this field have expressed it. Most especially is it true of the beginnings of the Urban Revolution that religious cult was part of the very fabric of the organization of govern-

ment. The king could fulfill his function as giver of life and giver of order only by virtue of the sacrality of his office and of the annual renewal of his potency. The firm belief in the gods, and in their role in the world of nature and of men, was unanimous: The proper observances toward them and the due carrying out of their will were assured by the sacral king's attention to the cult and to the code of justice.

However, the next step into which the higher cultures have tended to evolve, the Revolution of Democratization of the royal myth and ritual forms,[13] introduced some radical changes in the handling of these collective emotions and archetypal concerns. What had been the firm governing of the society's faith and conduct and morals from above — from a sacral center of authority and a pinnacle of hierarchy — slowly ceased to hold the general consensus of loyality. Government became increasingly a purely secular matter for handling the economy and enforcing law and order, while religion became a matter of private concern.

In our democratic modern society, few collective forms of belief are generally agreed to be valid, and hence there is less and less place for a myth and ritual cultic system imposed from a societal center. Rather, the trend is in the direction of viewing the contemporary culture as a collection of particular beliefs generated and fostered by each individual's own center. The archetypal functions of king, code, and cult are all found operating now within the psyche as the creation and operation of the inner spiritual life. Quite obviously, there is always a need for an order to prevent society from the possibility of formlessness, of finding itself lacking all cohesive or regulative forces. The prospect of a negative anarchy, of a disruptive chaos, only generates fear and reactionary moves toward centralization of power; in that case the golden opportunity for individuality to come into full flower in the setting of a democratic structure goes by the board.

Whenever individuals or societies find themselves faced with any such new problem to which there is no ready solution (because it involves issues which are too deep for ready understanding) the archetypal psyche is activated in response to the impasse. Its task is to provide some new orientation, and its habit is to express this in a new array of images which in fact become a new myth, along with new ways to give it expression even if not in ritual form.

The Revolution of Democratization did not simply express the spiri-
tualizing and internalizing of the myth and ritual imagery of the sacral
kingship. Along with that process there were consistently similar con-
cepts of compassion, of the brotherhood of man, of a sustained peace, of
"love." This seems to imply that the real meaning of democracy, its sig-
nificance in depth, lies not so much in the procedural sense of representa-
tive government, as in a *form of psychological culture* in which the regulative
and integrative forces are found *within the individual,* in the image of king
and code within the psyche. In this dimension, democracy is described as
possessing a new regulative dynamic for the society in which love, broth-
erhood, and compassion are as vital as the internalized king and code.
The older urban revolution had introduced a new kind of aggression and
dominance by force, as the expression of an executive function of rule
and conquest; the power principle came into its full bloom, personified
in the storm god and concentrated in the figure of the sacral king. With
the great religions and philosophies that gave voice to the new revolution
of democratization, the Eros principle received specific delineation as the
character of the new order, and the violent uses of power were put down
as wrong.

While that new cultural form was making its appearance in the Near
and Far East in the middle of the first millennium B.C., it is for us still a
new order that is in process of formation in the psyche. This I see as be-
ing so because of a clear historical circumstance, which is that Europe is
still young in its evolution. It had its Urban Revolution only in the twelfth
century A.D., compared with Israel's of the eleventh century B.C.; during
those medieval centuries it had its sacral kingship just as other new urban
cultures have had in their time. The Age of Reformation began to hollow
out the divine elements connected with the kingship, while the political
rebellions that followed undermined the authority of kings; with World
War I the sure place of monarchy in Europe was finished. Our Western
culture is still in the phase of the Revolution of Democratization, which
in its dimension of depth still awaits its fulfillment.

With our secular governments, and with our diminishing trust in
any generally accepted higher moral or spiritual authority, either in the
political or the ecclesiastical community, where do we find our real gov-

ernance — one that involves us in depth? I consider this to be the modern problem that the archetypal psyche is wrestling with in order to produce a convincing new myth that will satisfy the need of the times. Observation of the imagery in psychic depth shows political ideation to be one of the prevalent forms of myth in our time. Schizoid persons are by nature sensitive to this level of archetypal concern. Since the schizophrenic episode reveals this imagery in the open, we find there a predominance of political expressions concerning social reform.

In my series of cases, the patients' utterances are sufficiently similar from one to another to lead us to ask what makes this imagery so important to them. Briefly summarized, they sound like this:

Number 1. *The solution to her problem is the fourth party, the socialists, who are on one level (equality) and believe in the brotherhood of man and are sociable.*

Number 2. *He is elected to save the world from war with the communists and the A-bomb. There is born a new David, and the Garden of Eden will endure forever (as an era of lovingness).*

Number 3. *He is to lead a new order of the world mission of Our Lady, which will bring victory in heaven: It will bring tolerance for all four colors, continents, and races without discrimination.*

Number 4. *She has been given a special message by the Blessed Virgin for the world, to reform its morals: It is that women should keep their marriage vows.*

Number 5. *As the hero of law enforcement, he has been given a special mission of restoring law and order in society. There will then come a new order for the world in the form of equality for the four races, colors, and religions.*

Number 6. *Her four uncles are to set up a new order of government in four divisions of the kingdom, bringing an era of fair government and equality, in contrast to the former tyranny.*

Number 7. *She is to be the fourth in a succession of great religious founders and holy men, Moses, Paul, Luther, and herself; each is a reappearance of the same great spirit; there will be a New Bethlehem like the New Jerusalem, with a new order for the world in which there will be perfect men, knowing all that is important for human welfare — they will be born with the wisdom to enable men to live together in peace.*

Number 8. *She will give birth to a new divine child, David Emmanuel, who will bring a new salvation for the world.*

Number 9. *He will be the heroic reformer who will change the world and the order of society through communism; this can save the world, and he is giving it its last chance.*

Number 10. *She has been called to rewrite the Bible with a new gospel of love and kindness to heal the world of its illnesses; there is to be a New Jerusalem foursquare, with a new order of society, centered on this city as the City of Peace.*

Number 11. *There is an important world mission to which she is called, and a trumpet call announcing the end.*

Number 12. *She will give birth to a Divine Child, to bring the redemption of the world through a new order under the Blessed Virgin.*

When we hear imagery of reforming and saving the world by a code of brotherhood, love, compassion, and the welfare of the lowest, it strikes us at first as being little more than naïve idealism. However, in the context of the general societal issues of the times, I feel we should take this imagery as descriptive of the need for culture to be ruled by the Eros principle.

If true democracy has no place for the authoritarian imposition of codes of conduct and belief, and if there is to be a truly equalitarian society, there must be a growth of the emotional capacity of men to live together harmoniously by their own inner promptings. That is no simple requirement. It means that each must be of broad enough consciousness to be able to honor the point of view, the beliefs, goals, and needs of the others. But one can accept differences in others only to the extent that one is permissive and open to the same differences within one's own nature. If one can give recognition and acceptance to the various contradictions and oppositions in one's own inner makeup, then one can give the same reception to the corresponding elements in the makeup of others around us. In either case, the Eros principle is called upon: It is the dynamic principle that prompts one to relate to what is there.

For such high achievement of living in society, considerable inner development is an absolutely necessary prerequisite. Here the power principle that had been the cohesive dynamic of the social structure comes into play in a new manner. It goes through the same internalization that the kingship imagery did and is turned now toward the inner self. The proper place for the power motive then would no longer be in manipulating the environment, enforcing views upon persons in order

to make the world conform to the desired pattern. Rather, it is brought to bear upon the regulating and integrating of our own inner structure. Therefore the archetypal imagery of kingship and kingdom, with all its symbols of mastery and force, becomes applicable to this new task and goal: to make a coherent and well-knit and expanding inner culture within the individual psyche.

A glimpse of what is developing in the collective archetypal psyche in our time is given in the recent formulations of the "new theology" and the "new morality."[14] No longer is the god image represented by a Lord of Hosts enthroned in his heaven as king; for us that no longer holds much meaning. The conviction of the affect has dropped away from that image and gone elsewhere. Similarly, no longer is the law code of that king-god, his ten commandments of the covenant, binding. Those moral universals cease to regulate us by their imperatives. The current god image takes on an Eros quality instead, a loving spirit, a "god-in-the-midst" who comes alive in moments of vital "loving" encounter; that is, in situations of true relatedness.[15] His law is that of the spontaneous knowledge in the moment of experience of what is the "loving" thing to be done, with a minimal reference to the universals. This "situation ethic"[16] is springing to life today in the West as it did for early Christianity in the Near East in the hands of Paul.[17] The stress is upon the bedrock basis of any religion or any morality; that is, its actual experience by the individual. Yahweh is dethroned from the sky, and his law is dethroned from the judgment seat, but the new god image reappears as compellingly in the inner life of individuals. The Eros principle has taken over the god image and the moral imperative, while the power principle is given over to the regulation of the inner life.

In like manner, the rearing of children and their education are being governed by new concepts reflecting similar changes in our archetypal dynamics. The father figure is no longer autocratic, and the young are raised according to the principle of mutual understanding. In place of the imposition of a code of behavior and a body of teaching, we now strive toward evoking and encouraging of the child's individual creative nature, which is brought out by relating to the present, actual realities of his experience. This again is governed by the Eros principle.

These new movements may be recognized as the expression of profound preparations by the archetypal psyche to make itself ready for the era ahead, in which the social structure that had prevailed can no longer suffice for the new needs. This inner revolution seems to be fully as turbulent as the outer one taking place in the issues of youth, civil rights, or of the schools or the churches. The hue and cry now raised against the "establishment" demands a more honest and genuine basis of social cohesion.

SOCIETAL CONCERNS IN THE RENEWAL PROCESS

It used to be that our schizophrenic "patients" appeared to be so lost in their private myths that one could not recognize any application of their inner imagery to outer issues: Their concern over social reform seemed only a play of inflated and childish idealism and complaint against the faulty parental world. In the last decade, however, the tremendously wide prevalence of psychedelic "trips" has exposed the same material by a wholly different avenue. The drug experience has tapped the same roots of imagery, and has come up with the same ideals of "love" and "brotherhood," accompanied by an ardent revolt against the old ways of the "establishment." Consequently, we now witness, in a dynamic new subculture, the social expression of what was once considered to be only isolated ideation and vision in the withdrawn psychotic mind.[18] If the outward cultural expression of these psychic changes follows the design previously described in the affect-images (as it usually does), we may expect a massive social movement insisting upon extremes of individuality and equality, of freedom and tolerance, colored by ideals of brotherly love and nonviolence.

I find myself emerging from this set of investigations with a somewhat different view of what the schizophrenic process really concerns itself with. I had, of course, first been taught the dynamics that Freud had proposed in his study of the Schreber case,[19] in which the paranoid mechanism and homosexuality are linked together with the father problem in the formulation of the defenses in the Oedipal constellation: "I love him" becomes "I don't love him; I hate him," which in turn becomes "I don't hate him; he hates me." Soon after I found myself much

more taken with Jung's rendering of the symbolic process,[20] in which the regression leads back to the mother bond and at the same time to the archaic level of the psyche, remaking the desire for the mother into an intent to achieve rebirth through her. Then the overcoming of the mother bond is the achievement necessary for liberation from the childhood conditions, thus to be free to discover the world for oneself. In both Freudian and Jungian psychologies there is an emphasis upon the expression of the internal problems of the libidinal regressions, fixations, and conflicts. In both, the psyche is working out its own destiny, making its accommodations to its own limitations or freeing itself for more effective living.

In the same spirit, I have been visualizing the process as centering upon the self-image,[21] which was damaged by a central injury in early development, and which then attempts to reestablish its proper form through the operation of the central archetype in the regression. Yet I was never altogether clear about why the process expressed itself in terms of the kingship ideology, although I could find many reasons why it might make sense. My conclusion was that kingship was the mythological expression of the means by which an externalized psychic center of order was led, in the course of history, into an internalized and inwardly realized one, and that this corresponded to the need of the psychotic.[22]

More recently, I have begun to recognize more clearly that the cultural-societal aspect of the problem actually seems to dominate the mental content, and that an *entire way of life* is implicated in the outcome of the process. It is still true that the self-image lies at the core of this process and that the regression — the inward journey is directed toward finding one's essential nature, individuality, and identity — in short, one's selfhood. However, this quest then comes to its fruition in a point of view, in a world outlook,[23] and in a design of life that give explicit expression to this unique selfhood which would otherwise remain only implicit. For after all, in practical terms one's identity amounts to a way of seeing and of doing, of experiencing and of behaving.

True selfhood becomes a structure of values and meanings, unique, clear, sustained, and integrated. This is the same as a subjective culture, an internal psychic equivalent of societal culture. Indeed, this inner cul-

ture functions as the root of the outer one when multiplied into its collective dimension in an entire population.[24] I have traced out the means by which the psyche strives to achieve this creation, through centering, wiping out the old forms, letting the opposites collide and reverse themselves and merge and unite — out of it all effecting a new form of the self, a new design of life, and a new way of seeing the world. The keynote of today's new way is honesty in perceiving and expressing things; one wants to see things as they are and say them as they are — to "tell it like it is." It centers, then, on a new kind of truthfulness.

This kind of truth reflects the quality of Eros. Eros in this definition is not mere "desiring" but has the much broader significance of "relating." As Jung expresses his view of the Logos and Eros principles: "Eros is an interweaving; Logos is capacity for discrimination and detachment."[25] The Eros principle leads one to relate to things and to people, thus to experience them just as they are; it engages with them the way they come, and responds positively or negatively. Realistically disliking is as much a function of Eros as liking, because dislike does the object the courtesy of a full recognition. The Logos principle acts the other way, leading one to abstract from the experienced objects and to give them recognition only insofar as they conform to one's expectations, or one's already established view or presupposition. One selects and filters apperceptions, allowing only that which fits and rejecting the rest.

The Logos way easily leads into the urge to make things conform to what one needs them to be, thus into the power drive. Eros, on the other hand, tends to the "wide-open" stance, to relate to things the way they happen to be, whether one expected it or wanted it or even disliked it. Where the Logos way specializes in making right, the Eros way specializes in acknowledging. Eros requires the open mind, even to the point of persuading us of the value of psychedelic experiences; the power mode tends to constrict and control.

In religious traditions, the formulations of experiences of psychic depth provide ample testimony to the elevation of the Eros principle at the time that cultures reach maturity. Directly comparable to the Judeo-Christian God of Love that emerged in its later phases is the Hindu rendering of God as *Satya*, "Truth," (with Love and Ahimsa, "Nonviolence,"

as other attributes). This nonviolence has also the implication of nonviolation, or reverent respect.

In medieval Christianity, in the setting of a newly urban culture that had not reached this kind of maturation, the image of God was that of perfection, the ultimate Good, as a truly Logos quality of elevation of the ideal of how things ought to be rather than how they are. His goodness cast a deep shadow, an opposite, dwelling as deeply below as God was elevated upwards, as black as God was bright, and sowing imperfection and strife in the world over against his perfection. This God's great day came as he sat upon his judgment seat dealing out rewards and punishments, blessings and condemnations, according to the criteria of his eternal law. It has taken many centuries for Western man to find his way back to a God of Eros quality, with the existentialist moves in the new theology and new morality, in the accent on things as they are experientially rather than as they look when screened by abstractions.

THE "PATIENT" AND HIS EXPERIENCE OF THE CULTURE

One of the chief factors in the genesis of the schizophrenic experience is that such individuals have been raised in families or in conditions in which the Eros principle is weak, and where there has been little acknowledgment of the emotional realities. This milieu is usually a subculture in which emotional truth is suppressed — in which there is such an ingrained habit of judging the right and wrong ways about things that the eyes are blinded to the actual ways of feeling. If there is a constitutional factor along with this environmental one, it is that these are sensitive individuals who cannot afford to live this way, and who instead need to live in recognition of the truth of the emotional realities. I see the whole stormy process as one of coming to this realization, and to a self-image and a design of life that give full place to it.

Yet institutional psychiatric treatment is designed to nullify the meaningfulness of the work the psyche is doing. It does everything possible to suppress the experience of the individual the way it happens to come. When managerial treatment does this, it is acting in just that power mode that had prevailed during the years of the individual's upbringing and that had disturbed his natural development in the first place. Institutions in this way may become inadvertently schizophrenogenic.

I have listened to many individuals describe their previous personal experience of living under such institutional psychiatric care and management — long, angry harangues at the suppressive regime. I will try to reproduce that viewpoint now in a condensed paraphrase.

These individuals feel suddenly looked upon as estranged and alienated, threatening and dangerous to have around. They are then locked up and put away out of social intercourse. On admission in some wards they are stripped of personal possessions — jewelry, watches, and favorite articles — intensifying their experience of entering into death. When they want to say what is on their mind, their talk is considered confused gibberish, crazy patter. They are then "stoned-out" with drugs until they can no longer think and "tell it like it is" for them; the whole psychic process is put to a stop as much as possible. At this juncture they feel that an experience of great value is being stolen from them; or in the vernacular, they feel "ripped-off." As "patients," they find little chance to speak from where they are actually living emotionally, and it is sternly demanded of them that they try to talk about everyday "reality" in generally acceptable, rational, plain English — so plain that to them it loses its life or meaning. They feel herded about, watched over, and made to conform until such time as they yield. Often they narrate how they win their discharge by learning to put on a good show of "normal adjustment." They then find themselves in "rehabilitation" programs that teach them to heel to and conform to the generally accepted ways, ways that to them feel like pure pretenses. Often they find that if they reveal too much deviation from these, censure is brought down upon them for loss in "reality sense" and "judgment," and they are warned that this will only lead to rehospitalization. They feel that they are not allowed to be different because this would mean being disturbing to others.

When one hears and empathizes with the "patient's" standpoint and experience, one can no longer deny that the problem is not merely his own alone, but is shared by both sides, his and society's. Withdrawal is seen only in the "sick" one, but why is it not recognized in the "normal" entourage which recoils from him? Only the "sick" one is found to carry the paranoid fear, while members of the "normal" society around him are suspicious and fearful of the depth experience he is in. He is told he

is "systematizing" his beliefs, yet what he looks out upon is a world with a very rigidly systematized set of views about any psychic events that are unusual.

The culture that the "patient" will find normal is not that institutional one in which people withdraw and are suspicious, fearful, and intolerant of the nonrational; he sees "craziness" out there. His need is rather to step into a culture that is understanding and is sympathetic to the emotional truths, where things are in this sense real and meaningful. This would then be the culture honoring the Eros principle.

1. M. Eliade, *The Myth of the Eternal Return,* Bollingen series XLVI. New York: Pantheon, 1954, chaps. 2 and 3.

2. C. G. Jung, *Collected Works,* vol. 15: *The Spirit in Man, Art, and Literature,* Bollingen Series XX. New York: Pantheon, 1966.

3. J. W. Perry, *Lord of the Four Quarters.* New York: Braziller, 1966.

4. G. Bateson, *Perceval's Narrative.* Stanford: Stanford University Press, 1961.

5. A. Boisen, *The Exploration of the Inner World.* Chicago: Willett, Clark, 1936.

6. A. F. C. Wallace, "Stress and Rapid Personality Changes," *Internat. Rec. Med. Gen. Practice Clinics* 169, no. 12 (1956).

7. A. F. C. Wallace, *Culture and Personality.* New York: Random House, 1970.

8. P. A. Sorokin, *The Crisis of Our Age.* New York: Dutton, 1942.

9. J. Harrison, *Themis.* Cambridge: Cambridge University Press, 1912.

10. G. Murray, *Five Stages of Greek Religion.* New York: Columbia University Press, 1925.

11. F. M. Cornford, *From Religion to Philosophy.* London: Edward Arnold, 1912; New York: Harper Torchbooks, 1957.

12. E. Cassirer, *The Myth of the State.* New Haven: Yale University Press, 1946; J. W. Perry, "Reflections on the Nature of the Kingship Archetype," *Journal of Analytical Psychology* 11, no. 2 (1966).

13. J. H. Breasted, *Development of Religion and Thought in Ancient Egypt.* New York: Scribner's, 1912, lecture 8.

14. J. A. T. Robinson, *Honest to God.* Philadelphia: Westminster, 1963.

15. J. A. Pike, *Doing the Truth: A Summary of Christian Ethics.* New York: Macmillan, 1965.

16. J. Fletcher, *Situation Ethics: The New Morality.* Philadelphia: Westminster Paperback, 1966.

17. Gal. 2–5; Rom. 2–8.

18. T. Roszak, *The Making of a Counter-Culture: Reflections on the Technocratic Society and its Youthful Opposition.* Garden City: Anchor, 1969.

19. S. Freud, "Psychoanalytic Notes upon an Autobiographical Account of a Case of Paranoia," *Collected Works,* vol. 3. London: Hogarth, 1950.

20. C. G. Jung, *Collected Works,* vol. 5: *Symbols of Transformation,* Bollingen Series XX. New York: Pantheon, 1956.

21. J. W. Perry, "Reconstitutive Process in the Psychopathology of the Self," *Annals of the New York Academy of Science* 96, art. 3 (1962).

22. Perry, "Reflections on the Nature of the Kingship Archetype."

23. C. G. Jung, "Analytical Psychology and *Weltanschauung,*" *Collected Works,* vol. 8: *The Structure and Dynamics of the Psyche,* Bollingen Series XX. New York: Pantheon, 1960.

24. M. E. Spiro, "Culture and Personality: The Natural History of a False Dichotomy," *Psychiatry* 14 (February 1951): 19–46.

25. C. G. Jung, "Commentary on 'The Secret of the Golden Flower,'" *Collected Works,* vol. 15: *Alchemical Studies,* Bollingen Series XX. New York: Pantheon, 1967, par. 60.

LOVE AND POWER IN MADNESS

The nature of psychotic process may be looked upon in the main in two contrasting ways. One may see its ideational content as purely symptomatic of the disorder and thus while not without meaning, still of little use to the individual or to the therapist for recovery. On the other hand, the acute episode may be understood as an attempt of nature to reorganize, and the more essential disorder may be judged as being in the prepsychotic state. In this case, dependency upon heavy medication and "recovery" to a prepsychotic level would be regarded as unfortunate; instead, the mental content in the psychosis would be listened to with the expectation of finding there the items of value for further development of the hitherto insufficient personality. The crucial question is whether we may look into those psychotic productions for the lost affect, and if so, how it may become mobilized for the enrichment of the patient's otherwise impoverished life.

The nub of the problem of the acute schizophrenic episode is the observation made by Jung a half-century ago[1] — that the affect has not stopped functioning but has disappeared into the psyche's deepest levels, and that it may be discerned by way of the imagery in the so-called mental content. The task of recovering this lost affect is made particularly difficult in the case of schizophrenia by the fact that the psychotic ideation gives the appearance, at first, of having nothing to do with the personal life of the individual.

The problem of schizophrenic reactions compels further investigation of the interrelation of image and complex,[2] since the peculiar feature of the mental content in the acute episode is that it is rife with symbolic expressions of an almost purely mythological kind, while the personal emotional context of them tends to be bafflingly vague and obscure.

The following study is an attempt to trace out in a representative case what the "unconscious" imagery reveals of the psyche's own attempt at reconstitution and reorganization.

AN ACCOUNT OF A PSYCHOTIC INDIVIDUAL'S EXPERIENCE
(Case Number 2)

The individual in therapy was a nineteen-year-old boy who entered the inpatient service in a state of confusion and bizarre behavior of two months' duration. He had always lived at home.

The mother was an old-fashioned-looking woman, generally inhibited and with few expressions of feelings. While deferential to her husband, she would eventually reveal a capacity for tenaciousness, manipulation, and directiveness. For four years she had been in the menopause, with increased irritability and nervousness.

The father was equally inhibited, to the point of carrying an impassive and impersonal air. He was never close to the boy, and never gave him time. The maternal uncle was a closer father figure, very friendly, warm, and admiring of the patient.

There were two sisters — an older and a younger. The older resembled the boy and spoke with childish voice and silly manner and giggling. The younger was more wild and unmanageable and consorted with a delinquent gang with whom she got into trouble and spent some months in reform school. The older sister married just before the boy's illness began.

After certain traumatic events at age six, his schooling came hard. He had difficulty reading, and his mother took it upon herself to coach him. He evidently felt pushed. At twelve, his mental age was eight, and he spent the fourth to sixth grades in a school for retarded children. However, he was able to get through junior high and two years of polytechnic high; he quit at eighteen, having had enough of being pushed along.

The signs of the oncoming break were only that four months earlier, after two weeks at camp, he seemed preoccupied and unhappy. He began drinking for the first time. Two months before admission, he would come to the table acting like a dead man, mumbling to himself. Later on, he became hyperactive and talked excitedly and irrationally.

THE MAIN IDEATIONAL THEMES

I held interviews three times a week with him in which I listened attentively to the free flow of his symbolic content. Most predominant in his

ideation were his inflated identifications with superlative figures of three main types — governmental, religious, and heroic; in each role he single-handedly conducted an attack on enemies appropriate to the same three groups; that is, political systems, forces of evil, and monsters of various sorts. The three overlapped, of course.

In the governmental idiom, he was an ace airman ("ace-high"), and a second George Washington leading the defense of the country against the Russian communists, who were trying to capture the world. Russia was on hell's side and under Satan's rule, and his own death was to be a sacrifice for his people. At other times he thought he would be made ruler of the Russians, a nation of darkness and slavery. As Prince Valiant, king of the country, he sent 300 youths, members of his club, to their sacrificial deaths in the Korean War. Later in the process, the imagery shifted to a plot by the Germans to conquer the world and raise him up as universal emperor; the Germans were to be heroic superscientists and masters of the heavenly world through astronomy; they would shoot him in a rocket to the moon, where only he could survive.

The religious imagery described the patient as another Christ, leading the fight against the Devil; like Christ, he was to be crucified and rise again. The Garden of Eden figured prominently: It was once occupied by Father, Son, and Holy Ghost, but then taken over by the Devil. Interwoven with this were stories of four kings of the four directions, and a major world conflict between the king of the North and the king of the South.

As a mythical hero the patient found himself performing great wonders. As King Richard the Lion-hearted, he killed a tiger and strangled a serpent just after he was born. As a Japanese-born hero he took on the form of a serpent and acquired a "vicious power to strike back"; he killed a tarantula who was a Japanese mother dressed for battle, and he overcame several monsters.

It will be observed that when governments and wars were spoken of, he was mythologically cast as king, prince, founding father, or emperor; and that as victor against enemies and monsters, he saw himself involved in exploits that belonged to the ancient mythology of kingship — hence his roles as King Richard, Prince Valiant, emperor of the Germans, head of the Russian people, and Christ the King.

IMAGERY OF ORDER

Of all the features of schizophrenic mental content, I think it can readily
be agreed that one of the most regularly recurrent and most prominent
is the idea of supreme sovereignty, designated by the term "grandeur."
Elsewhere, I have proposed the thesis that this symbolic process is based
upon the same imagery as was the archaic myth and ritual of the sacral
kingship, in which one finds similar motifs of rule over the entire world
or cosmos.[3] Yet this suggestion only leads to the more essential and in-
teresting question of what psychological meaning is to be discerned in
these soaring aspirations toward universal rulership and messiahship.[4]

The principal ceremonial expression of the effecting of order was
the sacral king's warrior role as victor in the ritual drama of the "sacred
combat," or "cosmic conflict," in which he impersonated the storm god in
battle on behalf of the forces of light, life, and order against the forces of
darkness, death, and chaos, usually represented by monsters.

If we now translate mythological into psychological expression the
cosmic order can be taken as the structuring and regulating of the in-
ner world of the emotional life; that is, the "integrating" principle. The
sky would then be the image of the spontaneous activity of that "spirit,"
which strives toward ever increasing organization of the psyche in gen-
eral and of the image of its consciousness in particular. The storm and
wind, on the other hand, are the image of the more violent assertion of
will, recognizable as the aggression which plays such a necessary part in
the establishment of a strong mastery by consciousness. We are justified
in identifying the storm god with the archetypal force driving toward
ego-consciousness, inasmuch as he made his appearance on the stage of
history as the dominating mythological figure just at the time of the de-
velopment of urban societies, with their new capacities for mastery in
technological skills, their use of writing, and their thirst for conquest
and empire (and the personal aggrandizement thus achieved). This
powerful god arrived upon the human scene along with the sense of his-
tory — indeed, he may be called the maker of history.

It is evident that the male deities of the sky, as promoters of or-
ganization and integration, are archetypal affect-images belonging
to the "Logos" category of drives — the high-sky gods as images of

the integrative tendencies, and the storm-warrior gods as those of the "power" drives.

In the schizophrenic disorders that belong to the "renewal syndrome," or reconstitutive process under discussion, the most prominent forms of grandiosity are recognizable as identifications with these archetypal affect-images. Our case material affords a perfectly characteristic instance of these, only perhaps slightly more florid and flamboyant than some in its productivity.

IMAGERY OF THE CENTER

The individual drew with crayons during some of his interviews, making many representations of the quadrated circle in conjunction with his stories of kings, victors, and saviors.

The Garden of Paradise with its Trinity and Devil, and the kings of the four directions were instances of this arrangement of space. The crown of Prince Valiant consisted of a cube surmounted by a sphere from which sprang a radiation of seven stars or jewels on gold streamers. The breastplate of King Richard had concentric circles quadrated by two crossed swords, with signs indicating the club of 300 youths who went to their sacrificial death in war; a variant on this was a shield of concentric hearts quadrated by crossed swords.

Among the parallels from the sacral kingship of archaic times is the emphasis upon a world center or cosmic axis, a position of most intense and concentrated potency for creativeness, both in the sense of the giving of life and the giving of order.[5] This was typically the ritual locus at least of the king-god, if not of the king himself. This mythological image of the center was the location of a focus of power and governance, with a structuring of a sacred space around it in the form of a quadrated circle (the origin of the mandala). This surrounding structure was at one and the same time a cosmos, world, kingdom, temple, and throne room, in times when the archaic mythological mentality perceived these as sharing in the same nature and pattern.[6]

The themes of the center are so regularly recurrent from case to case in their basic outlines[7] that one needs a way to account for them. From the pioneer work of Jung and from several decades of observations on the

symbolism of the center and the quadrated circle (or mandala), it is evident that they have to do with the centering, ordering, and structuring of the self, the totality or wholeness of the entire psychic organism, as the dynamic focus of the "Individuation Process."[8] Inasmuch as this theme of the center often appears in ways that do not have to do with the establishment of mature selfhood in the sense implied by individuation, I have proposed the more generally descriptive term "central archetype" as more suitable, especially for discussion of its appearances in psychotic process.[9]

GENESIS OF THE PROBLEM

In terms of the quite immediate personal experience of the growing child, it appears that the central archetype is experienced in the first years of life, in projection onto the mother; that is, it functions as the dynamic core of the relation between mother and child.[10] She is experienced as that all-governing, omnipotent Great Mother whom Neumann describes as the first archetype of order, or the self.[11] Moreover, the child does not have what can be called a separate psychological existence until the ego begins to consolidate at the ages of five to seven. Up to then, he lives in a state of what we call "emotional participation" ("participation mystique") with the parents, first especially with the mother: he shares the mother's complexes, as introjects which color the central archetype with greater or less disturbance.[12]

Now, it is all important that the mother carry the role established by this archetypal image in a way that is suitable. The loving, nurturing function of the mother in respect to psychological life requires that she give affirmation and support to the child's growing nature, which means giving appropriate recognition and response to what the child's experience actually is at any moment. As soon as she is imposing upon the child expectations and judgments of her own which are not appropriate to the child, quite another thing goes on. Then, the male functions of mastery, manipulative control, and even aggressive power, come into play from her own masculine component (we call this her "animus").[13] The tendency seems to be, on the part of the mothers of schizophrenic persons, to assert this function in a particularly unfavorable way.

THE MOTHER'S ANIMUS THREAT AND ANIMUS EXPECTATION

The individual gave many indications that he saw women as mothers who were strong, aggressive, destructive, and goading their sons to rash feats which led to their death.

He spoke of them as wearing the pants, being the tougher fighters. It takes ten men to one woman. Men are the little Christmas trees which get cut and then burned every year, while women are the big redwoods with roots and fruits. In his transference, he saw his resident, a woman, as "a dragon, a woman that looks like a man, a man that is really a woman; a dragon plays for a man's eyes." "She is putting my eyes out."

There were many castration ideas. "The American attitude is to respect woman as holy, and they sterilize sex offenders. You should keep away." He was infatuated with a nurse on the ward, and he said that she tempted him and then hit him "in the balls"; "She is Hitler, the Devil, and Black; Hell always was a woman," a snake and a temptation.

These motifs came together the third month in a more clear indictment of the mother figure. "Women carry the gun. They want me to study science and go to war [this accompanies the idea of the Germans associated with the mother, being superscientists and ruling the world, and shooting him to the moon]. Women want men to go to war; they cut off the boys' tails like rats. They declare war on their sons. A mother crawls into her son's bed under the covers; that's why men go to war and don't marry. Mother's a German. Women don't want Father and me to fly [as an Ace]."

Every woman's a murderer who has killed her son and her husband. "I killed a Japanese woman who was a snake." He recounted the slaying of other maternal monsters: three King Cobras, an octopus, a crocodile, and a bear. Japanese women go around playing with other boys; German women win over Japanese. He spoke of their shooting all the mothers' sons, then the parents would be happy because there would be only girls left.

A child who has grown up under the aegis of a mother whom he perceives in this image feels himself contending with a very conditional affection — one that conveys the message that, unless he becomes what she wants of him, or rather, what her animus demands of him, he will lose her altogether (cf. Bateson's double-bind).[14] Thus, a dubious "love" is overclouded with the burden of expectation and the guilt of not measuring up. The child feels somehow fraught with faultiness, and learns to feel unacceptable and unlovable, and outside the bonds of lovingness.

Feelings become threatening, too dangerous to risk, and then they are withdrawn.

THE TWOFOLD SELF-IMAGE

In this individual's statement of his feeling about himself, he did not hesitate to present himself as infinitely pathetic — and not without reason.

"For 20 years I've been the little guy behind the 8-ball." "Father loves B [sister], Mother loves L [sister]; I've been in the middle from the start." "I'm called a ghost, just a white garment walking through the halls." "Father never let me be a man. No one ever loved me. My uncle was my real father. I've been a woman all my life; my penis was broken — you might as well cut it off. I'm an orphan stolen from the garbage collection."

Even after the acute episode was over in a short remission, it still went on in the same vein. "A black curtain separates me from other people which I can't get through. I've always felt like a sad sack. I've been on the outside looking in, outside the society . . . I'm like castor oil; it just passes right through you and nobody likes it . . . I'm like a cigarette you don't want to smoke . . . I've been hurt too much and my spirit's been killed, like a horse that can't go any more; I can't be hurt any more."

So low were his feelings of self-esteem and so debased his self-image. Yet diametrically opposed were other portrayals of himself as superlative and extraordinary, full of wishful qualities of a personal nature not directly composing part of the archetypal symbolism, yet bordering upon it.

He called himself "Ace High," the "Man of Steel," "with the strength of a hundred," of "ten thousand pounds," who can crush anything and can get on with the women, "the most perfect man" and a "leading scientist."

The implications for a boy who has felt puny, and in school has had problems of a question of mental retardation, are obvious. These expressions of strength were often interspersed with ones of withdrawal.

He said that strength makes him independent, so he can "go alone," never violating a woman, "keeping away from the girls," being "pure and holy and white as a sheet"; "I have no feelings" . . . "I'd rather be in Russia where you're left alone."

I have formulated this situation in the following way. From the feeling of faultiness there arise a couple of major effects. One is that the self-image becomes severely damaged. This situation has had its effect on two levels: on the personal self-image — that is, on the ego's view of itself as inadequate, faulty, and outside; and on the archetypal self-image, which is compensatorily aggrandized and exalted and central. The second effect is that, because of the hurtfulness of the first bond with the mother, all relationship comes to be held in greater and greater doubt, until gradually the whole proposition of closeness is more or less renounced. This means an abandonment of the Eros principle, and a shift of its energy into the opposite principle, that of Logos and Power.[15]

LOVE AND POWER

As I have already described these modes, the Logos way experiences persons primarily in terms of what the subject makes of them according to one's own values and meanings, while the Eros way experiences them in terms of what those persons reveal themselves to be as they manifest their own values and meanings. In more stressful circumstances, the Logos way becomes a power drive to make others conform to one's own expectations, while the Eros way appears as a love drive enabling one to delight in experiencing the otherness of other persons. An Eros-oriented parent, therefore, is ready to relate to what is actually there in a child's experience, especially to respond to his thought and feeling; the *power*-orientation filters out what one does not choose to recognize and what one does not want to have happen.

The shift of libido from the Eros to the Logos mode in the prepsychotic personality is encouraged by the very fact that the mother image was formed as it was. That is, the mother not only is the first carrier of the central archetype (of the self) in the earliest years, but also, as woman, should be the first representative of the Eros principle. If the child's experience of her was primarily not as a loving woman but as a controlling animus, then the stronger influence from her part will be that of promoting power and control, rather than relationship — the Logos rather than Eros principle.

This shift is encouraged by a felt need to find strength at least within the psychic activity of the subject. If one cannot find loving affirmation from outside, at least it seems one can achieve a sense of worth by, say, knowledge or good performance or accomplishment or some such effort of a prestige-winning nature.[16] In many individuals this can succeed to some extent. In prepsychotic personalities, the split between the debased personal self-image and the too-exalted archetypal one makes success improbable, especially since the fantasies of success in achievement (produced by the archetype) are so entangled with the image of dizzy heights of power and mastery or sainthood that the attempt is made to seem too forbidding.

The overall policy by which the schizoid personality lives is that of keeping the emotional field safely manageable according to his own preferences. The ultimate method of control on his part is the withdrawal of feeling, to reduce the field down toward neutrality. Since the patients belonging to the syndrome I am describing are by and large more than usually sensitive and perceptive, one can see what a great violation is done to their natures by this distortion of their potential for relating and by this constriction of their range of emotional interaction.

PROCESSES OF REORGANIZATION

I conceive the acute schizophrenic episode to be precipitated by the imbalance of the self-image, overly debased and overly exalted. The prepsychotic ego is threatened from without and from within: from without in the fear of recurrent hurt in relationship; from within in the dread of becoming engulfed by the inflating primordial images that tend always to overwhelm it. Anxiety mounts and it takes only some experience that stimulates the central archetype into activity to precipitate an eruption of the unconscious and an identification of the too weak ego with the too powerful images. Then the ego, thus inflated by the central archetype, feels itself to be a hero or a king or a god.

However, this central archetype is one that has a strong tendency to undergo a transformation process when activated. In the renewal process in royal ritual we find the features of the life-giving aspect of the kingship, in which the king-god is the personification of fertility in the

realm: He submits to a seasonal decease of resurgence; he, or his son, defeats the forces of death and wins reinvigorated life; and he performs the ritual marriage to promote the fertility of all life in nature. These qualities mark him as associated with the Eros principle.

If we now use the renewal imagery to characterize the reorganizational process, it becomes possible to discern in the material what components of the psychotic individual's makeup are undergoing change.

IMAGERY OF DEATH AND REBIRTH

The idea of renewal and rebirth came in a flow of ideation from him on Halloween day, when considerations of death are easily stimulated. He was speaking of various opposites, of right and left as head and heart, as his day mind and night mind, or as heaven's way and hell's way. Then, "You clean the whole body right through if possible without killing . . . If you're fighting Hell it's different, though. That means going to sacrifice . . . Cremation means burning them, and leaves ashes . . . It blows away and makes dust, and that goes into the air, and there's nothing. We become spirits, like Christ at Calvary; His body was a sacrifice. It shows the love He really had; so His spirit rose again. For me, I believe I have to do it."

He sees an alternative to this fate, too: "The body has no way of coming back. It's in the ground and rots. But it's horrible if they claw out of their graves like animals when they go crazy; they go nuts . . ."

Another form in which the rebirth motif was expressed was an another's idea of going to Russia by submarine, where he was to be killed and also schooled — in other words, initiated. He drew as he spoke with me:

"You're a Russian. You're trying to get the whole world . . . You get the whole round world [drew the world divided in two halves] . . . the whole world is surrounded by water in a circle out here [draws a band of water around the rim of the earth]. Why don't you send me to your underwater school? Then I'd be on your side . . . You're all absolutely identical . . . You're sending the fish to Moscow . . . You're the captain of the ship."

There are various subsidiary ideas of dismemberment and castration already touched upon:

When I'm asleep you take me to a room below and pound me up, balls and all. My parents were forced to poison me . . . I'm branded with hot water [at the genitals so all the jiz is

gone and nothing's left living. So I can be independent . . . To assassinate me, that's the communists' goal, to burn me and bury me alive.

I interpret these images of death as signifying the dismantling of a certain psychological structure that the psyche finds no longer tenable or favorable to life and growth — that is, to forward development. This I conceive to be a state of the self definable in terms of a structure of values and meanings formed by the promptings and indoctrinations from the mother's animus. All his life the boy has heard these judgments of a collective nature, held up before him as the pattern (ego-ideal) of what he ought to be and as the criterion by which he is found constantly faulty.

The dismantling of this structure is then followed by the creation of a new one, at first only in symbolic form. The new one represents the boy's own nature, his own preferences, views, and makeup according to his native endowment.

IMAGES AND AFFECTS OF EROS

One aspect of this realignment of values was that of the emergence of Eros from the predominantly power-motivated earlier state. This occurred in a patient's interview with the resident (a woman), in the fourth week.

You're a communist. You're Mussolini; Mussolini was a woman. I knew you were King of the North . . . It means the communists will die out if you release me. If you don't release me, an atom bomb will drop on the hospital . . . You have been putting my eyes out . . . The Devil met you first . . . You tempted the Devil. I'm George Washington and you're my wife. You belong to no one but me . . .

You were the first woman on earth and I was the first man. You're Eve and I'm Adam. David was our first son. Jesus Christ is our son. I was created first and you second. I knew you were a woman of iron like J am a man of iron . . . You remember when you sent Jesus Christ down from the moon and he was crucified at Calvary . . . We are reborn every nineteen years . . .

"It takes my mother to get my strength. I knew you were my mother . . . The Garden of Eden will live forever . . . The earth will never die. We were nailed on the cross, all three of us. I was nailed to the cross first, then you, then Jesus Christ. He died and was buried, but we rose again and are spirits.

You saved my life by coming back to me. You went to the North and I went to the South. I have always looked for my tree and I have never found it. You were the man and I was the woman. When I got sick I knew right away that I was a woman. My breasts swelled up, and I knew I had to find you. You are Mary and I am Joseph ... You changed me from a woman to a man. It's because you changed yourself from a man to a woman ... You and me started the Christmas tree. We will have a big redwood tree ...

The resident notes that "as the patient talked, he changed from an extremely tense, excited, agitated state to a calm, relaxed one. There were tears in his eyes when he talked of my being his wife, and of my saving his life. As he got up to leave he said, 'Now I am happy.' He leaned over and kissed me gently on the cheek."

That same day occurred an interview with me. He came at first with an air of steely anger at me, and intense suspiciousness written over his face, and narrowing of the eyes:

You're responsible for my illness. You're Stalin, the communist ... You're keeping me in here to kill me ... I know the real reason for my nervousness. My father would never let me be a man ... But he isn't going to do it any more; I won't let him. That's why I'm here; no one ever loved me. I never knew who I was. My penis was broken. You might as well have cut it off. But you fixed it up again. I'll always be grateful to you all the rest of my life. That's real love. You're my real father, I know ...

At the end of the session, he was weeping with considerable tenderness of feeling in his voice. He was making it evident in these dramatic encounters that something new was happening to him which was deeply moving and causing profound changes in his relation to himself and to those close to him.

Once the ego has identified with the central archetype it finds itself going through the process that this archetype tends to undergo, that of death and dismemberment. The agency of destruction is the archetype of the King's Enemy, here as so very often in present-day schizophrenics, represented by communism. On the mythological level it is the image of darkness, chaos, death, and everything opposite to the archetype of light order, and life; on the personal level, it is the image of all those values that oppose those of the ego-conscious stand point and threaten

it with nullification. In this situation of a constricted ego structure, the opposition is between those values and meanings that belong to the conventions dictated by the family subculture and all those that are left out of this order and considered unacceptable but that are being activated. In this sense, the darkness of the "shadow" components, as Jung had termed them,[17] represents their "outsideness," their rejectedness. They intermingle in the imagery with the patient's own feeling of rejectedness, outsideness, and unacceptability, and they dismantle the structure derived from the mother's animus-dictates.

The death and dismemberment theme is accompanied by a regression of the libido to light up the associations of infancy, hand in hand with the archetypal imagery of the return to the beginnings of time (Eden) and the world creation and new birth. Its aim seems to be to mobilize and bring to consciousness the components hitherto held in abeyance or in repression, in an unconscious or even inactive state, but now needed for the personality's further growth.

It is clear how strong was the activation of the archetypes having to do with the Eros principle, so much needed for relationship in this personality starved of warmth and human intercourse. These components lay buried from infancy on, since that bond with the mother failed to fulfill the archetypal requirement of activating the capacity to love. The regression must then lead back into that very emotional situation to reach those affective potentialities thus far existing only in a state of dormancy.

The new birth is the archetypal expression of a successful return of this kind to the mother bond, and coincides with the appearance of the newly activated contents exhumed from their burial in infancy. The Divine Child is the affect-image of the new start with this added completeness. For its meaning we have only to listen to the description of its own metaphorical sense, as it appears with the affective tone flooding into the patient's speech and action at the time. All the warmth of lovingness excited him to a high pitch of intensity. In the two interviews just described, he challenged each therapist with the most intense power identifications, then turned them over into their most ardent Eros aspects.

All this play of ideation and affect is the autonomous, archetypal psyche giving expression to its own concerns and efforts, in terms of Sacred Marriage and New Birth imagery. What the ego does with it is another matter. Were the patient able to sustain this process, this Sacred Marriage imagery would probably soon motivate a love experience. Then in a more real form he would meet an opportunity for mutual affirmation of the self between himself and another, and with it the first conscious intimations of his true nature. For this is nature's way of realizing one's manhood, one's knowledge of oneself as a person of strength and a person of warmth, as a man of power and a man of Eros.

INDICATIONS FOR THERAPY

Speaking to the question of therapeutic method, one of the basic tenets of this procedure is that therapy should follow the psyche's own spontaneous movements of the libido — more simply, you work with what the psyche presents. This implies that the psyche is trying to work out its own problems in its own strange and nonrational way, and that the therapist would do well to take these efforts as his guide.

During that phase of the process in which symbols of mastery, government, and power are most prevalent, one does well to follow the intent of this imagery. The psyche is at this time in a state of withdrawal from relationship and of investing all its energy into activating the central archetype; both the withdrawal and the regression are aimful, representing an intent to structure and order the inner, intrapersonal psychic field. I do not feel it is wise in this phase to interrupt this process too drastically with efforts to push the patient into interpersonal relationships, and force him into an unwanted and untimely activeness; the occasion calls for intrapersonal work instead.

However, when the renewal of the central archetype has reached the point at which the images of Eros are formed and active and accompanied by sufficient affect, inasmuch as the libido has now entered into the arena of relatedness, there is new motivation and interest for this effort of relating. Then the time is ripe for encouraging the expression of the Eros functions in interpersonal directions.

During the turmoil of the episode, relatedness is made problematic by the fact that things are going on in the individual's preoccupations that are extremely difficult to communicate. The therapeutic relationship serves as a testing ground for the experience of revealing very private and personal ideas and feelings heretofore held secret. Since these present themselves largely in nonrational imagery, the question of creative expression to convey them must be considered.

1. C.G. Jung, "The Content of Psychoses" (1914), "Schizophrenia" (1958), *Collected Works,* vol. 3: *Psychogenesis of Mental Disease,* Bollingen Series XX. New York: Pantheon, 1960.

2. Ibid. See also "Recent Thoughts on Schizophrenia."

3. J.W. Perry, "Reconstitutive Process in the Psychopathology of the Self," *Annals of the New York Academy of Sciences* 96, art. 3 (January 1962): 867–68.

4. J.W. Perry, "Reflections on the Nature *of* the Kingship Archetype," *Journal of Analytical Psychology* XI, no. 2 (1966).

5. J.W. Perry, *Lord of the Four Quarters.* New York: Braziller, 1966, introd.

6. J.W. Perry, *The Self in Psychotic Process.* Berkeley: University of California Press, 1953.

7. J.W. Perry, "Reconstitutive Process in the Psychopathology of the Self."

8. C.G. Jung, "Conscious, Unconscious and Individuation," "Concerning Mandala Symbolism," *Collected Works,* vol. 9.1: *The Archetypes and the Collective Unconscious,* Bollingen Series XX. New York: Pantheon, 1959; *Collected Works,* vol. 7: *Two Essays on Analytical Psychology,* Bollingen Series XX. New York: Pantheon, 1953, pp. 108, 171ff, 238.

9. J.W. Perry, "Acute Catatonic Schizophrenia," *Journal of Analytical Psychology* II, no. 2 (1957).

10. Ibid.

11. E. Neumann, *The Great Mother,* Bollingen Series XLVII. New York: Pantheon, 1955; *The Origins and History of Consciousness,* Bollingen Series XXXLII. New York: Pantheon, 1954.

12. C.G. Jung, "Analytical Psychology and Education," *Collected Works*, vol. 12: *The Development of Personality*, Bollingen Series XX. New York: Pantheon, 1964, lecture 3; *Analytical Psychology: Its Theory and Practice*. New York: Pantheon, 1968, pp. 82–188.

13. C.G. Jung, *Collected Works*, vol. 7: *Two Essays on Analytical Psychology*, Bollingen Series XX. New York: Pantheon, 1953, part 2, chap. 2; *Collected Works*, vol. 9.2: *Aion*, Bollingen Series XX. New York: Pantheon, 1959, chap. 3.

14. G. Bateson et al., "Towards a Theory of Schizophrenia," *Behavioral Sciences* (1956): 251–64.

15. C.G. Jung, "Secret of the Golden Flower," *Collected Works*, vol. 8: *Alchemical Studies*, Bollingen Series XX. New York: Pantheon, 1967; *Collected Works*, vol. 7: *Two Essays on Analytical Psychology*, Bollingen Series XX. New York: Pantheon, 1953, part 2, chaps. 2–4.

16. P. Metman, 'The Ego in Schizophrenia," *Journal of Analytical Psychology* II, no. I (January 1957).

17. C.G. Jung, *Collected Works*, vol. 9.2: *Aion*, Bollingen Series XX. New York: Pantheon, 1959, chap. 2; *Collected Works*, vol. 7: *Two Essays on Analytical Psychology*, Bollingen Series XX. New York: Pantheon, 1953, pp. 24, 29, 52–53, 94, 236ff.

THE CREATIVE ELEMENT IN THE
RENEWAL PROCESS

They are silent because the division walls
are broken down in the brain,
and hours when they might be understood at all
begin and leave again.

Often when they go to the window at night
suddenly everything seems right:
their hands touch something tangible,
the heart is high and can pray . . .

— Rilke[1]

All of us who have touched the deep inner spaces of psychic life, whether in psychotic, psychedelic, or deeply meditative states, have experienced the convincing realness of those interior regions. Even while we know first hand how overwhelming they are in their feeling and visual forms, we often sense how crushingly incapable we are to give them words. For the beauty, the terror, and the love; for the visions of meaning and the flashes of insight, the words of our conscious instrumentation are found too small and cramped, too constrictive, and our modes of expression too encased in old structures of familiar experience.

When I first read Dante's *Divine Comedy*, I thought his oft-repeated protestations that "words failed him" were affectations of humility before the awesome greatness of his vision. How could it be that a poet with the most supreme command of language could find no words for what he wanted to say? Now I realize he meant exactly that:

[I] have seen things which he who descends from there above neither know how nor is able to recount.[2]

To contain the full dimensions of the experience of inner depth with all its vitality, we need fresh original expressions that are equally quickened with the sense of wonderment.

The psychotic individual in his deeply interior psychic spaces feels isolated because he cannot convey them to the persons around him who are not there, who are not dwelling at the same level of psychic functioning. Especially is this so when such an individual knows that to reveal his inner experience might only serve to condemn him to a diagnostic category, "schizophrenia," full of forebodings and implications of a crippled life. My concern in researches into this condition has been to explore ways of crossing the chasm of communication.

When we are confronted with a psychotic individual in the acute episode, what we see is a person deeply withdrawn, irrational, and overwhelmed in a world of symbolic imagery. I once found a young male patient looking out the window at the sky lost in contemplation of his "father," whom he perceived as the dome of heaven itself or as God residing in it. He talked of the "sun" up there, by which he meant the offspring of the sky (who is therefore its "son"), and this had implications of the brightness of spiritual illumination. The celestial father and the sun were references to his own relation to his father, but they crowded out any mention of this personal level of experience.

Medical psychiatric zeal leads the staff to come down upon such a condition with a host of recommendations and treatment plans: "What the patient most needs is . . . " A busy program of directive action ensues — to socialize, to orient to reality, and to improve body awareness, through crisis intervention, milieu, and many other modes. This represents the physicianly stance, to correct the disordered condition — in this case, to change the person's experience. Sometimes these ways resemble medical rites of riddance, to drive out forces that one thinks should not be there.

But there is another way. If we can relinquish our drive to make changes, and just quietly listen to what the individual's psyche itself is doing, we find surprising things happening. The psyche is already busy

with its own aims to repair the situation. In fact, we discern that the psyche had drawn the individual into this predicament for a very good reason, to bring about some very much needed changes in the organization of the self and of the emotional life. As we hear the stream of talk about the person's preoccupations and concerns, we see him immersed in a very different dimension of experience: one of nonrational, symbolic ideation, a world of mythical kings and heroes, sacrificial death and new birth, clashes of cosmic and political powers, all seeming very far removed from the here and now. The clinician throws up his hands in dismay and exclaims that the affect has gone and that it must be roused again — things must be changed. Yet if we keep listening, we find the psyche is already doing just that — that the images are at work in recovering and stirring up dormant affective potentials.

The model by which I work sees the image and the emotion coupled together as two facets of one phenomenon, which I have termed "affect-image": The image renders the meaning of the emotion, while the emotion lends the dynamism to its image.[3] On this account the images lead to the lost affects. They are the means by which the affects become processed in nature's own way, unfamiliar as it is to us. Thus in the young man just mentioned, the images of the celestial father and son become the devices by which the emotions concerning the father-son relationship, and thus his own fatherly potential, become activated and resolved. It is my belief that the psyche still knows best how to mend its problems of such basic nature. I also find that with this approach to psychic turmoil, the disturbed individual feels a relief from his appalling isolation and inability to communicate; he is immensely relieved if he finds we can listen to what his psyche is doing.

"Watching" might be a better term than "listening," since, as we have noted, the contents of the psychotic experience appear mostly in image form (including the use of drawings) and the words communicating them are at best only approximate. Visual forms of expression are closer to the nature of the phenomena themselves. What, then, are these elements in the psychotic process?

In sum, one may epitomize the contents as themes of a mythological cast, which have a trend with a distinct ground plan, despite the superfi-

cially random appearance of the flow of symbolic concerns. There is an initial phase in themes of death and dissolution of old forms. The process drives toward an inchoate state in which opposites of all kinds come into play: light and dark, good and evil, beauty and ugliness, order and chaos, revolutionary and conservative politics, peace and war, masculine and feminine qualities, and a host of other contrasting principles. The individual experiences these opposites falling asunder, clashing with each other, reversing their positions in relation to each other, and finally uniting in resolution. Then follows a phase of creation and birth of new forms. The elements in this renewal process in psychosis and in myth and ritual forms have been fully discussed.

(I must emphasize that these contents and processes found in psychosis were in no sense given shape by me as they occurred. They are spontaneous productions that arise from the individual's depth, whose morphology may be quite independent of any influence from outside. I have heard, since this formulation was made, many descriptions of such sequences of psychotic process occurring in persons whom I did not know until after they had passed through their episode.)

In this renewal process one may recognize many motifs representing creative activity. The prevalence of themes of creation and ordering of new forms stands out strikingly when one focuses attention on them. An impressive motif is the creation of the world, which entails a victory of the forces of order and light over those of chaos and darkness. Another is the re-creation of oneself by a return to the breast or the womb and achieving a second birth. The sacred marriage motif touches upon the essence of the generative principle giving rise to images of conceiving new life and new birth. When one watches the production of symbolic designs in art forms during this renewal process, one may observe gradual attempts at forming a center and a periphery and may notice a step-by-step division of the enclosed area into quadrated form.[4] I find the formative, aesthetic function most clearly visible in this effort, which arrives finally at formations of mandala designs. It is not unusual to perceive a contrast of the ugliness of chaos and disorder with the beauty of ordered composition.

These considerations lead me to think of the much discussed question of the relation of creativity to schizophrenic process in a somewhat special light. I find it helpful to think of the process as dealing in essence with matters of order and disorder; or better, of organization, disorganization, and reorganization; or of integration, disintegration, and reintegration. One might question whether creativity is an outcome of the process, or perhaps a fortunate accompaniment of the process which then may foster and facilitate recovery. I myself see it as having a much closer relation to the essential psychotic dynamic, as a part of the very nature of the renewal process itself. The motifs and contents making themselves known from psychic depth in this turmoil portray the inner nature of the creative function itself. The individual in the episode, after all, forms what any artist seeks to achieve: a world image, an image of society, and an image of man (the self) and his experience.

Frank Barron's eloquent formulations of the creative personality contain observations that apply to this creative element in the renewal process. In creative individuals "we see frequently . . . an ability to transcend the ordinary boundaries of structures of consciousness to break through the regularities of perception, to shatter what is stable or constant in consciousness, to go beyond the given world . . . " Of the creative writer he says, "Such individuals are involved constantly in the creation of their private universes of meaning; they are cosmologists, all." He draws the same parallel with the psychedelic experience as I do with the psychotic one: "Certain aspects of the creative process . . . are analogous to the kind of breaking of perceptual constancies that is initiated mechanically by . . . the drug." The creative vision requires an act of rejection breaking the previous world structure, and it needs the work of the symbol as "the medium through which a superior vision of reality is sought, thus presenting "a reality transcended."[5]

When creativity is found in this renewal process, it must not be taken as identical with aesthetics, or with artistic giftedness, and especially not with productivity.[6] The point I am emphasizing is that in the acute psychotic episode there are many motifs depicting the essence of the creative process. One often finds these expressed graphically in drawings of a schematic or diagrammatic character that reveal no talent at all for

artistic expression.[7] They are in this case made of the raw material of the creative impulse. On the other hand, in certain individuals comparable motifs and diagrammatic themes may be represented in fine aesthetic form. For the purposes of therapy, psychotic individuals need to be assured that the meaning of their expression in one or another form is not to be judged on artistic merit, but rather that the freedom to let go and allow motifs to find their own expression in some artistic medium is of the highest value. Even without talent, the formative creative principle is at work, as I see it, as the fundamental process of renewal and reorganization goes on during the acute episode. An intriguing possibility for research is the question of whether it helps an individual to accomplish his renewal process and to bring it to fruition if he or she has a special talent that might help to expedite it; that is, has a repertoire of potential expressive forms to give structure to his or her otherwise somewhat amorphous experience.

In my interviews with persons in psychosis I have usually sat where there was a table nearby on which were paper, crayons, and paints. There is such a predominance of symbolic imagery in the preoccupations that there is a natural inclination to lay them out in visual form, for all the world like a young child spontaneously spinning out designs and colors in a spirit of play. Often a symbolic process is stirred into action and accomplished by this means.

An example is the experience of a young man of twenty-two as he went through a two-fold set of emotions: one of finding himself at odds with the attendant staff because he was combative and obstreperous in his behavior on the ward; the other of being preoccupied with death. As we were sitting together he began playing with the crayons humming a western song, and his drawing took the form of a cowboy in gay colors. I nearly passed this off as a doodle accompanying the tune, but fortunately asked him what cowboys meant to him. He wanted to live on a ranch, he answered, but his wife was a city girl and had no taste for it. Indicating my curiosity I encouraged him to enlarge on this. His grandfather, his father's father, was such a cowboy, a rangy, engaging, swash-buckling roisterer, easily violent, footloose, but lovable; he met his end in a barroom brawl at this young man's present age. He remained only a legend,

since his father never knew him. When I remarked that he seemed to take after his grandfather, he pondered this, and often in a later meeting scribbled "I'm my own grandfather."

Being thus introduced to his problematic self-image derived from this legendary grandfather, we now found ourselves in an ongoing process. He drew graveyard scenes, often in a depressed mood. Then followed a representation of the death of this forebear himself, lying back on the ground with his last breath going up in rings and with flowers growing up out of his body. Finally, new birth manifested itself in a drawing of the Holy Trinity in the heavens, he and his wife being god and goddess, and their daughter a divine child. Since he was expressing many tender feelings for this girl, I took this image to show the constellation of some new potential for warmth and relatedness; the grandfather's demise, by the same token, was an archetypal expression of the death motif; that is, the coming to an end of an old and no longer viable self-image as a prelude to the formation of a new one.

The drawing of the dead grandfather precisely resembles the Egyptian representation of the dead Osiris; out of the body of each grows the vegetation designating the new life out of death. Both are grandfather figures, embodying the transforming principle.

The renewal process consists fundamentally of a reorganization of the self. I would formulate its psychology in this way. We witness in it a "high arousal state" in which the lower centers are activated at the expense of the higher, and which Roland Fischer has appropriately termed "hyperphrenia."[8] Hyperphrenia is a condition in which the energy has been withdrawn from the ego functions and from the complexes that govern the everyday activity of the emotions, and has been concentrated instead at the deeper levels of the psyche which are composed of the emotionally laden, symbolic affect-images. The experience of the psychotic individual in this state is not unlike the psychedelic one, in which he senses himself overwhelmed by a nonrational psyche that is wholly other than the one of his everyday experience. In the psychosis, his cognitive structures or schemata[9] have disintegrated, and their level has been overrun by a spontaneous overflow of images and emotions, displacing the once rational functions. If the observer's model hinges upon a psy-

chopathology, he will see this disintegration as ominous; if he can recognize the reorganizational character of the psychosis, he can view the disintegration as a necessary phase of the reintegrative process.

The work of therapy is to foster and enhance this trend toward reintegration. The role of creative expression in this context is to give form to the phases in the self's transformation (such as death and rebirth or world destruction and creation) that is spontaneously occurring in the renewal process. The reorganizational tendencies will be ongoing and spontaneous if the therapeutic conditions are favorable, but interpretation facilitates their coming to consciousness. Especially in regard to the individual's feeling about himself, as experienced in his self-image and in the image reflected back to him in his relationships, the comments made in the therapeutic interchange play a vital role in bringing them to awareness. I see the role of interpretation in this regard as helping nature to convert the raw, archaic modes of image and emotion into the more differentiated concepts and values belonging to the conscious ego functions of thinking and feeling.[10] In this way the cognitive structures, through being temporarily disintegrated, are rebuilt along new lines representing the individual's new experience of his self and his world.[11]

When the episode has run its course, the process of "reentry" from the condition of being "spaced out" — of taking the fruits of the episode into daily life — contains the problem of how to integrate these contents of psychic depth. It is a question of making coherent that which was jumbled, and of differentiating that which was inchoate. The episode is a kind of pregnant chaos, like that described in Plato's *Timaeus* as the "teeming womb" and "nurse of all Becoming."[12] The motif of the Creation tells eloquently of the need for the action of order over chaos, for bringing the formative principle to bear upon it. I am reminded, in this phase of the psychic process, of what some of the Christian mystics have experienced after their illumination. Jacob Boehme, you will recall, declared that he learned more about the nature of the world in the quarter hour of his transport than he could have in several years in a university;[13] it took him decades to elaborate in articulate form the recognition of meaning that had arrived in an amorphously conglomerate form. A psychosis is less instantaneously global, yet in six weeks or so a whole uni-

verse of meaning makes itself known to the individual. It, too, needs a long labor of assimilation to make articulate and specific its fertile yield. Just as mystics have tended to reapproximate their amorphous experience to recognizable traditional formulations — as Gershom Scholem points out[14] — so the individual after the psychosis needs to bring the unfamiliar contents of his experience into line with the familiar world.

Another role of creative expression in this process, then, has to do with this work of reentry, by ordering and assimilating, through the formative work upon the raw material of the psychic productions. This represents the work, in Kris's terms,[15] of the "ego functions" upon the crude "primary process" productions.

To speak again of a mode of therapy, I feel it is not fitting to "do things to" the psychotic individual. One does not have to direct his work, but rather the great need is to allow the psyche to proceed with its own intentions. Far from management, what the psyche requires is that the therapist relate intensively to it in all its specific expressions. This means relating to all that might make its appearance there, without needing to abstract from it, to force it, or to make it be something. This way becomes an easy, flowing, appreciating response to what emerges into experience. In this spirit much is found beautiful along the way, and the profound contents that emerge can become exciting and deeply moving to both the psychotic individual and the therapist. Terror and turmoil may still occur, but in my experience they happen far less under these circumstances.

Creative expression, then, provides a vehicle for this aesthetic-formative aspect of the psychotic experience. Any of us who have worked with persons in this condition have seen many creations of high aesthetic value, whether they be in poems, paintings, sculptures, dance forms, or even prose statements of the inner experience.

A musical artist of notable talent, Dory Previn, has made a moving statement of the subjective experience of order and chaos during her psychotic turmoil:

> After the initial periods . . . I was no longer patient with occupational therapy. I was every time compelled to write, I felt (I think) if I could put the shattered fragments of the mind down on a piece

of paper with limited space and margin, I could arrange them and rearrange them until, out of the unlimited chaos, I could at least make some order within the limits of that square of paper. Then I would look at the completed lyric, see the order in it and feel some miniscule sense of relief. Beyond the edges of the paper was terror and confusion.

She made a comment revealing the character of the true artist, that she would observe and compose in the midst of any state of being:

> No matter how disoriented I was, I always seemed to have this logical, lucid third eye and ear which watched and listened, and put down on paper every "bizarre" thing I was doing, seeing, or hearing (those voices, "Mr. Whisper"). Why I had that I don't know.

From her notations grew three albums revealing the full dimensions of her inner experience in deeply moving songs.[16] With her endearing humor she points it up:

> ... terrified and fortunate till I die. At which time I will probably say, "Would you hold this death thing for just a minute? I'd like to write a song about it before I check out."[17]

We have discussed several functions of creative expression in the acute psychotic episode. As pure communication, it can express in the therapeutic setting that which is not easily put into words but is more readily expressed visually, inasmuch as the content of the process is in large part composed of symbolic imagery. Creativity is a natural and essential part of the psychotic "renewal process" itself, which is rife with themes of creative imagery, such as world creation, the victory of order over chaos, the engendering and birth of new life, and other motifs of this kind. Re-entry into life is facilitated by the formative work upon the inchoate state of the psychic contents; assimilation and ordering are enhanced by art work. Finally, if the process is running its course in a more or less coherent way when a therapist is relating to it sensitively and unobtrusively, many artistic creations of some aesthetic value may make their appearance.

1. R.M. Rilke, *Selected Poems,* translated by C.F. MacIntyre. Berkeley: University of California Press, 1958, p. 99.

2. Dante, *Paradise,* translated by C.E. Norton. Boston and New York: Houghton Mifflin, 1892, canto 1.

3. J.W. Perry, "Emotions and Object Relations," *Journal of Analytical Psychology* xv, no. 1 (1970).

4. J.W. Perry, *The Self in Psychotic Process.* Berkeley: University of California Press, 1953.

5. F. Barron, *Creativity and Psychological Health.* Princeton: Van Nostrand, 1963, chaps. 19 and 20.

6. S. Arieti, "The Rise of Creativity," *The Intrapsychic Self.* New York: Basic Books, 1967, part III.

7. J.W. Perry, "Reconstitutive Process," for examples in plates.

8. R. Fischer, "A Cartography of the Ecstatic and Meditative States," *Science* 174 (November 26, 1971): 897–904.

9. J. Piaget, *The Construction of Reality in the Child.* New York: Basic Books, 1954; A.F.C. Wallace, "Culture and Cognition." *Culture and Personality.* New York: Random House, 1970, chap. 3.

10. C.G. Jung, *Psychological Types.* New York: Harcourt Brace, 1923.

11. A.F.C. Wallace, "Stress and Rapid Personality Changes," *International Record of Medicine* 169, no. 12 (1956). I am indebted to Karen Rabin, student psychologist, for her work on this formulation.

12. Plato, "Timaeus," *The Dialogues of Plato,* translated by B. Jowett. London: Macmillan, 1871, II.

13. J. Boehme, *The Works of Jacob Behmen.* London: M. Richardson, 1764, I, 15.

14. G. Scholem, "Religious Authority and Mysticism," *Commentary* (November 1964), p. 32.

15. E. Kris, *Psychoanalytic Exploration in Art.* New York: International Universities Press, 1952.

16. D. Previn, *On My Way to Where.* New York: McCall, 1971.

17. D. Previn, personal communication, July 1972.

A PHILOSOPHY AND METHOD OF THERAPY

The psychotic turmoil in the renewal syndrome can be regarded as the psyche's attempt to accomplish something. I have leaned in the direction of assigning the element of sickness and pathology to the prepsychotic state, and that of potential growth and reintegration to the psychotic process. This raises some knotty questions as to what to call schizophrenia; is it really illness, craziness, pathology, or disorder? This has been the medical model of both formulation and treatment of this state. Are we justified in rearranging our perception of it so far as to think of it as a disruption of the adaptive psychic functions on the way toward better integration? In these days of psychedelic drug experiences, such terms as "spacing out" or "tripping out" — into mental states that are very difficult to distinguish from psychotic ones — are perhaps far more descriptive of the nature of the phenomenon.

The question is not merely conceptual or academic. It reaches into the very core of the phenomenon of "insanity" or "craziness." For the present-day literature is pointing out something that everyday experience teaches all of us who work in therapy with people in the schizophrenic state; namely, that what is absolutely crucial to the individual who is beginning to "space out" is the emotional response of the persons in his surroundings. If they are appalled, bewildered, and afraid, and have the feeling they are separated by a yawning chasm from this individual who has drifted into another world that is no longer recognizable as part of human experience, then the individual in the plight feels himself isolated and alone. Panic seizes him when he realizes he has dropped out of the world of human communication. When his sense of identity has dissolved inevitably in his turmoil, he is completely prey to whatever image of himself happens to come onto the mental stage. If he is looked

upon by those around him as insane and crazy, that is exactly what he "becomes"; that is, it is the image he adopts of himself, and his behavior will give expression to that. The other way, if he has friends who are not at all appalled at what he is undergoing, because perhaps they have had their own "trips" on various drugs, and they regard it instead as an impressive and fascinating experience even if uncomfortable, then the individual does not feel crazy and does not act so.

In all this the element of withdrawal is perhaps at the root of how things go at this juncture. The individual beginning to "space out" becomes engrossed in his inner world, in a play of emotions, images, and experiences that become inordinately active and powerful; he is swept into preoccupations as the libido shifts from its usual conscious level down into this archetypal world. He is withdrawn at this juncture, both because of his preoccupation and because he cannot tolerate the discrepancy between the quality of the input from outside and that of the experiences going on inside. He is generally oversensitive and overstimulated and has to shut down on the input. But there is another more deadly withdrawal that occurs. The persons in the surroundings withdraw from him and his strange state. Even if they are trying to be kind and tolerant, they may at a subtle level seem demeaning, and may convey at least a hardly perceptible recoil; that to the individual in his very heightened state of discernment is very perceptible indeed. It makes a gigantic impact upon him, and tends to aggravate his own withdrawal from their response. Who is "alienated" now, at this point? If the individual is in a legitimate psychic "space," then we must confess that the so-called normal persons around him are alienated because of their lack of appreciation or experience of that space. They are the ones who are at a loss, alienated, and withdrawn in respect to this individual, and suspicious toward him. The person "spaced out" catches the mirror image of the emotional attitude of the persons around him.

Therefore the very core of the issue of setting up the right conditions for a good experience in this turmoil will be this emotional attitude of the surroundings. The "patient" needs "asylum" in the sense of sanctuary, a safe and congenial space to be in while living through his experience in depth. It must be in a community of persons who are sufficiently

familiar with this inner world not to be afraid or condemning of it, and on the contrary, are able to relate to it from point to point along the way of this inward journey. They must hold off their Kraepelinian symptom-and-diagnosis set, and attune themselves instead to psychic experience the way it happens to come.

A second issue at the kernel of right conditions is that of the style of management — whether it be on the medical model of imposing control and regimen, or on the other model, which looks for the equivalent order from a different source. The choice of models rests upon one's concept of what psychosis is and does.

If acute schizophrenia is a rampant chaos of primary process material, and if the ego normally is the only psychic organ that is capable of ordering and integrating the psyche, and if now this center of mastery has withdrawn defensively into the welter of meaningless irrationality, then management of the patient would be required to provide that order from outside. Then imposing controls and setting limits would be justified, and attention would be given to establishing a regime of living and grooming that helps the ego to accustom itself to its adaptive functions once more. This medical model tends to form hierarchical structures of the staff personnel, for the presupposition is that the doctor is the expert who understands the "patient's" pathology, dynamics, and needs, and can administer the appropriate treatment regime through his nursing staff, which in turn assigns functions to the attending staff. The bottom of this pyramid is the "sick" patient, who is below "normals." The restoration of order to the psyche comes from the top downward; from the doctor's trained skills through the nursing staff to the patient's ego-consciousness, which, it is hoped, will similarly impose order once more upon the disordered psyche.

Now, if the view of the psyche is that in the acute schizophrenic break a nonrational process is set in motion that is seeking to reorganize the self, and resynthesize and reintegrate along new lines, then this whole concept of a therapeutic regime would be turned around. Here, the emphasis would be placed on encouraging the spontaneous moves that make their appearance from psychic depth; in fact, the lead in the process of recovery would emanate from the bottom, from what is below

the ego-consciousness of the disturbed individual. (I will refer to him now as the "Individual.") In that case, the persons who live closest to him will be the ones who know best what is happening at this significant level, and that means that the members of the community of Individuals and the attendant staff will be in the most favored position for an understanding of what he is experiencing. The philosophy of therapy, in this case, is not one of imposing order from above by a regimen of strict management but rather a more fluid one of sensitively following the Individual's concerns as they evolve through the process in order to catalyze it. In this model, a democratic structure of the ward community is the appropriate form, in which ordering and integrating are expected to emerge from the spontaneous concerns, feelings, and insights of both resident Individuals and staff together. The nurses' skills and the doctors' special abilities are called upon as specific functions and contributions to the total handling of the ward community, but more in the sense of a horizontal differentiation of labor and function than of a hierarchical pyramiding of them.

Democracy can be recognized as a stage of psychic development in which the ordering and ruling principle is realized as belonging essentially within the psychic life of the Individual. (I have described elsewhere how crucial it is in the new orientation that the Individual be engaged in discovering in his psychotic process.) The social structure and culture established in the therapeutic milieu should be a reflection of this natural need, a fitting external expression of what is happening in depth.

My own experience has given rue a taste of each of the modes of handling persons in psychosis: a benign old-style private hospital, a busy medical-model neuropsychiatric clinic, a crowded, overworked county hospital service, an experimental milieu in a state hospital, and a non-hospital residence. The cases I studied in depth were in the first three of these. The state hospital was the site of the "Agnews Project" in San José, California, where for two and a half years an experimental program was carried out on a special research ward to differentiate between those subjects who fared better with tranquilizer medication and those who did better without it. The "drug-utilization" experiment was designed by Julian Silverman, making use of neurophysiological measurements

of "attention styles" — those who are oriented outwardly and those in-wardly — to differentiate on admission between those who go deeply into an inner subjective experience by preference and those who resist it and hold it out in projection. I am not in a position to give any account of the results of the experiment, since the data are being processed at the time of the present writing, except to say that we did find many individu-als without medication undergoing their psychosis fruitfully and with good outcome in their follow-up assessments. It was my task to conceive and describe a milieu design and to advise and consult with the staff dur-ing the progress of the experiment. I learned much from the difficulties, frustrations, errors, and puzzlements of those years, as well as from the beautiful and revealing episodes that occurred from time to time.

The following description of a desirable milieu for the "develop-mental crisis model" of psychosis and its therapy is a transcription of the one used for the design of the Agnews Project, only slightly revised. That project was given its death knell with the closing of the entire state hospital. However, a double-headed phoenix has arisen from the ashes of its demise, in the form of two nonhospital residences for the handling of acute schizophrenic episodes in young adults: in San José, Soteria, a somewhat Laingian-style project, and in San Francisco, Diabasis, a somewhat Jungian-style one set up to follow the philosophy detailed in this volume. I am engaged in this latter undertaking at the present writ-ing, which is operating as one of the facilities of the Northeast Commu-nity Mental Health Services of the county.

Again, the therapy and milieu design as outlined in this chapter is being used as guideline and philosophy of this residence.

THE DESIGN OF THE MILIEU

Such an ideal "asylum" should be a nonhospital residence, if that is possible, or if a hospital ward, it should be as informally structured as possible.

The milieu would not cling to any set theory of schizophrenia or set method of treatment, but rather would be guided by certain general observations from the experiences with this syndrome. One such im-pression is that an Individual in this psychic space is highly sensitive to the attitude around him toward his condition. If the attitude is one of

empathy and respect for his inner experience, which allows him to give full expression to his unusual and nonrational concerns, then he can communicate these actively in a number of ways, verbal and nonverbal, and in consequence become tractable at least to the person to whom he has given his primary confidence. On the other hand, if he were to find himself in an environment in which he is prevented from communicating his concerns, anger would mount and then rage, and the problem of handling his combativeness would be apt to become acute.

The value in giving full attention to the preoccupations of the Individual, however, is more than that of winning his trust. The affect which has dropped away from everyday concerns appears associated with the nonrational, symbolic, mythological, and archaic mental content. These "affect-images" can frequently be identified as portraying specific deep emotional concerns with life issues, and at such times the lost affect can be reinstated in its living context, in making these simple connections between the images and the affect belonging to them. The key to restoring the affect to the personality lies not in the ego, but in the archaic images. Then the contents of the significant complexes make their appearance once more as recognizable problems.

A further and perhaps even more valuable benefit from giving full attention to the Individual's inner preoccupations is that in these symbolic images may be discerned a process whose basic ingredients are regularly recurrent from case to case and which reveal traits that mark the process as disintegrative and reintegrative in its character. It appears to be at this level of the turbulent play of affect and image that a deep and massive reorganization of the components of the self is taking place in the psychotic episode. It also appears that this reconstitutive process is facilitated by the intensification of affect that occurs in a one-to-one relationship or transference. This "therapeutic" rapport with another seems to provide a containing framework for the Individual, within which the process can be experienced in its fullest intensity and yet in some measure of security for him. It does not seem particularly important that the person in the "therapist" position be able to make "interpretations" according to any psychological theory; his empathetic participation with the Individual in the inner experience seems to be sufficient.

The general policy of the milieu would be in accord with these observations. This service would provide a unique atmosphere based on the attitude that the Individual's experience is an "altered state of consciousness" to be explored, and not a sickness to be immediately put to a finish. The Individual would be given to understand that the nonrational concerns he is caught up in are not going to be looked upon as bizarre and disordered thinking, but rather to be respected and related to as potentially meaningful. It would therefore constitute both a nonhospital atmosphere and a well-staffed service, with all the advantages that this can provide for protection of the Individuals during their acute turmoil. This provides an atmosphere of attentive concern for the Individual's welfare. In this sense, this undertaking sets out to do something more difficult than the usual hospital service does, in setting up such an environment for the Individual with maximum freedom to experience and to express his inner process and its contents. While such maximum permissiveness is to be provided at the same time the Individual needs the assurance of an equally maximum security in which to let go; for if there is apprehensiveness in regard to safety, his sense of freedom would be curtailed. This is particularly true of those Individuals who go through the turmoil most fruitfully, who are the most hyperactive, delusional, and disturbed. There is a freedom/security ratio to be sought out, assuring the most release and trust and also the most promise of no danger to the Individual or the service.

The staff of paraprofessionals would be trained in relating to the Individual's altered state of consciousness and all his inner preoccupations as much as possible without anxiety and without pressure to make him conform to any expectation. This would include also how to let the Individual alone when he needs to be. In the staffing of such a service it is well to maximize the role of the paraprofessional attendant staff and minimize that of the professional staff, so that something may be learned of the possibilities of the most effective use of limited funds for providing what is needed for good outcome. Such a paraprofessional staff should be trained to act in the role of "gurus" to the patients in their inward journey.

For the selection of such a staff, it becomes evident that a considerable number of potential members come to light — consisting of interested persons who have had to contend with psychic turmoils or altered states of consciousness themselves, whether in psychotic breaks, adolescent storms, psychedelic or religious experiences, or their own psychotherapy or analysis. There is a need to assess which of these kinds of persons are able to handle the milieu experience; some will be too involved or too confused themselves, and some will discover that they are only wanting to work out their own psychic distress in projection in therapeutic encounters — and yet among these will be found some who come with the most ready empathy with the psychotic experience.

The staff would be exposed to all the possibilities of relating to Individuals in altered states of consciousness, and of tolerant attending to nonrational streams of talk and other communication. They would not be indoctrinated in any particular psychological theories, but rather would be encouraged to adopt a general attitude of openness to anything that may come from the Individual's psyche. Their preparation should include as much exposure as possible to the feel and look and sound of schizophrenic experiences, whether from accounts in case studies, literary works by former patients, or tapes and films. They may thus find themselves ready to respond with some sense of recognition to whatever comes from the Individual.

The service would require some specific appointments for its own purposes. There should be room and ease for communal associating with one another, and at the same time equally for withdrawal and privacy. There should thus be arrangements for single rooms as well as double. Since late evening and nighttime are apt to be the times of most intensive psychic activity and productiveness on the part of the Individual, arrangements should be made to have an adequate staff present and ready to relate to him during these hours. There would be present on the service itself the facilities for sitting together at meals, and it would be advantageous for the attendant staff to be present at table with the Individuals.

Since Individuals in this psychic space are prone to give expression to their imagery in plastic form and find considerable release in so doing, and since this provides an excellent means of communication with the

attendant staff, there should be a room on the service for creative expression. A part-time art therapist would be of help in providing instruction in the means and media of expression, not for busy work in leather purses and copper ashtrays. The actual times that Individuals will want to make use of them will be as much during the evenings as the days, and therefore it would be of advantage to have this room open and its equipment available at any time, day or night. The use of music would be available as well as the plastic arts for expression, also dance and body-awareness methods. The service should have a room for withdrawal and quiet solitude, for a setting that allows an Individual to concentrate on his inner process. There must be a room, too, for the free expression of rage, in which neither staff nor resident Individuals need fear the consequences of destructiveness, as would be the case if the rage were expressed on the general service itself; in this situation an attendant could be present to relate to the Individual's rage permissively without undue alarm and consequent suppression, and without applying the traumatic seclusion routine.

The service would be conducted as a "therapeutic community." The main work of "therapy" would be given into the hands of the attendant staff, as part of the exploration of the question of how much can be accomplished by the right use of low-budget, paraprofessional personnel. In this case the psychiatric staff would act in the capacity of consultants and supervisors to the lay staff. The questions would arise: how the resident Individuals do with one-to-one interviews and with group sessions; how necessary the one or the other is for good progress; whether it is best for these to be clearly structured in time and frequency, or left to the Individual's feeling of the moment. At least, arrangements should be made to make it possible for the Individual to have a closed, one-to-one session with an attendant at least three times a week, as well as plenty of opportunity for conversations during the days and evenings. Notes should be kept by the interviewer on the content of the Individual's concerns for a full documentation of the contents of the psychotic process in regard to images and affective issues. The hope would be that such a staff would learn how best to be of help to the Individual in making connections between his inner image preoccupations and his emotional life situation. Toward this end, the senior consultant staff would hold

weekly interviews with each of the attendant staff to help them to grasp the import of their Individual's process, allay their own anxieties, and increase their tolerance for the nonrational contents and feelings with which they are dealing.

Since transference projections fall unpredictably on men and women of the staff, and since these provide excellent soil for beneficial therapeutic relationships, ways would be explored to make it possible for the Individual to find his "own therapist" by this avenue. Some of the work of supervision and consultation would then be given to helping the attendant staff member handle such emotional relationships.

Group sessions of the whole therapeutic community would take place regularly, and efforts would be made to find ways in which the inner concerns of nonrational nature can be brought into play fruitfully, to help the Individual to feel less isolated with these and regard them as less bizarre and more meaningful.

Special attention would be devoted to helping the individual explore his cultural and emotional environment and his difficulties with it. To this end social anthropologists could be called in on consultation to throw light on the issues involved. Also, when the situation indicates it, the family of an Individual could be asked to participate in interviews with one of the staff and sometimes in a group encounter with the Individual.

THE COURSE OF THE EPISODE

We have already noted that, in the psychotic process, if the social environment conveys to the Individual that he is ill and intolerable, and he experiences himself as crazy, then he becomes just that. His progress may well be a downhill one into deterioration, and then he is insane and then chronic. Very likely the best eventuality for him would then be to go through the whole acute experience once more with a new opportunity to experience it as a reconstitutive process.

Another factor making for craziness is the Individual's own inclination to put the inner psychic experience to other, defensive uses. There is then a discernible difference between his genuine inward journey and process, and the acting out that he may do in relation to his outward setting. The first six to ten weeks of his acute phase are the ones in which

his intrapersonal concerns tend to be absorbing, and he needs to be intensively occupied with them, and "spaced out." Later, his appetite for interpersonal affective relations grows. But by this time he has learned that these preoccupations and the scattered fragmentations of thought can become handy devices for distancing the persons around him and evading communication. He can withdraw into them to get away, rather than to explore them. This is an interpersonal use to which he puts the material that properly belongs to his intrapersonal process, and he finds himself playing games rather than getting on with the work. The skill of the staff in discerning the difference between the bona fide inner process engrossing the individual, and this pseudo-inner content being used defensively by him, will be critical in helping him to find his own best outcome. If the Individual's attention style is such that he shows himself almost incapable of doing anything but exteriorizing his inner contents in the paranoid mode, it may then turn out that medication and setting of limits and controls may be the only recourse.

Ordinarily the progress of an Individual's experience tends to go roughly along these lines: For six to ten weeks he may be engrossed in his inner process, withdrawn in it and preoccupied, yet able to communicate it to one that he trusts in a therapeutic relation. The next four weeks or so, perhaps the sixth to twelfth, tend to be the time he is motivated to explore the possibilities of applying the fruits of his process in interpersonal affective relationships; he tends to have a new interest in people's feelings, and to engage with them and enjoy a concern with them that he has not experienced before. At the end of three months he is usually ready to go out, and the best procedure is to enter a residence in the outer community where kindred spirits live in a setting much like that of the milieu, only now with the direction of interest placed toward exploring the possibilities of a congenial way of life and set of cultural conditions out in the world. Communes are excellent living arrangements for this phase, or else community residences in the nature of halfway houses.

What is perhaps most crucial in this phase of the second three-month period is the Individual's need to assimilate the contents that have been stirred up in his inward journey. He has a chance now to go over it, discuss it, and reflect about it. I have stressed how important this

phase has been in the lives of the great mystics, who by the hard labor of making sense of their insights accomplished tremendous work, and grew in stature themselves. The same may be said of the equivalent psychotic journey. This at the least has the effect of enriching the Individual's own consciousness, structuring his personality, and broadening his scope of awareness. Further than this, it may also bring to light unforeseen talents — in writing, the plastic arts, or music, or perhaps in scholarship or psychological exploration. It is also probable that those persons who come through their journey enriched and gifted may turn out to be the best source of congenial therapists, who would be able to react with unusual understanding to others going through their psychosis.

A question that invariably arises when discussing inner process in psychosis is, How many of the persons undergoing the episode can be expected to come through it "improved"? A related query is, What do follow-up studies indicate as to basic changes for the better in this process? First of all, this is only one among several different schizophrenic syndromes. In my series of twelve persons belonging to the group undergoing this syndrome, while I did no systematic follow-up studies, I did observe that those who experienced the whole renewal process fully in all its elements left the ward distinctly improved, enriched, and in touch with important issues in their emotional life. Particularly so were the young lady of chapter 2 (number 12), she of chapter 3 (number 7), she of chapter 6 (number 10), and she whom I described in "The Self in Psychotic Process." The young man of chapter 1 (number 3) and he of chapter 10 (number 2) fared well enough but not as strikingly as these. The one in this chapter (number 5) made good improvements but had some recurrent episodes, as also did one young lady I have written about.[1] The ideal would have been for me to continue psychotherapy with these after their discharge, but I was for several reasons unable.

Other investigations will tell more of the outcome of the episode. The Agnews Project, while it was not really a full trial of the thesis because the milieu was not allowed to be kept true to its design, will provide some statistics that are still in process at the time of this writing. The Diabasis Project now under way is going to be a fuller test of the effectiveness of this mode of therapy under more favorable conditions, as will also the work coming from Soteria.

This present study of the inner process in psychosis, therefore, is an attempt to investigate and understand what the psyche itself is attempting to accomplish during this form of episode. How the individual's ego-consciousness does or does not respond is a whole other study in itself. Afterwards many eventualities may supervene, some of which may throw the individual back into renewed turmoil, and much depends on whether the individual is continuing in a psychotherapy working in depth. I regard this volume, then, as a study of a process and not as an assessment of a kind of therapy.

THE INDIVIDUAL THERAPY

Based on my own experience with psychotic persons, I have a conviction that each Individual does best if he has special access to a particular person on the staff for intensive "psychotherapy." If it does not occur because no arrangement is made for it, Individuals soon complain that they are in no way being given a real hearing. "Intensive psychotherapy" need not be regarded as "treatment" of the "patient" by the staff member, in the sense of doing something to the sick "patient." Especially it need not be considered a prerogative of the psychological professions. Rather, it may be seen as the setting up and establishing of a relationship in which any such staff member can be invited into the inner space and inner process in which the Individual finds himself, to take the journey with him.

As I have seen it, the Individual's preoccupations in the early weeks of the episode are often very secret. He is inclined to assume at first that he cannot be understood, and that he must remain alone in isolation with his concerns and hence a prey to the enormous, overpowering strength of them. He is then overcome with fear, or he panics, and sinks into the feeling of craziness. It often takes many days and many sessions for the Individual to feel convinced that perhaps he can in fact be understood. Upon reaching such an attitude he soon becomes coherent. He then begins to reveal where he has been and what has been going on in his inner journey. However, this is usually given in a spirit of trust and privacy, with an expectation of respect for confidentiality; hence, I have learned to be scrupulous about absolute honesty as to whom I talk with about the Individual, and what and how much I might pass on of his confidences.

The question often comes up, why the structured sessions with certain Individuals? Is it not enough to relate casually and randomly to him, letting him say and confide what he wants to spontaneously whenever the occasion arises? I am in agreement that this should go on in just this fashion but it is not enough. It takes an immense amount of involvement, effort, and reflection to get into an Individual's inner world with any sufficient degree of recognition of the various complicated things going on there. This effort means a lot to him, for it is usually the first time in his life that anyone has been willing to make such an attempt. The combination of the two persons' experience sets up an emotionally charged mutual relationship in which each is resonating to the other vibrantly.

As I see it, then, this mutual bond becomes something that the Individual cherishes, and he needs to know he can rely upon it regularly. It results in several consequences. It intensifies the psychic process by adding this strongly emotional dynamic charge to it. Whereas the Individual's attention, train of ideation, and attempt to relate had all tended to scatter and fragment up to this point, they now draw together into some consistency. There now appears a tendency toward the shaping of the inner journey or process in some degree of coherency and of movement, proceeding from day to day with the activation of new and needed contents. One gets the sense, in these conditions, of the unfolding of a process with some sort of inner plan to it. When it feels that way to the therapist, the Individual is probably feeling the inner pressure to convey this inner experience to him with some degree of coherence; hence it prompts him to clarify his concerns along the way. Also there is an equal pressure from an expectation of movement and progress along the journey, and a distaste for stasis. I cannot see the casual and unsustained, random relations with staff as accomplishing anything like this intensification of the psychotic process.

Now, if my impressions are on the right line — that for the first phase of the episode the need is to explore the whole inward journey — then we need every possible adjunct to therapy to give creative expression to the symbols and images that appear during it. My habit has been to have implements for drawing and painting on the table at which the Individual and I sit for our interview, and I have found that in most

cases scribbling drawings and diagrams in color comes as naturally and spontaneously as to a child of five or six. Modeling is excellent for giving firm three-dimensional substance to objects and figures of one's fantasy. A method that is being explored is the sand tray with little figures and objects for settings, with which one can objectify all kinds of psychic contents, processes, and fantasies, without the encumbrance of the work to draw or paint it all out. Puppets might be used with changeable stage settings, especially if one contrived a full array of common archetypal motifs in the figures. Music, dance, and body-sensitivity exercises are all helpful and vital activities that Individuals enjoy and profit from, especially in their efforts to retrieve their hidden affectivity. I would only caution again that in these initial weeks one must take care not to be intrusive, but rather to show infinite tolerance and respect for the Individual's need for privacy and withdrawal in apartness. His affect and his taste for relationship will come in due time.

In the second phase, when the "symbol trip" is showing signs of having run its full course and the emphasis turns toward loosening up the affectivity that has been missing up to this point, then all manner of devices to give expression to this newly won affectivity are in order. If the Individual tends to sink back in passivity or to use withdrawal to play frustrating "games," then more intrusive ways of getting his energies mobilized are in order, providing, of course, that these represent his own psyche's intentions. It appears to me that psychodrama has its most efficacious use in this phase, especially of the forceful kind that shakes loose the Individual's anger, hostility, desire, fear, love, or any other emotion. The other adjuncts already used in the first phase can be kept going with great effectiveness.

In the third phase, when living in the community residence seems in order, all these activities could well be kept going. I would feel that the specific tasks of this phase are to assimilate the new dimensions of experience that have been activated in the psychotic episode, and to elaborate the Individual's knowledge about them enough to enrich their meaningfulness to him. Writing, painting, and discussion are useful ways toward this end. During this, I would especially emphasize finding out how to establish the way of life that has been manifesting itself during the

inward journey, and during the experience of dwelling in a therapeutic community.

IMAGE AND EMOTION IN MOMENTS OF REALIZATION

In the progress of therapy, only minimal (i.e., few and very simple) interventions are needed from the therapist. It constantly impresses me that the subliminal psyche knows much better than any therapist what it needs and how to achieve it. The problem is only with the ego that cannot discern the meaning of the psyche and that finds it therefore hard to cooperate with its efforts. I therefore have come to feel that rendering "interpretations" is not the business of therapy in the psychotic episode. Rather, the aim is to enter the Individual's inner world — if invited in, that is. When there, if one listens attentively and remembers from day to day, one hears from the Individual in what respect the symbolic imagery, though seeming so far away from life, is actually dealing with issues that belong very much in the troublesome areas of the Individual's personal emotional concerns. Then, it is well to remind him of what he has been saying, in piecemeal fashion, that has to do with these urgent issues. I can think only of the term "making connections" for this function, and it is a function shared by Individual and therapist alike; one reestablishes the lost connections between the affect-images and their life setting in the emotional issues at stake. These are the very connections which the schizophrenic fragmentation has disrupted; by the same token, reestablishing them undoes the work of the psychotic splitting.

I will cite just a few of the many instances in my experience with many cases in which the symbolic imagery came through vividly as describing very tangible emotional concerns.

Case number 1. *In her second drawing she constructed a design representing a plant with blossom, leaves, and base, which were at the same time sun and moon and the circle of the world around; she put square corners outside the circle to designate the world of the afterlife added to this world. The four long leaves of the plant represented her relationship to two friends and the rivalry that arose between them, during their adolescent years; they were opposite aspects in her own makeup. What had obviously been left as a hurtful traumatic passage in her earlier life was now rehearsed, rendered in symbol, and resolved in a harmonious integration into a whole cosmic balance of opposites.*

Case number 3. *In a design of cosmic diagrams, he represented the four dimensions of existence (hell, purgatory, heaven, and the world) as the "four degrees of initiation" in his experience of death and rebirth. In the middle of the last of the diagrams, he indicated a vertical passage between a white pole above and a black one below. These he said were head and heart, spirit and body; these in turn referred to the conflict between his pull toward the life of celibacy as a priest and that toward the life of love and marriage. He could be a spiritual father or a family father. He had considered training both for the priesthood and for engineering. These were opposites that tore him apart, and were finding their resolution again in a cosmic diagram that brought all opposites into symmetrical relation.*

Case number 5. *In a drawing of a conjunction (and thus marriage) of sun and moon, he was designating the conception of a new world. He termed it, "Home on the Range." What he narrated while drawing it was his pressing dream of living his life on a ranch with his wife. In their union in such a way of life they would create a new world for themselves. The issue was full of anguish for him, because life in the city resulted in his being swallowed up in the whole clan of her side of the family, which emphasized their differences and showed up his inadequacy. The issue found its resolution in a harmonious union of cosmic bodies giving issue to a new world.*

Case number 6. *She had a vivid delusional fantasy of her four uncles overthrowing the old emperor of the Aztecs and setting up a new arrangement of the nation in four equal kingdoms, replacing the old tyranny with a new ideology of equality and justice. This old Emperor was their father, in the mother's family. She went into a full emotional account of the resemblance between her mother and grandfather in their autocratic ways, and how controlling the mother had been to her, the patient. The picture of the new fourfold Aztec nation was obviously an image of her own new independence and selfhood resulting from her rebellion against the mother's dominance.*

Case number 9. *He was suspended in his choice between the democratic and the communist worlds and ideologies. These opposites were not merely political in nature, but had qualities of character that to him were more important. The democracies were soft and wishy-washy and their men sissies; the communists were tough, hard, and aggressive. The former were religiously inclined, which was weakening to them; the latter were worldly and could cope with things more effectively. He associated the former with his mother, who encouraged his own religiousness and tended to undermine his manhood, and the latter with his father, who was cold and distant but made a good model for effective manly dealing with the world of realities.*

Case number 10. *In a painting of a crucifixion of a crowned serpent, she at first said she was representing the snake of the caduceus of the medical professions. Further fantasies about a new order of society as a New Jerusalem showed her to be in open rebellion against the world of science and technology, promoting instead an inviting pastoral sort of life close to the earth and emphasizing marriage, home, and children. Her mother had made her into a pseudo-husband, tending the home while the patient went off to work in her profession, and she resented this masculinizing and distorting of her nature. All this was compacted in the image of the serpent being sacrificed on the cross.*

I could cite many more instances of these connections of mythological-style imagery with the emotional concerns and conflicts of these and other Individuals. The work of therapy is filled with them. I have come to think of them as the crucial nodal points of the work of therapy, and refer to them as "moments of realization." These are the exciting junctures at which an abstract kind of symbolic expression suddenly is found to touch upon a critical issue in the life of the Individual, and the affect comes rushing into play in a sudden and dramatic burst or release.

The model for formulating this event concerns the relation of affect and image and emotional concern, and the most applicable one in my view is the complex-theory. The play of symbolic imagery leads to the affect which has been separated and lost from view in the schizophrenic break. As soon as the image is associated with the personal issue that it symbolizes, the affect comes bursting through, and the contents of the entire complex make themselves known. This is more than a mere restoration of the complex out of its fragmentation. It is, rather, activated now, and there is a new ability to resolve it. The whole problem in the conflict is now put into a framework of a separating out of opposites on a cosmic-mythological scale, and a resolution of these by some sort of symbolic device. Such a resolution on a symbolic level seems to be a step on the way toward integration in terms of the handling of the emotional issues themselves. Such a resolution appears to constitute the problem-solving ability of the subliminal psyche — an ability which becomes manifest during the psychotic episode itself.

1. See "Acute Catatonic Schizophrenia," *Journal of Analytical Psychology* 11, no. 2 (1957).

BIBLIOGRAPHY

Albright, William F., *The Archeology of Palestine.* Baltimore: Penguin, 1960.
____, *The Biblical Period from Abraham to Ezra.* New York: Harper and Row, 1965.
Arieti, Silvano, *The Intrapsychic Self.* New York: Basic Books, 1967.
Barron, Frank X., *Creativity and Psychological Health.* Princeton: Van Nostrand, 1963.
Bateson, Gregory, *Perceval's Narrative.* Stanford: Stanford University Press, 1961.
____, "Towards a Theory of Schizophrenia," *Behavioral Sciences* (1956), 251–64.
Bentzen, Aage, *King and Messiah.* London: Lutterworth, 1955.
Birkeland, Harris, *The Evildoers in the Book of Psalms.* Oslo: Avhandlinger utgitt av Det Norske Videnskaps, 1955.
Bodde, Derk, "Harmony and Conflict in Chinese Philosophy," in *Studies and Thought in Chinese Philosophy,* edited by Arthur Wright. Chicago: Chicago University Press, 1953.
Boehme, Jacob, *Dialogues on the Supersensuous Life.* London, Methuen, 1901.
____, *Des gottseeligen, hocherleuchteten alletheosophische Wercken.* Amsterdam, 1682.
____, *The Works of Jacob Behmen,* revised by W. Law. London: M. Richardson, 1764–81, Vol. I.
Boisen, Anton T., *The Exploration of the Inner World.* Chicago: Willett, Clark, 1936.
Breasted, James H., *Development of Religion and Thought in Ancient Egypt.* New York, Scribner, 1912.
Bucke, Richard M., *Cosmic Consciousness.* New York: Dutton, 1969.
Campbell, Joseph, *The Hero with a Thousand Faces,* Bollingen Series XVII. New York: Pantheon, 1949.

____, *The Masks of God.* New York: Viking Press, 1959–68, Vol. I–IV.

Cassirer, Ernst, *The Myth of the State.* New Haven: Yale University Press, 1946.

Chamberlin, R. B., ed., *The Dartmouth Bible.* Boston: Houghton Mifflin, 1961.

Childe, V. Gordon, *The Prehistory of European Society.* London: Penguin, 1954.

Cornford, Francis M., *From Religion to Philosophy.* New York: Harper and Row, 1957.

Dante, Alighieri, *Paradise,* translated by C. E. Norton. New York: Houghton Mifflin, 1892.

____, *Vita Nuova,* XLI, quoted in C. Williams, *The Figure of Beatrice.* New York: Noonday Press, 1961.

Davidson, H. R. Ellis, *Gods and Myths of Northern Europe.* Baltimore: Penguin Books, 1964.

Duchesne-Guillemin, Jacques, *The Hymns of Zarathustra.* Boston: Beacon paperback, 1963.

Dutt, Romesh C., *The Mahabharata,* abr., New York: Everyman, Dutton, 1955.

Eliade, Mircea, *Birth and Rebirth.* New York: Harper, 1958.

____, *The Myth of the Eternal Return,* Bollingen Series XLVI. New York: Pantheon, 1954.

____, *Shamanism: Archaic Techniques of Ecstasy,* translated by W. R. Trask, Bollingen Series LXXVI. New York: Pantheon, 1964.

Firdausi, "The Shah Nameh," abr., *The World's Great Classics: Oriental Literature.* New York: Colonial Press, 1899, Vol. I.

Fischer, Roland A., "A Cartography of the Ecstatic and Meditative States," *Science* CLXXIV (November 26, 1971), 897–904.

Fletcher, J., *Situation Ethics: The New Morality.* Philadelphia: Westminster, 1966.

Fox, George, *The Journal of George Fox,* edited by J. L. Nickalls. Cambridge: Cambridge University Press, 1952.

Frankfort, Henri, ed., *Before Philosophy; the Intellectual Adventure of Ancient Man.* London: Penguin, 1954.

____, *Kingship and the Gods: A Study of Ancient Near Eastern Religion as the Integration of Society and Nature.* Chicago: University of Chicago Press, 1948.

Freud, Sigmund, *Collected Papers* II. London: Hogarth, 1924.

____, *Collected Papers* III. London: Hogarth, 1950.

Frye, Northrop, *Fearful Symmetry*. Princeton: Princeton University Press, 1969.

Gaster, Theodor H., *Thespis: Ritual, Myth and Drama in the Ancient Near East*. Garden City: Doubleday, Anchor Books, 1961.

Gennep, Arnold van, *The Rites of Passage*. Chicago: University of Chicago Press, 1960.

Grønbech, Vilhelm P., *The Culture of Teutons*. London: Oxford University Press, 1931.

Gunkel, Hermann, *Schöpfung und Chaos*. Göttingen: Vandenhoeck and Ruprecht, 1895.

Harrison, Jane, *Themis*. Cambridge: Cambridge University Press, 1927.

Hartmann, Franz, *The Life and Doctrines of Jacob Boehme*. London: Kegan Paul, Trench, Trubner, 1891.

Hocart, Arthur M., *Kings and Councillors*. Cairo: Egyptian University, Barbey, 1936.

____, *Kingship*. London: Oxford University Press, 1927.

Homer, *The Iliad,* translated by A. T. Murray. Cambridge: Cambridge University Press, 1924.

Hooke, Samuel H., ed., *The Labyrinth*. New York: Macmillan, 1935.

____, *Myth and Ritual*. London: Oxford University Press, 1933.

____, *Myth, Ritual, and Kingship*. Oxford: Clarendon Press, 1958.

The I Ching or Book of Changes, translated by Richard Wilhelm, Bollingen Series XIX. New York: Pantheon, 1950.

Jacobs, Jane, *The Economy of Cities*. New York: Random House, 1969.

Jacobsen, Thorkild, "Mesopotamia," in Henri Frankfort, *Before Philosophy*. Harmondsworth, Middlesex, Penguin, 1954.

James, Edwin O., *The Ancient Gods: The History and Diffusion of Religion in the Ancient Near East and the Eastern Mediterranean*. New York: Putnam, 1960.

____, *Christian Myth and Ritual*. New York: Meridian Books, 1965.

____, *The Cult of the Mother Goddess*. New York: Barnes and Noble, 1959.

____, *Myth and Ritual in the Ancient Near East*. New York: Praeger, 1958.

____, *Seasonal Feasts and Festivals*. New York: Barnes and Noble, 1961.

James, William, *Varieties of Religious Experience*. New York: Random House, 1902.

Jastrow, Morris, *Die Religion Babyloniens und Assyriens.* Giessen: A. Töpelmann. 1905–12.

Johnson, A.R., *Sacral Kingship in Ancient Israel.* Cardiff: University of Wales, 1955.

Jones, R.M., "Liberalism in the Mystical Tradition," in D. Roberts and H. van Dusen, *Liberal Theology: An Appraisal.* New York: Scribner, 1942.

Jung, C.G., *Collected Works,* translated by R.F.C. Hull. Bollingen Series XX. New York: Pantheon. (Now published by Princeton University Press.)

____, *Analytical Psychology: Its Theory and Practice,* The Tavistock Lectures. New York: Pantheon, 1968.

____, *Psychological Types,* translated by H. Godwin Baynes. New York: Harcourt Brace, 1923.

____, *The Secret of the Golden Flower.* London: Kegan Paul, Trench, Truber, 1935.

Klausner, Joseph, *The Messianic Idea in Israel,* translated by W. F. Stinespring. New York: Macmillan, 1955.

Kris, Ernst, *Psychoanalytic Explorations in Art.* New York: International Universities Press, 1952.

LaBarre, Weston, "Materials for a History of Studies of Crisis Cults: A Bibliographic Essay," *Current Anthropology* XII, no. 1 (1971).

Lao-tse, "The Tao-Teh-Ching," in *The Wisdom of Lao-tse,* ed. Lin Yutang. New York: Modern Library, 1948.

Laski, Marghanita, *Ecstasy.* New York: Greenwood Press, 1968.

Latourette, Kenneth S., *The Chinese: Their History and Culture.* New York: Macmillan, 1946.

Leuba, James H., *Psychology of Religious Mysticism.* New York: Harcourt, Brace, 1929.

Loomis, Roger S., *The Grail: From Celtic Myth to Christian Symbol.* New York: Columbia University Press, 1963.

L'Orange, Hans P., *Studies on the Iconography of Cosmic Kingship in the Ancient World.* Cambridge: Harvard University Press, 1953.

Martensen, Hans L., *Jacob Boehme: His Life and Teaching; or Studies in Theosophy,* translated by T. Rhys Evans. New York: Harper, 1949.

Menninger, Karl, *A Psychiatrist's World.* New York: Viking, 1959.

____, *The Vital Balance.* New York: Viking, 1969.

Metman, Philip, "The Ego in Schizophrenia," *Journal of Analytical Psychology* I, no. 2 (1956), 161–176; II, no. 1 (1957), 51–71.

Mowinckel, Sigmund O. P., *He That Cometh,* translated by G. W. Anderson. New York: Abingdon, 1954.

Murray, Gilbert, *Five Stages of Greek Religion.* New York: Columbia University Press, 1925.

The Nibelungenlied, translated by W. N. Lettsom. New York: Colonial Press, 1901.

Neumann, Eric, *Art and the Creative Unconscious,* Bollingen Series LXI. Princeton: Princeton University Press, 1959.

____, *The Great Mother,* Bollingen Series XLVII. New York: Pantheon, 1955.

____, *The Origins and History of Consciousness,* Bollingen Series XLII. New York: Pantheon, 1954.

Nijinsky, Vaslav, *The Diary of Vaslav Nijinski,* edited by Romola Nijinsky. Berkeley: University of California Press, 1968.

Perry, John W., "Acute Catatonic Schizophrenia," *Journal of Analytical Psychology* II, no. 2 (1957), 137–52.

____, "Emotions and Object Relations," *Journal of Analytical Psychology* XV, no. 1 (1970), 112.

____, "Image, Complex and Transference in Schizophrenia," in *Psychotherapy of the Psychoses,* edited by A. Burton. New York: Basic Books, 1961.

____, "A Jungian Formulation of Schizophrenia," *American Journal of Psychotherapy* X, no. 1 (1956), 54–65.

____, *Lord of the Four Quarters.* New York: Braziller, 1966.

____, "Reconstitutive Process in the Psychopathology of the Self," *Annals of the New York Academy of Sciences* XCVI, Art. 3 (January 27, 1962), 853–76.

____, "Reflections on the Nature of the Kingship Archetype," *Journal of Analytical Psychology* XI, no. 2 (1966), 147–62.

____, *The Self in Psychotic Process.* Berkeley: University of California Press, 1953.

____, "Societal Implications of the Renewal Process," *Spring* (1971), 153–67.

Piaget, Jean, *The Construction of Reality in the Child.* New York: Basic Books, 1954.

Pike, James A., *Doing the Truth: A Summary of Christian Ethics.* New York: Macmillan, 1965.

Plato, *The Dialogues of Plato,* translated by B. Jowett. Oxford: Clarendon Press, 1871.

Plotinus, "Ennead VI," in J. Katz, *The Philosophy of Plotinus.* New York: Appleton-Century-Crofts, 1950.

Pritchard, James B., *Ancient Near Eastern Texts Relating to the Old Testament.* Princeton: Princeton University Press, 1958.

Raglan, Fitz Roy R. S., *The Hero: A Study in Tradition, Myth, and Drama.* London: Methuen, 1936.

Récéjac, Édouard, *Essay on the Bases of Mystic Knowledge,* translated by S. C. Upton. London: Kegan Paul, Trench, Trubner, 1899.

Rilke, Rainer M., *Selected Poems,* translated by C. F. MacIntyre. Berkeley: University of California Press, 1958.

Robinson, John A. T., *Honest to God.* Philadelphia: Westminster, 1963.

Roszak, Theodore, *The Making of a Counter-Culture: Reflections on the Technocratic Society and its Youthful Opposition.* Garden City: Anchor paperback, 1969.

St. John of the Cross, "Dark Night of the Soul," in *Complete Works of Saint John of the Cross,* translated by E. A. Peers. London: Burns, Oates, and Washburn, 1953.

____, *Life and Works,* trans. D. Lewis. London: Thomas Baker, 1889–91.

Scheif, Thomas J., *Being Mentally Ill.* Chicago: Aldine, 1966.

Scholem, Gershom G., "Religious Authority and Mysticism," *Commentary* (November, 1964), 32.

Schrader, O., "Aryan Religion," in *Encyclopaedia of Religion and Ethics,* ed. James Hastings. Edinburgh: Clark, 1909, Vol. 2, p. 51.

Silverman, Julian, "Shamans and Acute Schizophrenia," *American Anthropologist* LXIX, no. 1 (1967), 21–31.

Smith, W. R., *The Religion of the Semites.* New York: Meridian Books, 1956.

Sorokin, Pitirim A., *The Crisis of our Age.* New York: Dutton, 1942.

Spiro, Melford E., "Culture and Personality: The Natural History of a False Dichotomy," *Psychiatry* XIV (February, 1951), 1946.

Sullivan, Harry S., *Schizophrenia as a Human Process,* New York: Norton, 1962.

Suso, Heinrich, *The Life of Blessed Henry Suso by Himself,* translated by T. F. Knox. London: Methuen, 1913.

Underhill, Evelyn, *Mysticism.* London: Methuen, 1912.

Wallace, A. F., *Culture and Personality.* New York: Random House, 1970.

____, "Stress and Rapid Personality Changes," *International Record of Medical and General Practice Clinics* CLXIX, no. 12 (1956), 761–74.

Wickes, Frances, *The Inner World of Man.* New York: Farrar and Rinehart, 1938.

Winston, David, "The Iranian Component in the Bible, Apocrypha, and Qumran; A Review of the Evidence," *History of Religions* V, no. 2 (Winter, 1966), 183–216.

Wolf-Windegg, P., *Die Gekrönten: Sinn und Sinnbilder des Königtums.* Stuttgart, Ernst Klett, 1958.

Wooley, L., *History Unearthed.* New York: Praeger, 1958.

INDEX

N

O

P

S

ABOUT THE AUTHOR

John Weir Perry (1914–1998) was a Jungian psychiatrist whose deep insight into the nature of so-called "schizophrenia" opened the way for a radically new, more compassionate approach to this condition. He first met C.G. Jung in Switzerland as a young medical student, where he was intrigued by Jung's assertion that schizophrenia is a natural healing process.

During the 1970s, Perry founded an experimental residential facility called Diabasis in Berkeley, California, designed as a supportive home for young adults who were experiencing the initial days of their first "acute schizophrenic break." At Diabasis, these full-blown "schizophrenics" were able to emerge "on the far side of madness", as Perry put it, "weller than well," without any treatment by medication, electroshock, or locked doors.

Perry was the author of many books, including *The Self in Psychotic Process: Its Symbolization in Schizophrenia* (with a foreword by Jung), *The Heart of History: Individuality in Evolution, Trials of the Visionary Mind: Spiritual Emergency and the Renewal Process,* and *Lord of the Four Quarters: The Mythology of Kingship.*